Indian Ocean CURRENT

SIX ARTISTIC NARRATIVES

SHIRAZ BAYJOO · SHILPA GUPTA · NICHOLAS HLOBO
WANGECHI MUTU · PENNY SIOPIS · HAJRA WAHEED

Prasannan Parthasarathi, editor

McMullen Museum of Art, Boston College

This publication is issued in conjunction with the exhibition *Indian Ocean Current: Six Artistic Narratives* in the Daley Family and Monan Galleries at the McMullen Museum of Art, Boston College, January 27–May 31, 2020. Organized by the McMullen Museum, *Indian Ocean Current* has been curated by Prasannan Parthasarathi and Salim Currimjee and underwritten by Boston College with major support from the Patrons of the McMullen Museum and Liliane and Christian Haub in honor of Marie-Liliane '13, Maximilian '14, and Constantin '17 Haub.

Library of Congress Control Number: 2019948581
ISBN: 978-1-892850-40-9

Distributed by the University of Chicago Press
Printed in the United States of America
© 2020 The Trustees of Boston College

Copyeditor: Kate Shugert
Designer: John McCoy

Front: Penny Siopis (b. 1953), detail of *Warm Waters* [5], 2018–19, glue, ink, and oil on paper, 12.2 x 8.7 in., 111
Endpaper (front): Wangechi Mutu (b. 1972), detail of *I'm too Misty*, 2015, collage painting on linoleum, 40 x 33 in., 92
Flyleaf (front): Nicholas Hlobo (b. 1975), detail of *Amatholana asibhozo*, 2017, ribbon and leather on canvas, 19.7 (diam.) x 2.1 in., 66, 74
Flyleaf (back): Shilpa Gupta (b. 1976), detail of *Untitled (There Is No Border Here)*, 2005–06, wall drawing with self-adhesive tape, 118 x 118 in., 40
Endpaper (back): Hajra Waheed (b. 1980), detail of *Untitled (MAP)*, 2016, infographic print on vellum, 304 x 25 in., 152–55
Back: Shiraz Bayjoo (b. 1979), *Extraordinary Quarantines #38*, 2014, giclée print, 20 x 20 in., 23

CONTENTS

Preface

In 2016 Prasannan Parthasarathi, a professor in Boston College's History Department, spoke to me about his long-standing research and teaching interests in the history of the Indian Ocean. He was writing a book on environmental change in nineteenth-century South India and had just returned from a research trip to Mauritius where he had studied the records of migrants from South India to that island. While there he had seen his old friend, the architect Salim Currimjee, founder of the Institute of Contemporary Art Indian Ocean, a platform for art education and public programming. He and Currimjee wondered if the McMullen might consider an exhibition of works by contemporary artists from lands bordering the ocean, one that would speak to the movement of goods, ideas, and people across it and to the consequences of its current rising water levels.

Embracing the idea, the McMullen team met with Parthasarathi and Currimjee only to realize that the project had even richer possibilities than originally envisioned for exploring relationships between art and climate change. The project team then widened to include experts in climate science: Gail Kineke, a professor from Boston College's Earth and Environmental Sciences Department, scientists Hyodae Seo, Sujata Murty, and Caroline Ummenhofer from the Woods Hole Oceanographic Institution, and Christopher Scotese of Northwestern University and the Field Museum.

Concurrently, Currimjee proposed artists whose work in various media probe and stimulate dialogue about concerns within the diverse communities that now populate the Indian Ocean world. The McMullen was delighted when six outstanding artists with roots in different communities surrounding the western Indian Ocean, Shiraz Bayjoo, Shilpa Gupta, Nicholas Hlobo, Wangechi Mutu, Penny Siopis, and Hajra Waheed agreed to participate in the exhibition.

The curators then assembled a team of distinguished scholars from a range of disciplines who were eager to write essays for the catalogue edited by Parthasarathi about the artists' work and the issues they engender. The Museum is grateful to Sana Aiyar, Sunil Amrith, Salim Currimjee, Zara Currimjee, Bérénice Guyot-Réchard, Pedro Machado, David Northrup, Prasannan Parthasarathi, and Kalpana R. Seshadri for their contributions.

This exhibition epitomizes what a university museum of art can contribute to the understanding of a crisis in a distant part of the world when faculty and other experts from the humanities, sciences, and social sciences collaborate on a project. It could not have been undertaken without the historical knowledge, vision, dedication, and enthusiasm of Prasannan Parthasarathi and the art historical expertise of Salim Currimjee.

To both of them the Museum extends its deepest thanks for leading this project.

Special thanks are also due to colleagues at the McMullen Museum. Assistant Director Diana Larsen has designed the galleries innovatively to accommodate both art and scientific displays. Assistant Director John McCoy designed the catalogue and adapted the digital didactics for the exhibition's scientific component to reflect a contemporary aesthetic. Manager of Publications and Exhibitions Kate Shugert expertly oversaw the editing of the catalogue in addition to organizing all the loans. Rachel Chamberlain, Manager of Education, Outreach, and Digital Resources, has created a series of programs and events to engage audiences with the artists' works and reflect on current concerns in the Indian Ocean world.

The spirit of collaboration carried over into other areas of our University. Professor of Art Mark Cooper and Professor of Computer Science Lewis Tseng provided invaluable advice. The Institute for the Liberal Arts, directed by Professor Mary Crane, the Lowell Lecture Series, directed by Professor James Smith, along with the Asian Studies, History, and English Departments have supported related programs; Jack Dunn and Rosanne Pellegrini of the Office of University Communications oversaw publicity; Anastos Chiavaras from the Office of Risk Management and Peter

Preface

Marino from the Center for Centers have aided, respectively, with securing insurance and budgeting. James Husson, Diana Griffith, and Ericka Webb of University Advancement have helped with funding.

Of course, the exhibition would not have been possible without the munificence and cooperation of its lenders. We extend thanks to each of the artists for their participation as well as to Ed Cross Fine Art; Galleria Continua (Mario Cristiani, Lorenzo Fiaschi, Maurizio Rigillo, and Margherita Tinagli); Lehmann Maupin (Anna Stothart, Amy Cosier, and Lisa McCarthy); Stevenson Cape Town (Joost Bosland and Marc Barben); Studio of Wangechi Mutu (Astrid Meek); Studio of Hajra Waheed (Tiffany Le); Museum Voorlinden, Wassenaar (Suzanne Swarts and Marie-Fleur Dijk); Midori Yamamura and Luis H. Francia; and an anonymous private collector.

The McMullen remains grateful for the following Museum endowments that provide vital support for all our projects: Linda '64 and Adam Crescenzi Fund, Janet M. and C. Michael Daley '58 Fund, Gerard and Jane Gaughan Fund for Exhibitions, Hecksher Family Fund, Hightower Family Fund, John F. McCarthy and Gail M. Bayer Fund, Christopher J. Toomey '78 Fund, and Alison S. and William M. Vareika '74, P'09, '15 Fund.

The McMullen Museum could never have realized a project involving transport of works from around the world without the ongoing support of the administration of Boston College and the McMullen Family Foundation. We especially thank Jacqueline McMullen, President William P. Leahy, SJ; Provost David Quigley; Vice Provost Billy Soo; and Morrissey College of Arts and Sciences Dean Gregory Kalscheur, SJ. Major support for the exhibition was provided by the Patrons of the McMullen Museum, chaired by C. Michael Daley, and by Liliane and Christian Haub in honor of Marie-Liliane '13, Maximilian '14, and Constantin '17 Haub.

The contributions of all mentioned above have our profound appreciation for making possible *Indian Ocean Current*'s timely reflection on an area of urgent concern in our world.

Nancy Netzer
Inaugural Robert L. and Judith T. Winston Director and Professor of Art History

Introduction

Salim Currimjee & Prasannan Parthasarathi

For thousands of years humans have plied the waters of the Indian Ocean. From ancient times to the nineteenth century, merchants carried cotton cloth from India to far-flung lands, returning with cargoes of horses, spices, and precious metals. In the sixteenth and seventeenth centuries, soldiers from East Africa fought in the armies of kings in western and southern India, on occasion themselves becoming rulers in their own right. Islam traveled from its home in the Arabian Peninsula across the Indian Ocean to South and Southeast Asia and for centuries Muslims from these areas have made the journey in reverse in the great pilgrimage to Mecca. The ocean made all this possible and for many millennia humans and water have been inextricably linked in the Indian Ocean world.

Indian Ocean Current: Six Artistic Narratives explores the contemporary legacy of this long movement of people, things, and ideas. It showcases the work of six artists with deep ties to the lands surrounding the western half of the Indian Ocean: Shiraz Bayjoo, Shilpa Gupta, Nicholas Hlobo, Wangechi Mutu, Penny Siopis, and Hajra Waheed. Through a variety of mediums and forms—including paintings, videos, collages, sculptures, and photographs—these six artists grapple with the past, present, and future of the Indian Ocean.

Indian Ocean Current probes complex and vexing questions: How do we make sense of the great mixing of peoples in the region's past and present? How do we conceive of the water that linked distant shores? How do we address the borders that divide spaces that for so long were undivided? What do the rising waters resulting from global warming portend for the future of the Indian Ocean and, most importantly, for its inhabitants?

The Indian Ocean is the only ocean in the world in which currents and winds reverse direction during the year in the system known as the monsoon. As land and water temperature differences wax and wane, currents and winds shift. From April to August, the winds blow from the southwest to the northeast, reversing direction from December to March. The seasonal predictability of these shifts made long distance journeys on the ocean possible from a very early date. This is why the Indian Ocean became the first of the world's oceans to be a dense zone of commercial activity. It was a mercantile lake.

The Indian Ocean is a striking illustration of the deep ties between humans and the geological features of our planet. These features are being reshaped today, an effect of anthropogenic climate change, and the relationship between humans and water in the Indian Ocean world is being remade with potentially disastrous consequences.

The richness of commercial life in the Indian Ocean is what attracted medieval Europeans to its waters. While few Europeans had direct access to that world, the products of the Indian Ocean entered the Mediterranean via sea and land. It was the fabled riches of the Indian Ocean that inspired the Portuguese to seek a sea route around Africa, which they did successfully in 1498 when Vasco de Gama rounded the Cape of Good Hope and sailed with the help of an Indian pilot from East Africa to Calicut in southwestern India. From that date, a succession of Europeans—Portuguese, Dutch, English, French, Danish—sailed in its waters.

Shiraz Bayjoo

Shiraz Bayjoo recalls that European presence with his video *Sea Shanty* (16–20). Shanties were songs that sailors sang while working onboard large vessels. While the sailors on these ships were drawn from across the Indian Ocean, as well as all over the world, the sea shanty came to be associated with Europeans.

Bayjoo is based in London, but is originally from Mauritius, an island that lies 1,200 miles off the east coast of Africa. Mauritius was uninhabited before Europeans entered the Indian Ocean. From the sixteenth century, it became a port of call for ships from Europe where they replenished supplies of food and water. Mauritius

3

also exported ebony and sugar to markets in the Indian Ocean. Sugar plantations took off after the abolition of slavery in the British Empire in 1833 and laborers were brought there from across the Indian Ocean world to cultivate the plant. Africans, Indians, Southeast Asians, and Chinese all made homes on the island.

Mauritius is a microcosm of the Indian Ocean world. Its plural society is where past and present meet and this is captured in Bayjoo's *Extraordinary Quarantines* (21–24). On the island, the Hindu god Hanuman, Rama's trusted devotee and lieutenant, coexists with a Christian burial ground. Indians, many descendants of indentured laborers, but some heirs to vast merchant fortunes built on the basis of the Indian Ocean trade, coexist with Africans, Chinese, and even a Francophone plantocracy.

Wangechi Mutu

Violence and coercion played a role in the building of plural Indian Ocean societies, and Wangechi Mutu's video *Amazing Grace* (86–91) reminds us of this history. Mutu is from Kenya and today divides her time between Nairobi and Brooklyn, New York. She is steeped in the worlds of both the Atlantic and Indian Oceans and her video reflects this double consciousness—in it she sings "Amazing Grace" in Kikuyu.

The author of "Amazing Grace," John Newton (1725–1807), was a British abolitionist who influenced, among others, William Wilberforce, Hannah More, and William Cowper. Newton had been a slave trader in his early years, and the hymn celebrates his delivery from that path of sin. Although "Amazing Grace" was written in the context of the Atlantic slave trade, it has relevance for the Indian Ocean as well.

The Atlantic dominates discussions of modern slavery, but the Indian Ocean had a long history of slave trading. While this history predated the coming of Europeans, the Portuguese, Dutch, French, and English took to the commerce and purchased enslaved persons in major entrepôts to work in their fortresses, cities,

and plantations. Between 1400 and 1900 it is estimated that 2.6 million individuals from Africa were traded as slaves in the Indian Ocean. For the sake of comparison, in the same period some 12.5 million enslaved Africans were traded in the Atlantic.

The indentured labor system, in which laborers entered into long-term agreements to migrate and work on plantations, emerged after slavery was abolished in the early nineteenth century. It rested on coercion as well and Hugh Tinker, an early historian of the system, labeled it "a new system of slavery."[1] While that analogy to slavery is now thought to be overstated, it nevertheless points to the violence upon which even indentured labor rested. The pluralism of the Indian Ocean world was a product of the violent displacement of many millions.

Shilpa Gupta

The plural world of the Indian Ocean began to be torn asunder from the 1930s with the economic crisis of the Great Depression, nationalist movements that challenged the European colonial order, and World War II. Nations came to be defined in exclusive terms, at times along ethnic lines and at other moments and places along religious ones. The Indian Ocean world has been home to riots against foreigners and successive waves of expulsions of outsiders. Indians have been expelled from East Africa, Muslims from India, Hindus from Pakistan, and Rohingya from Burma.

After World War II, decolonization and the end of empire came to the Indian Ocean and nation-states were created, and with them borders were erected. Shilpa Gupta of Mumbai, India, subjects these borders to her critical eye and exposes them for the artificial constructions that they are. *Untitled (There Is No Border Here/No hay frontera aquí)* (40–41) points to the impossibility of separating peoples and territories. "I tried very hard to cut the sky in half, one for my lover and one for me, but the sky kept moving

and clouds from his territory came into mine/Me esforcé intensamente por dividir el cielo en dos, una parte para mi amado, y otra para mí, pero el cielo continuó moviéndose y las nubes de su territorio invadieron mi espacio," the flags proclaim. The works that comprise *Fenced Borders* (46–51) speak to the geographical and cultural connections that unite across borders, whether they are a shared love of mangoes or mangrove trees rooted in the swampy soils of the Sundarbans. Gupta speaks to the refusal of many in the Indian Ocean world to allow borders and nation-states to divide.

Nicholas Hlobo

Politics in the Indian Ocean world are not found only in the large scale, but operate at the level of the personal and intimate as well. Nicholas Hlobo of Johannesburg, South Africa, works in a variety of media to explore questions of masculinity, sexuality, ethnicity, and race. South Africa is a diverse society, in part due to its longstanding connections across the Indian Ocean to the Indian subcontinent. At the same time, Hlobo draws upon postapartheid South Africa and his Xhosa culture (reflected in the titles of his works in this exhibition) to explore both past and present and imagine a new future. The work boots and industrial materials in *Ngumgudu nemizano* (64–65) evoke simultaneously hard labor and fetish wardrobes. In *Amatholana asibhozo* (66–74) Hlobo joins together a stereotypically masculine attribute, leather, with a feminine one, ribbon. They are literally stitched together—blurring the divides between masculine and feminine and the home and the outside world. The stitching additionally recalls Hlobo's grandmother whom he watched embroidering when he was a young boy.

Hlobo's work also brings to mind the sea and its animals. The flabby leather bag of *Ngumgudu nemizano* suggests a fluid underwater creature such as an octopus. The stitching of *Amatholana asibhozo* resembles eels, animals that travel long

4

distances, journeying from freshwater to salt in order to breed. The eel represents the long and difficult path that Hlobo himself has taken. His work powerfully points to the multiple ways of being in the contemporary Indian Ocean world and the fluidity and multiplicity of the self.

Hajra Waheed

Since 1945 the Indian Ocean world has become the world's center of oil extraction, an activity that in the words of Gabrielle Hecht is "turning our planet inside out."[2] The deposits of oil in the western stretches of the ocean, on lands bordering the Persian Gulf, are the lifeblood of the global economy. Hajra Waheed, now based in Montréal, Canada, explores the mindsets and the sheer human effort that make possible this work of extraction. *Untitled (MAP)* (152–55) is a classified map of the largest offshore oil field in the world, located 165 miles north of Dhahran, Saudi Arabia, where the artist spent her youth. It "speaks to the fact that surveillance does not live solely on a horizontal plane or two-dimensional map, but manifests as a vertical occupation on a scale that reaches from satellites in the sky to below the surface of the sea."[3] And this is all done in the name of extraction.

The burning of petroleum, along with coal and natural gas, has released enormous quantities of heat trapping gases into our planet's atmosphere. Concentrations of carbon dioxide have gone from 280 parts per million in the preindustrial period, to more than 400. As a result, global temperatures have risen 1°C, leading to warmer oceanic waters. The Indian Ocean is especially vulnerable to this warming. Between 2000 and 2015 it has absorbed 70% of the heat that has been pumped into the world's oceans. The northern Indian Ocean has seen some of the biggest increases in sea level in the world, threatening the tens of millions who live along that coastline.

Penny Siopis

The rising waters of the Indian Ocean inspired Penny Siopis of Cape Town, South Africa, to undertake the works that are included in *Indian Ocean Current*. *She Breathes Water* (104–9) is a film assembled from found footage that laments the damage that humans have wrought upon our planet. Foreseeing the possibility of a world in which humans will cease to exist, she asks, "Can you imagine the world without you?" *Warm Waters* (110–39) is a series of paintings that consist of ink, glue, and oil on paper. Siopis writes, "The material process of the paintings is a fluid affair; the glue's capacity to change its form and colour when it comes into contact with other forces—air, gravity, water, my gestures—imbues it with a presence that holds onto itself as 'something other,' yet can simultaneously take on the guise of an image." The colors overflow the borders of the works, mirroring the rising waters of the Indian Ocean, refusing to be confined or constrained. Is this the human future? In these paintings Siopis was inspired as well by Bernardin de Saint-Pierre's *Paul et Virginie*, set on Mauritius during French rule. For Siopis, Mauritius, a tropical island, is "an ideal 'figure' through which to imagine the 'ground' of rising waters."[4]

The essays in this catalogue provide the context for the works on display in *Indian Ocean Current: Six Artistic Narratives.*

David Northrup's "The Indian Ocean World" gives a succinct but "deep" history of the ocean and it is a foundation for the chapters that follow. Northrup writes that ships crossed the waters of the Indian Ocean from at least the third millennium BCE. In Roman times the trading world of the Indian Ocean was linked to that of the Mediterranean to its west and the South China Sea to its east. Over centuries the density of commerce on the ocean's waters increased and outsiders were drawn to its trading routes, from the Chinese during the Ming dynasty to Euro-

peans from the fifteenth century. Northrup ends his account with the rise of European empires in the nineteenth century and dramatic technological transformations in production and transport. These led to a radical reordering of the Indian Ocean world.

In his "Slavery and Histories of Unfreedom in the Indian Ocean," Pedro Machado explores the forms of involuntary migration that were found in the Indian Ocean. It is difficult to avoid comparisons with slavery in the Atlantic, given that system looms large in all discussions of servitude. Nevertheless, several differences stand out. First, the persons who were enslaved in the Indian Ocean were primarily Asians, not Africans. Second, the work that the enslaved did varied widely in the Indian Ocean. They did not work predominantly on plantations, as was the case in the Atlantic. Finally, when the plantation complex did expand in the nineteenth century, it was after slavery was abolished. Much of the plantation labor force was brought as indentured servants, largely from India, to Mauritius, Natal, and elsewhere.

Kalpana R. Seshadri's "What the Ocean Gives Us to Think" is a profound meditation on the ocean. Seventy percent of our planet is covered by the waters of its oceans. The oceans are what color our planet blue. Yet green is the color of environmentalism, a sign of our terrestrial bias. No summary can do the essay justice. Let us quote an important passage: "Because the Ocean is deep, it gives us to think 'depth,' and in-depth. That the Ocean gives us to think depth is 'deeply' consequential. Without a concept of depth, we could not conceptualize something called the truth or morality." This is why Seshadri urges us "to listen to the Ocean speak."

Just as violence was present when the plural world of the Indian Ocean was formed, it was there when that world was dissolved in the middle decades of the twentieth century. Sana Aiyar, in her "Colonialism's Afterlives and Invocations of Oceanic History," reminds us of long-

5

standing tensions in the Indian Ocean world, arising from economic inequality, religious difference, and ethnic and racial competition and discrimination. These tensions were heightened in the straitened economic conditions of the Great Depression in the 1930s, erupting in the form of riots and violence against "outsiders"—in many cases Indians. These antagonisms continued to simmer in the decades after World War II when the age of empire came to a close in the Indian Ocean world and was succeeded by decolonization and independence. New nations with new borders emerged and new citizens were defined. In East Africa, Burma, and elsewhere Indians were seen as a "colonial hangover" who held back "real" citizens. Such conflicts played out in India itself in the bloody end of empire that was Partition.

After 1945, European empires in the Indian Ocean came to an end and were replaced by nation-states, a shift Bérénice Guyot-Réchard traces in her essay, "The Indian Ocean after 1945." This did not mean the end of a European and later North American presence, as the ocean became a site for Cold War rivalries. Oil, which became easier to ship with revolutions in transport such as the tanker, magnified the importance of the Indian Ocean and choke points like the Straits of Hormuz became global hot spots. Many of the newly independent nations in the Indian Ocean world rejected these superpower intrusions, giving rise to an Afro-Asian bloc of countries that pushed an alternative program of non-alignment, anti-imperialism, and anti-racism. Afro-Asianism, with its geographical center in the Indian Ocean, also challenged the hegemony of Europe in intellectual, cultural, and artistic life. Afro-Asianism culminated in the 1970s with calls for an Indian Ocean "zone of peace," but these efforts foundered as a consequence of nationalism and competition for the riches of the ocean. The silent victim was the ocean itself.

The final two essays deal with climate change. Sunil Amrith's "Climate Change and the Future of the Indian Ocean" traces the long meteorological and climatological engagement with the ocean. For Europeans and others, charting the currents and winds and their shifts over the seasons of the year was critical for the dominance of the ocean's waters. This became less imperative in the age of steam when fossil fuels allowed humans to transcend the rhythms of nature. In that period, the Indian Ocean world underwent enormous environmental changes, much of it on land where forests were cut, the arable was expanded, and agriculture was intensified. But the ocean never disappeared from view. In the twentieth century it came to be seen as a resource for growing populations. And new scientific tools led to a revived interest in the Indian Ocean's role in both local and global climate. This is why the Indian Ocean became a key site for documenting anthropogenic climate change.

Zara Currimjee picks up where Amrith leaves off. She notes in her essay, "The State of the Indian Ocean: A Scientific Perspective," that the Indian Ocean is the least understood of the world's oceans. Comprehensive scientific studies of its waters began only in the late 1950s. However, it is widely acknowledged that the Indian Ocean plays a key role in the heating of our planet; that the oceanic ecosystem is under intense pressure; and that coastal and island communities are extremely vulnerable. In 2014, scientists in Pune, India, reported that for the last century the western Indian Ocean has been warming more rapidly than any other tropical ocean. The reasons for this are still not understood, but the ramifications are enormous. As a result of warmer waters, phytoplankton populations have fallen, reducing supplies of food for countless species of fish, leading to declines in a range of marine animals. Cyclones have intensified, and wrought devastation across the region. Another result of warmer water is rising ocean levels. In the past thirty years, the northern Indian Ocean has risen almost twice as fast as the global average (0.12 inches per year versus the global rate of 0.07 inches per year). Across the Indian Ocean, coastal cities, as well as islands that are home to many millions, are in grave danger of inundation from these waters.

The configuration of land and water in the Indian Ocean gave rise to the regular winds of the monsoon. Those winds made possible dense exchanges and linkages for many millennia. As a result of the extraction and burning of fossil fuels, the relationship between land and water is being reordered and the future of life itself endangered. The six artists who comprise *Indian Ocean Current* contend with the complex past and present of this Indian Ocean world. They also ask us to confront a frightening future. The rising waters of the Indian Ocean will not respect individuals, borders, or nation-states. Will we have the sense to see that?

Salim Currimjee is a practicing architect and artist based in Mauritius and works throughout the Indian Ocean region. He studied biology and art history at Williams College and obtained his MArch from Rice University. In May 2015 he founded ICAIO, Institute of Contemporary Art Indian Ocean, an independent and nonprofit foundation that is a platform for art education and public art programming in Mauritius. Through the visits of international contemporary artists engaging with children and students of Mauritius, ICAIO honors the cultural diversity of the country and seeks to activate critical thinking and dialogue through the arts of the region.

Prasannan Parthasarathi is professor of South Asian history at Boston College. He is the author of *The Transition to a Colonial Economy: Weavers, Merchants and Kings in South India, 1720–1800* (2001), *The Spinning World: A Global History of Cotton Textile*s (2009), and *Why Europe Grew Rich and Asia Did Not: Global Economic Divergence, 1600–1850* (2011), which received the Jerry Bentley Book Prize of the World History Association and was named a *Choice* magazine outstanding academic title. He is now at work on a study of agriculture and the environment in nineteenth-century South India.

1 Hugh Tinker, *A New System of Slavery: The Export of Indian Labour Overseas, 1830–1920* (New York: Institute of Race Relations, Oxford UP, 1974).

2 Gabrielle Hecht, "Inside-Out Earth," *American Historical Review* (forthcoming).

3 "Hajra Waheed at Small Arms," Toronto Biennial of Art, https://torontobiennial.org/work/hajra-waheed-at-small-arms/.

4 "Penny Siopis: *Warm Water Imaginaries,*" Stevenson, https://www.stevenson.info/exhibition/3917.

The Indian Ocean World

David Northrup

This essay presents an overview of the development of the sea routes that became so important in the exchange of goods, the movement of people, and the spread of ideas and beliefs—all central themes explored in *Indian Ocean Current: Six Artistic Narratives.* Besides presenting a capsule history of the Indian Ocean world, it explores some of the consequences of the Indian Ocean gradually becoming part of a global maritime system.

For a long time, oceans, lakes, and rivers hindered contacts among people, but waterways became efficient means of communication and commerce after some learned how to build rafts, canoes, and boats. The pioneering water travelers navigated by keeping riverbanks and lake shores in sight, and at first ocean voyagers also stayed close to the coast so they could tell where they were. Gradually mariners developed the skills necessary to travel long distances across open water. Thousands of years ago the Indian Ocean became the first ocean to be crisscrossed by regular water routes that brought the surrounding lands into regular contact.[1]

Early Indian Ocean Trade

In many ways water travel was an extension of overland routes, but it had the distinct advantages of being much faster and cheaper. By using sails to capture the wind, vessels became much more efficient than land caravans for transporting cargo and passengers. Maritime trading began early and in several different parts of the Indian Ocean. One well documented early example is the trade in the Red Sea (an arm of the Indian Ocean) between ancient Egypt and the land called Punt on the African coast near the southern end of the sea. That connection went back to the middle of the third millennium BCE, and from the fifteenth century BCE onward Egyptian texts and scenes carved in stone (including a sailboat) provide detailed information about the regular trade to and from Punt. Punt supplied Egypt with gold, ivory, incense, wild animal skins, and cattle. It is also recorded that King Solomon of Israel in the tenth century BCE sent fleets every three years to a place called Ophir below the mouth of the Red Sea for similar African goods, including gold in great quantities.[2]

Aside from exceptions such as these, the records for the earliest history of Indian Ocean navigation tend to be few and fragmentary. The first ocean-going vessels would have been for fishing, with trade being a logical adaptation of that technology. There are suggestions of maritime trade along the west coast of India from the third millennium BCE. Trade between western India and the Arabian Peninsula existed at least from Roman times, when the Indian Ocean was clearly part of a much larger system that extended westward into the Mediterranean and eastward into the South China Sea. Arabs concentrated their efforts along the Red Sea, coastal Africa, and the South Arabian coast, meeting traders from northwest India at neutral market towns such as Ormuz at the mouth of the Persian Gulf. In time, Arab, Indian, and Persian mariners learned to make longer voyages across the Arabian Sea, taking advantage of the monsoon winds, which blow westward for half the year then reverse direction. There is evidence that Indians used star maps to facilitate nighttime navigation. Besides the Arabs and Indians, voyagers from the East Indies crossed the southern Indian Ocean in outrigger canoes, introducing the banana to the African mainland and colonizing the large island of Madagascar. Such voyages date to the beginning of the Common Era and ended in the fifteenth century, but the inhabitants of Madagascar still speak a language of the family found in Southeast Asia and the South Pacific.[3]

As the cargoes of Punt and Ophir suggest, early trade on land and sea was mostly in luxury goods for an elite clientele. That would change as larger ships were built to carry goods aimed at less elite consumers. In the absence of manifests and cargo lists, the most detailed evidence of the scope of the Indian Ocean trade comes from the wreckage of a ship

that sank in the Java Sea in the tenth century CE. Modern divers have retrieved much of the cargo from that wreck, including tin from the Malay Peninsula, silver from China, bronze statues from India, and glass beads from Persia. There were also human bones, from people who may well have been slaves who were unable to escape when the ship began to sink because they were tied up. Just as the fibers of the rope did not survive the long submersion, it is likely that the vessel also carried Indian cottons and Chinese silks. Typical of the hundreds or even thousands of vessels then plying the eastern Indian Ocean, the sunken ship was ninety-feet long and twenty-five wide, made of wood

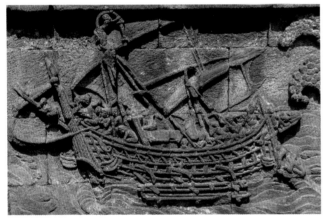

1. Relief panel of a ship from the Buddhist temple at Borobudur, Java, c. 800 CE (Peter Cook, Flickr).

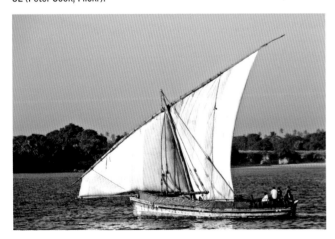

2. Dhow, a type of vessel in use in the western Indian Ocean for more than a millennium, off the coast of Dar es Salaam, Tanzania, 2010 (Sajjad Sherally Fazel/Wikimedia Commons [CC BY-SA 3.0]).

carefully fitted and attached with dowels, not nails.[4]

By the date of this shipwreck, trading communities around the Indian Ocean were exchanging a large volume of goods (fig. 1). With the rise of the Arab Empire in the seventh century, Muslims grew in importance in the maritime trade to the point that the Indian Ocean seemed to be an Islamic sea. Arabic gradually became a lingua franca of the Arabian Sea, Islamic law governed transactions, and a common faith inspired trust among merchants. This was important because land-based governments did not control the trade routes, except for rulers of the port cities who found it in their self-interest to look after the security of the visiting traders. Once at sea, merchants were on their own.[5]

The waterways were in the hands of many ethnic communities, who were skilled navigators and successful negotiators with distant merchant partners (fig. 2). Settlements of Asians and Middle Easterners became widely dispersed around the Indian Ocean. For example, about a thousand years ago the growing importance of the gold trade from southern Africa attracted Arab and Persian merchants, who intermarried with coastal Africans and learned to speak the language of the coastal trading cities, which became known as Swahili (from the Arabic word meaning "shores").

The Moroccan scholar Ibn Battuta, who rode merchant ships to reach the rich trading cities of the Swahili coast in 1331, described the hospitality he received from the Muslim rulers and the splendid buildings he saw. At the eastern end of the Indian Ocean the important passage between the island of Sumatra and the Malay Peninsula provided access to the spices of the East Indies and the goods of East Asia.[6]

Chinese and European Voyages to the Indies

In the fifteenth century, two outside states dispatched ships to explore the riches of the Indian Ocean for quite differ-

ent motives. From the east came spectacular Chinese fleets, sailing through the ocean as far as the Swahili coast. Between 1403 and 1433, the Ming dynasty, which had overthrown China's Mongol rulers in 1388, sent seven large fleets into the Indian Ocean under the command of Admiral Zheng He, a Chinese Muslim. Meant to display Ming wealth and power, the first expedition included sixty-two specially constructed giant ships 300-feet long and 150-feet wide with waterproof bulkheads. The purpose was not commercial, even though the expeditions gave rich "presents" to the rulers along the way and received lavish gifts in return. Nor were the fleets intended for military or political gain, although one defeated a pirates' nest that had imperiled trade. Having accomplished their goal of "showing the flag," the Ming discontinued the expeditions, ordered the ships destroyed, and burned most records of their accomplishments.

Historians point out the great irony that these spectacular Ming voyages were discontinued and largely erased from memory just decades before a much smaller and less impressive Portuguese fleet under Vasco da Gama sailed around the southern tip of Africa and across the Indian Ocean to India in 1498. Da Gama's fleet opened a new all-water route from Europe to the fabled commercial riches of the Indies, but the crusader crosses on his ships' sails signaled another somewhat contradictory motive: to reduce Muslim power and expand the reach of Christianity. Even though da Gama's ships would have been dwarfed by those of the Ming, the small and powerful cannons mounted on their decks gave them a sufficient military edge to gain a lasting place for the Europeans in the lucrative commercial networks of the Indian Ocean.[7]

In 1510 the Portuguese set up a naval and administrative headquarters at Goa on the west coast of India and slowly edged their way into the existing trading system. The goods flowing back to Europe attracted the attention of northern Europeans whose impacts in the Indian

Ocean would be greater because they were financed by investors in joint-stock companies, which also had charters from their governments granting them monopoly rights. The most important were the Dutch East India Company (VOC), which established its headquarters at Batavia (now Jakarta, Indonesia) in 1628, and the London-based East India Company (EIC), which during the seventeenth century negotiated the establishment of three major bases on the coast of India at Madras, Calcutta, and Bombay (now called Chennai, Kolkata, and Mumbai). The French monarch also created a Company of the Indies, which was chronically underfunded compared to the VOC and EIC. The Indian Ocean had become firmly linked by a global maritime system to the Atlantic continents, whose imports were underwritten by the flow of silver from Spanish America. Some of this silver also entered the Indian Ocean world from the Pacific via the galleons that sailed from Acapulco to Manila.[8]

The Europeans used violence strategically in the early years to gain access to the lucrative trade of the Indies, but, like trading companies elsewhere, their success depended greatly on making alliances with local rulers and traders, and especially by paying competitive prices for the goods they sought. Aside from early Portuguese battles with the Ottoman Empire, the greatest military conflicts were between the different European powers, which were extensions of conflicts in Europe. The outcome of the Seven Years' War (1756–63) led to the prohibition of any further expansion of the French Company, while the EIC would continue expanding in India. Meanwhile, four hard-fought Anglo-Dutch wars between 1652 and 1784 eventually gave the EIC the upper hand over the VOC. Another key gain for the EIC was an alliance with the Mughal Empire that had ruled much of India since 1526. Initially the Mughals were the much stronger partner, but over time the EIC became a key prop supporting the Mughal emperor's authority over rival Indian rulers.

Older Eurocentric histories portray the European newcomers as somehow dominant in the Indian Ocean from an early date, but that is an exaggeration. From the beginning, European success had depended on strategic alliances with established local players. For example, the city of Malindi on the Swahili coast allied with the Portuguese against its larger rival Mombasa. Similarly the city-state of Cochin in southwestern India used Portuguese help to gain ground over its better established neighbor, Calicut. The EIC gradually expanded its territorial control in India through alliances with one Indian principality against another. Nor did the numerous Muslim Arabs suddenly disappear at the first sight of a European ship. On the Swahili coast they even expanded their presence at European expense. In the 1600s the sultanate of Oman seized control of the large island of Zanzibar and took the important port of Mombasa from the Portuguese, eventually developing Zanzibar as the world's greatest producer of cloves.[9]

Mutually beneficial working relationships with many smaller players were also essential to the Europeans' success. For example, in 1600 the majority of the population in Hormuz at the mouth of the Persian Gulf, a nominally Portuguese port, came from the important Indian trading region of Gujarat. The large overseas Chinese populations in Indian Ocean trading centers were also indispensable to making the system work, despite the Chinese government's official disapproval. Thus, Chinese were eight times as numerous as Spaniards in the Spanish port of Manila and something similar was the case in Dutch Batavia.[10]

In satisfying their desire for a share of the rich trade of the Indian Ocean, Europeans sought bases in the Indian subcontinent, not only because of its central location, but also as it was the source of their most desired commodities. One of these was the peppercorn produced in several regions of India. The quantity of pepper shipped to Europe rose to 7.5 million pounds a year by the early eighteenth century. The many Indian farmers who cultivated, picked, and sorted the spices were clearly as essential a component of the trade as those who transported and marketed them, even if the farmers' labors are less noted in the records.

Indian handwoven cotton textiles also became a staple of the export trade to Europe and beyond. For centuries Indians had been making colorful, washable cotton textiles for overseas markets as well as domestic ones. The textile industry required many layers of labor input, from those who cultivated, picked, and processed cotton fibers to those who spun the fibers into thread, those who wove the thread into cloth, and those who dyed, printed, or painted the cloths. Europeans were not the principal foreign market for textiles, but the quantities they bought and carried away became substantial. In the first half of the eighteenth century the EIC alone was transporting back 800,000 Indian cotton cloths in peak years, and the VOC was carrying an average of 360,000 a year. Through greater labor inputs and improvements in technologies, specialists in the cotton textile industry were able to increase the volume produced and to earn income.[11]

As important as Indian cotton textiles became, trade included a wide range of other commodities from various locations in the Indian Ocean. As ships loaded with tea sailed from China to Britain, they passed by two places that were exporting the makings of another hot beverage, coffee, whose consumption was increasing in Europe. The port of Mocha in South Arabia, which had long been the major source of coffee beans for Arab and Turkish markets, soon came to supply French and EIC traders with beans for the newly fashionable coffee houses in Europe. The Dutch went a step further, by starting coffee plantations that made Java another major coffee exporter. From the 1600s, the Dutch and other Europeans also transported more exotic spices than

pepper from the so-called Spice Islands of Southeast Asia (now the Maluku Islands). For the VOC in the mid-eighteenth century the trade in "fine spices" such as cloves, nutmeg, mace, and cinnamon was nearly twice as valuable as that in pepper.[12]

While commerce was the principal driving force behind the massive links across the Indian Ocean and beyond, regular voyages also fostered cultural exchanges. Early on, Hinduism had spread widely into Southeast Asia. From the seventh century, Arab traders also had helped spread Islam around the Indian Ocean. Catholic missionaries regularly used Portuguese or Spanish trade ships to take their religion to new locales. New converts to Christianity were few in the Indian Ocean basin, in contrast to Catholic successes in Japan and China. Even so, the early missionaries made new connections with existing Christian communities in Ethiopia and South India.

Dramatic Transformations in the 1800s

In the nineteenth century the Indian Ocean was transformed by three dramatic changes, all of which starred Great Britain. The first was political: the Mughal Empire (founded in 1526) and the EIC were abolished and their territories subsumed

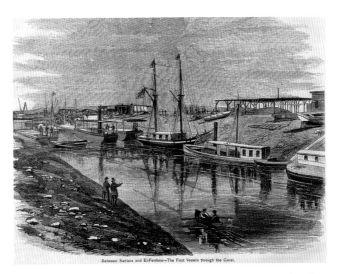

3. "Between Kantara and El-Ferdane—The First Vessels through the Canal" (*Illustrated Supplement: Appletons' Journal* 18 [July 31, 1869]: 4).

into a new India under direct British rule. The second was the Industrial Revolution in England, which vastly expanded British wealth and power, with major consequences for the people of India and other parts of the Indian Ocean basin. The third transformation was a massive increase in the size, speed, and reliability of ocean transport, which tamed the monsoons and increased the speed of voyages. Given the implications of these transformations, it can be tempting to imagine that they were part of a grand scheme of empire building, but in fact these changes largely occurred for separate and uncoordinated reasons.

In the early 1800s the EIC controlled territories on the Indian subcontinent that were larger than all of Western Europe and contained a population twenty times that of Great Britain. The Company propped up its ally, the Mughal emperor, who had little effective control over the princely states he supposedly ruled. A rebellion in 1857 persuaded Great Britain to consolidate and reform this jerry-built empire. The last traces of Mughal and Company rule were eliminated. Queen Victoria was proclaimed empress of India, and her Indian subjects were guaranteed equal protection of the law and the freedom to practice their traditional religions and customs. However, political power in British India lay in the hands of an appointed governor-general and a new Indian civil service, mostly graduates of elite British universities.

East of India, in the nineteenth century Britain added holdings in Burma and the Malay Peninsula, including the port of Singapore. To the southwest, the British Empire acquired island colonies, including Mauritius, and the important port of Cape Town, from the Dutch after the demise of the VOC in 1799. Thereafter the Dutch government ruled most of the East Indies directly, an empire almost comparable in size to Britain's Indian Empire.

Another form of official British presence in the ocean was the Royal Navy, whose anti-slavery patrols along the eastern African coast between 1860 and 1890 intercepted over one thousand vessels

and liberated twelve thousand enslaved Africans. This slave trade was mostly in the hands of wealthy Arab merchants, with Indian merchants from Gujarat supplying important financing. To diminish the shipping of slaves, the British foreign office pressed coastal rulers to withdraw from selling slaves for export, of which the most important was the 1873 treaty with the Omani sultan of Zanzibar. Under pressure to abolish slavery on his plantations and facing other forces, the sultan sold his mainland African territories, which became the basis of German East Africa and British East Africa.[13]

The reordering of British India's economy was as important as the transformation of its political institutions. The Industrial Revolution underway in Britain affected India in several ways. By the period 1870–1913, instead of there being a large market in Britain for Indian cottons, India had became a major market for machine-made cotton textiles from Britain. The industrialization of textile production in Britain had sudden and profound impacts on preindustrial spinners, weavers, and dyers in the Indian subcontinent, just as it did on their counterparts in England. Nevertheless, India's total exports increased fivefold during that period, as the loss of jobs in textile production was offset by the spread of commercial agriculture, as Indian-grown jute, cotton fiber, indigo, and tea found a growing market in Britain. These neat tallies of changes in India's exports overlay much messier transformations in Indian society, which are a topic of debate among historians.[14]

British industrialization and imperial rule also spurred the construction of a railroad network in British India, which by 1910 was the fourth largest in the world. The commercial benefit of the train lines was muted because of the many non-economic motives behind their construction: some were built to move troops to quell rebellion and others to bring food relief to famine-prone areas. Even lines that were commercially viable were often designed

for moving goods to port cities for export rather than for promoting trade within the vast subcontinent. Although most lines were not profitable before 1900, the British who invested in them were protected against financial loss by government subsidies paid out of taxes on Indians. Some railroads were of great benefit to Indian growers because train transport was much faster and cost much less than using traditional oxcarts. At first, the social impact of the new railroads was limited, because the Indian masses distrusted mixing people of different castes, religions, and sexes in passenger cars. After 1900, more and more Indians rode the trains.[15]

Many parties had a hand in bringing about the third transformation, in ocean transport. A canal across the 120 miles of Suez to connect the Mediterranean and Atlantic to the Red Sea and Indian Ocean was an old dream that reached fruition only after the French consul in Egypt persuaded the Egyptian ruler to undertake the project. The Suez Canal was begun in 1859 using a small army of men with shovels to dig a narrow channel that was then enlarged with giant mechanical devices. Britain was at first suspicious of the project but became enthusiastic as the canal neared completion in 1869, since it would shorten a voyage from Europe to Bombay by half (fig. 3).

Initially most ships had to be towed because maneuvering through the canal with sails was difficult. By the 1880s steam-powered ships could propel themselves through it by day and at night using electric headlights.[16]

Private, not public, initiatives had been behind the development of steamships. When the EIC lost its royal monopoly over shipping, private British firms had moved into the business. Some concentrated on swifter movement of passengers and freight to and from Britain, but the most successful was William Mackinnon's British Steam Navigation Company whose fleet of modern and efficient steamships provided speedy connections all around the Indian Ocean region. By the end of the

1800s his company was the largest steamship line operating in the Indian Ocean. A pious Scottish Presbyterian, Mackinnon was an ardent opponent of the slave trade as well as a firm believer in the blessings that British imperial expansion could bring. In 1888 he founded the Imperial British East Africa Company, which received a royal charter to extend the British Empire into East Africa. Following a British declaration of a protectorate in 1890 over the northern territories of Zanzibar, the IBEAC took over the administration and the construction of railways through British East Africa (later Kenya) to Uganda.[17]

The development of electromagnetic telegraphy in the 1830s rapidly led to much quicker communication over landlines. Once many technological difficulties had been overcome, British companies were able to lay an undersea cable connecting India to Britain in 1870. Other cables soon crisscrossed the Indian Ocean. This global "system of electrical nerves" enabled imperial nations to centralize decision making, eliminating the need for quick thinking by the aptly termed "man on the spot." The telegraph enabled the India Office in London to exchange messages with the governor of India in a single day. Businesses also benefited from having up-to-date information about prices, markets, and events in distant places. Another benefit of the telegraph was that ship captains could communicate with their owners at ports of call and later by radio waves.[18]

The transformations of the nineteenth century helped usher in the New Imperialism. Though generally condemned today, when seen in hindsight the expansion of European empires was both a logical outcome of the events that precipitated them and a useful stepping-stone toward the emergence of modern African and Asian nationalism. Everywhere, colonial governments were quite small and dependent on the implicit consent of those they ruled. They integrated the Indian Ocean peoples into a global economic system and created the modern boundaries of such

states as India, Indonesia, South Africa, and Kenya. When their subjects united to oppose foreign rule, they had the numbers, institutions, and languages to gain independence.[19]

David Northrup, professor emeritus of history at Boston College, has published widely in African and world history. His publications include *Indentured Labor in the Age of Imperialism, 1834–1922* (1995), *How English Became the Global Language* (2013), *Seven Myths of Africa in World History* (2017), and contributions to *The Cambridge World History* (2015), *The Cambridge World History of Slavery* (2017), and *The Oxford Illustrated History of the World* (2019). He is a past president of the World History Association and currently chairs that organization's Dissertation Prize Committee.

1 Edward A. Alpers, *The Indian Ocean in World History* (New York: Oxford UP, 2014); Sujit Sivasundaram, "The Indian Ocean," in *Oceanic Histories*, ed. David Armitage, Alison Bashford, and Sujit Sivasundaram (Cambridge: CUP, 2018), 31–61.

2 David O'Connor, "Egypt, 1552–664 BC," in *The Cambridge History of Africa: Volume 1; From Earliest Times to c. 500 BC*, ed. J. Desmond Clark (Cambridge: CUP, 1982), 917–18, 935–40; 1 Kings 9:26–28, 10:11–12, 22.

3 Himanshu Prabha Ray, "The Indian Ocean in Antiquity: Whither Maritime History?," *Topoi: Orient-Occident* 10 (2000): 335–52; George F. Hourani, *Arab Seafaring in the Indian Ocean in Ancient and Early Medieval Times*, rev. ed. (Princeton: PUP, 1995), 3–11; Kenneth Pomeranz and Stephen Topik, *The World That Trade Created: Society, Culture, and the World Economy, 1400 to the Present*, 2nd ed. (Armonk: M. E. Sharpe, 2006), 16–18.

4 Stewart Gordon, *When Asia Was the World: Traveling Merchants, Scholars, Warriors, and Monks Who Created the "Riches of the East"* (Cambridge: Da Capo, 2008), 57–75.

5 Alpers, *Indian Ocean*, 40–55.

6 Patricia Risso, *Merchants & Faith: Muslim Commerce and Culture in the Indian Ocean* (Boulder: Westview, 1995), 43–54; Said Hamdun and Noël King, *Ibn Battuta in Black Africa* (Princeton: Markus Wiener, 1975), 15–25.

7 Edward L. Dreyer, *Zheng He: China and the Oceans in the Early Ming Dynasty, 1405–1433* (New York: Pearson Longman, 2007); Glenn J. Ames, *Vasco da Gama: Renaissance Crusader* (New York: Pearson Longman, 2005).

8 Niels Steensgaard, "The Growth and Composition of the Long-Distance Trade of England and the Dutch Republic before 1750," in *The Rise of Merchant Empires: Long-Distance Trade in the Early Modern World, 1350–1750*, ed. James D. Tracy (Cambridge: CUP, 1990), 102–52.

9 Risso, *Merchants & Faith*, 86–87.

10 Wang Gungwu, "Merchants without Empire: The Hokkien Sojourning Communities," in Tracy, *Merchant Empires*, 400–21; Pomeranz and Topik, *World That Trade Created*, 7–9.

11 Bishnupriya Gupta, "Competition and Control in the Market for Textiles: Indian Weavers and the English East India Company in the Eighteenth Century," in *How India Clothed the World: The World of South Asian Textiles, 1500–1850*, ed. Giorgio Riello and Tirthankar Roy (Leiden: Brill, 2009), 281–305; Prasannan Parthasarathi, "Cotton Textiles in the Indian Subcontinent," in *The Spinning World: A Global History of Cotton Textiles, 1200–1800*, ed. Giorgio Riello and Prasannan Parathasarathi (Oxford: OUP, 2009), 17–41; Steensgaard, "Growth and Composition," 126.

12 Pomeranz and Topik, *World That Trade Created*, 80–83; Steensgaard, "Growth and Composition," 113–18, 122, 128–31, 148.

13 Abdul Sheriff, *Slaves, Spices & Ivory in Zanzibar: Integration of an East African Commercial Empire into the World Economy, 1770–1873* (London: James Currey, 1987); W. G. Clarence-Smith, ed., *The Economics of the Indian Ocean Slave Trade in the Nineteenth Century* (London: Frank Cass, 1989), 10–11.

14 Prasannan Parthasarathi and Ian Wendt, "Decline in Three Keys: Indian Cotton Manufacturing from the Late Eighteenth Century," in Riello and Parthasarathi, *Spinning World*, 397–407.

15 Pomeranz and Topik, *World That Trade Created*, 67–69; Daniel R. Headrick, *The Tools of Empire: Technology and European Imperialism in the Nineteenth Century* (New York: Oxford UP, 1981), 180–90.

16 Headrick, 150–56.

17 Headrick, 172–74.

18 Headrick, 157–64; Robert Kubicek, "British Expansion, Empire, and Technological Change," in *The Oxford History of the British Empire: Volume 3; The Nineteenth Century*, ed. Andrew Porter (Oxford: OUP, 1999), 259–62.

19 Niall Ferguson, *Empire: The Rise and Demise of the British World Order and the Lessons for Global Power* (New York: Basic Books, 2003), xii–xxix, presents a stimulating balance sheet of the legacies and issues of imperialism.

Shiraz Bayjoo

(b. 1979) is a Mauritian artist based between London and Mauritius. His multidisciplinary practice of video, painting, photography, and sculpture employs archival photographs and artifacts to explore the social, political, and historical conditions integral to Mauritian cultural identity and the wider Indian Ocean region. Bayjoo studied at the University of Wales Institute, Cardiff, and was artist in residence at Whitechapel Gallery, London during 2011. He has exhibited at Tate Britain and Institute of International Visual Arts, London; the Dakar, Sharjah, and Sydney biennials; and is a recipient of support from Grants for the Arts, Arts Council of England and a Gasworks Fellowship.

Sea Shanty, 2013
digital video, 2:10 (video still)

Sea Shanty, 2013
digital video, 2:10 (video still)

Sea Shanty, 2013
digital video, 2:10 (video still)

Sea Shanty, 2013
digital video, 2:10 (video still)

Sea Shanty, 2013
digital video, 2:10 (video still)

Extraordinary Quarantines #12, 2014
giclée print, 20 x 20 in.

Extraordinary Quarantines #15, 2014
giclée print, 20 x 20 in.

Extraordinary Quarantines #38, 2014
giclée print, 20 x 20 in.

23

Extraordinary Quarantines #40, 2014
giclée print, 20 x 20 in.

Fig. 7 (*Ocean Miniatures* series), 2016
acrylic, resin, wood, 6.7 x 4.7 x 1 in.

Aldabra No. 2 (*Ocean Miniatures* series), 2016
acrylic, resin, wood, 6.7 x 8.9 x 0.6 in.

Ma Coeur 2 (*Ocean Miniatures* series), 2017
acrylic on board, resin, metal, 6.5 x 4.1 x 2.8 in.

Madagascar (*Ocean Miniatures* series), 2017
acrylic on board, resin, metal, 9.4 x 6.7 x 6.1 in.

Slavery and Histories of Unfreedom in the Indian Ocean

Pedro Machado

The societies that ring the Indian Ocean have been indelibly shaped by the movement of thousands of unfree people. A great variety of commodities as well as ideas moved across the waters of this vast seascape, but so too did enormous numbers of slaves, unfree, and indentured humans. Indeed, trade in the Indian Ocean cannot be understood without these forced migrations whose trajectories were complex and multidirectional, and—in a reminder that the ocean was a global space—reached into the Atlantic and Pacific worlds. Unfreedom encompassed a wide range of experiences and statuses, including various forms of obligation, chattel slavery, and debt-bondage, but also indentured servitude and convict labor that at times were closely connected to one another.[1]

This was a sea where the forced migrations of women, men, and children often resulted in long-distance dislocation from homes in the interiors of mainland and island Africa, South Asia, and insular Southeast Asia. A sense of this dislocation is conveyed powerfully by Wangechi Mutu's *Amazing Grace* (86–91). The famous eighteenth-century hymn is widely considered to contain an anti-slavery message. Its author, John Newton (1725–1807), was a British slave trader in the Atlantic as a young man and later in life sought redemption, and this led him to compose the piece.

Mutu complicates the famous hymn, rendering it in Kikuyu (Gĩkũyũ, a Kenyan language). And its message is no less appropriate for the slave trading world of the Indian Ocean. For the traffic in humans in the Indian Ocean world, no less than the Atlantic, rested on violence. It dislocated many thousands, separated parents from children, husbands from wives, and brothers from sisters. It helped to produce the enormously plural societies that we see across the Indian Ocean world in which Africans, Indians, Arabs, Europeans, and others are thrown together in a great social mixing.

Conceptualizing Slavery and Unfreedom

For many scholars and readers alike, slavery is overwhelmingly equated with chattel slavery, in which individuals were bought and sold in markets and owned as property. This reflects the dominance of the Atlantic plantation complex in understandings of slavery. These plantations relied upon the labor of vast numbers of Africans to produce sugar, coffee, cotton, and other commodities in harsh conditions for European and American consumers. The brutalities of the transatlantic trade in African slaves and the equally violent rhythms of plantation life throughout the Americas formed the quintes-

sential picture of the structures of slavery as a commercial enterprise and lived experience.

This Atlantic model, while key to understanding the diasporic histories of African dispersal in the Americas and Caribbean, is of limited utility when we turn to the Indian Ocean, for most of the bodies that were shipped across its waters were not African. Nor did they labor on plantations. Rather, slavery and unfreedom in the Indian Ocean were far more complex, their histories much deeper, and those who were traded and those who engaged in the trade more varied than in the Atlantic. Chattel slavery certainly existed in the Indian Ocean but Africa was not the only source for these slaves, who flowed into, as well as out of, that continent. Overwhelmingly, it was Asians who were shipped as slaves across the waters of the Indian Ocean.

Plantations were not the dominant site of labor organization, and slavery and unfreedom in the Indian Ocean existed in social, cultural, and political systems that defined belonging within hierarchies of dependency. While mobility was possible, especially in more "open systems" characterized by porous boundaries between slavery, kinship systems, and other forms of labor control, slave and unfree status established one's place and consolidated social and labor obligations to individu-

als who served as patrons. In turn, these patrons were themselves reliant on these ties to ensure their own place among peers and dependents.[2] In the Indian Ocean, forms of status obligation, bondage, and temporary slavery—for example, for debt—coexisted with forms of hereditary slavery. Experiences of slavery were diverse and were contingent on the specifics of regional and social structures.

No single experience or place can thus define the myriad forms of unfreedom that existed throughout the long history of Indian Ocean slavery, and it is only by going beyond an Atlantic model that we can more fully understand its extent, nature, and dynamics as a key element of oceanic history.

Routes

Slaves and unfree peoples were traded for thousands of years in the Indian Ocean. A lack of sources makes it difficult to establish the trade's magnitude, yet there is little doubt that it was significant. Slaves from areas throughout northeast Africa—including today's Djibouti, Eritrea, Ethiopia, Somalia, and Sudan—were trafficked regularly to ancient Egypt, for example, and in an anonymous mariner's guide from the first century CE (the *Periplus of the Erythraean Sea*) slaves are listed as one of the commodities traded along the ocean's northwest littoral. This was during one of the peak periods in the long history of Indian Ocean slaving.[3] By the beginning of the ninth century CE, slaves were also being shipped from the East African coast south of the Horn in a trade that was well established and increasingly drawing in large numbers of individuals. A sense of the scale of this trade is suggested by the dense concentrations of East Africans on agricultural estates in southern Mesopotamia where many of these so-called Zanj slaves became involved in a large-scale revolt against the Abbasid caliphate in the 870s and early 880s that severely weakened Baghdad and its empire.[4]

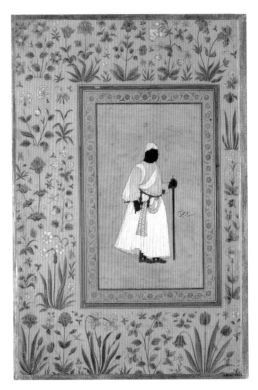

1. Hashim, *Malik 'Ambar*, c. 1620, opaque watercolor and gold on paper, 15.2 x 10.4 in. (Victoria & Albert Museum, London, IM.21-1925).

Over the following centuries, slavery and slave trading remained key components of Indian Ocean exchange. The rapid expansion of Islam around the coastline of the Arabian Sea after the seventh century CE inaugurated a second significant period of slaving from approximately 800 to 1300 and enabled Muslim mercantile groups to create far-flung commercial networks that moved not only commodities such as Indian textiles—as well as ideas—but also bonded peoples. These networks facilitated the transoceanic shipment of slaves from the Horn and eastern Africa to the Arabian Peninsula, Persian Gulf, and South Asia.[5]

By the thirteenth century, enslaved Africans from the highlands of Ethiopia were found in the Ilyas Shahi sultanate of Delhi, and the Muslim jurist Ibn Battuta encountered slaves (known as *habashi*) working as sailors and soldiers. They also occupied positions of political authority and from the late fifteenth and sixteenth

centuries were powerful figures in the political and military life of India.[6]

The most prominent was Malik 'Ambar, born with the Oromo name of Chapu in the Horn of Africa around 1548 and sold into slavery at the slave market of Mokha (fig. 1). After a short stay in Baghdad, he was sold to an important Ahmadnagar amir in the Deccan where he became a major military leader and then himself a political official. He helped to repel an invasion by Mughal forces and maintained maritime interests, engaging in Indian Ocean trade. African slaves played significant political roles in the Deccan and elsewhere in South Asia for several decades.[7]

Slave trading was carried out by a variety of Muslim, Arab, and Swahili merchants who transported thousands of captives to markets in the Arabian Peninsula, Gulf, and South and Southeast Asia. Recent estimates of the magnitude of this trade places annual exports of African slaves at around one thousand a year between 800 and 1700, increasing in the eighteenth century to four to five thousand a year, including exports from Madagascar.[8] Overall, and once we include European trafficking discussed below, slave trading into the Indian Ocean from the Red Sea, East Africa, and Madagascar may have involved the shipment of up to 2.6 million slaves between 1401 and 1900. While this was a fraction of the Atlantic slave trade, where around 12.5 million slaves were traded between the fifteenth and nineteenth centuries, it represents a significant trafficking in human beings.

The thousands of Africans who were sent from the shores of East Africa into the slave trades of the western Indian Ocean (African slaves did reach more distant locations such as China and parts of Southeast Asia but were a small minority) in most instances had already traveled long distances to the coast before they were loaded onto sailing vessels. They were drawn from the vast internal slave trades in Africa that fed all of the continent's external trades but are

often overlooked in discussions of Indian Ocean slavery.[9] Most captives never left Africa but their capture and trade within the continent is as much a part of the global African diaspora as those who were shipped to Hadhramaut, Oman, Gujarat, western India, or Sri Lanka. For those who were taken from the continent, their journey in the western Indian Ocean was an extension of natal displacement that had begun many months—and in some cases years—before they reached the coast and the ships that transported them across the sea. They were already outsiders within Africa before even reaching the new lands of the Arabian Peninsula or South Asia.

Africans may have constituted a minority of slaves traded in the waters of the Indian Ocean. Indian and Southeast Asian slaves were trafficked in significant numbers along regional networks that shipped slaves over short, medium, and long distances, across overland and maritime routes. It is difficult to establish the volume of these trades, however.

That slavery was a common social status is confirmed by the number of sources that describe types of slavery and how someone could become unfree. For instance, the Shari'a and Sunni Muslim *hadiths* recognized particular ways of recruiting slaves, and Bugi, Malay, Javanese, and other texts of Southeast Asian legal codes discuss the ways in which someone could enter a state of bondage.[10] Regional slave trading networks comprised of Indian, Chinese, and other Asian merchants shipped unfree peoples between areas of the Bay of Bengal, insular Southeast Asia, and coastal China. They were likely well established and a feature of exchange by at least the ninth or tenth centuries, and continued to grow. Their scale, reach, and intensity is suggested by later sources, for instance in Dutch materials that show that in the seventeenth and early eighteenth centuries regional networks in the Indonesian archipelago were able to secure supplies of approximately 100,000–150,000

slaves from Bali, Lombok, Sumbawa, and other islands.[11]

The coming of Europeans to the Indian Ocean after 1498 expanded slavery and the trade in both Africans and Asians. In many European settlements, slavery became a defining feature of social life. It is estimated that Europeans in the Indian Ocean alone demanded well over half a million slaves between 1500 and 1850.[12]

Soon after the Portuguese arrived on the Swahili coast in the 1490s, they began transporting a few hundred slaves every year from the area to their settlements in India, China, and Japan for their labor and military needs.[13] In the late eighteenth and early nineteenth centuries, Portuguese slavers expanded their trade in East African slaves to the islands of the western Indian Ocean such as Mauritius. Significant numbers of slaves from the Indian Ocean trading world were also shipped to Brazil where they worked in towns and cities as well as the sugar plantations of Bahia. Portuguese slave traders even sent Asian slaves across the Pacific to Mexico in the sixteenth and seventeenth centuries.[14]

The entry of Dutch and later French traders into the Indian Ocean led to even greater European involvement in the trade of unfree peoples. With its commercial networks that spanned southern and eastern Africa, India, and Sri Lanka, and Southeast Asia, the VOC (Vereenigde Oost-Indische Compagnie or Dutch East India Company) and private merchants purchased slaves in a number of areas. Until the 1660s the Indian subcontinent was the most important source, with supplies often related to natural and manmade disasters such as famine and drought (the "famine-slave cycle," a reminder of the role environmental factors can play in producing slaves) when sale into bondage became a mode of survival. In the late seventeenth century, political changes in India led the Dutch to turn to Southeast Asia for their slaves. Wars and raiding expeditions secured supplies for many decades. The scale of Dutch

involvement in slavery was reflected in the more than sixty-six thousand slaves that could be found in VOC establishments by the late seventeenth century. The Dutch continued to import large numbers of slaves into their establishments in the Indian Ocean throughout the eighteenth century.[15]

In sum, direct Dutch involvement in slave trading throughout the Indian Ocean may have been responsible for shipping around one hundred thousand (and likely more) slaves from the early seventeenth until the first decade of the nineteenth century, while Dutch demand in Batavia (fig. 2) may have resulted in as

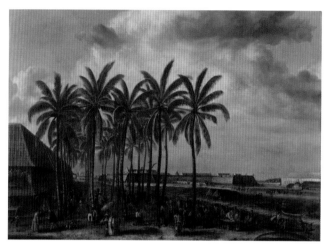

2. Andries Beeckman (1628–64), *The Castle of Batavia*, c. 1661, oil on canvas, 42.5 x 59.6 in. (Rijksmuseum, Amsterdam, SK-A-19).

many as two to three hundred thousand slaves being brought to its shores by local merchants.[16] Dutch settlements in the Indian Ocean reflected the Company's wide-ranging slave trade. Cape Town, for instance, contained slaves from India, Sri Lanka, Java, and other islands of today's Indonesia, Melaka, Macao, Madagascar, the Mascarenes, and Mozambique.[17]

French slave trading was a notable feature of the Indian Ocean world in the eighteenth and early nineteenth centuries. Colonization of the Mascarene Islands of Île de Bourbon (Réunion; 1663) and the Île de France (Mauritius; 1721) by the French Compagnie des Indes was

the catalyst for the trade, which drew primarily on captives from South Asia and Africa. The French needed substantial numbers of workers for their plantations, beginning with coffee in Réunion in the 1720s and more significantly sugar in Mauritius from the 1790s.[18] In these islands the slave population grew from just under forty thousand in the mid-1760s to almost 133,000 by the first decade of the nineteenth century, with slaves providing critical labor services at port facilities, and growing foodstuffs needed by naval squadrons and other vessels sailing in the region. After the islands came under British control in 1810, a clandestine trade in captives continued and at least 107,000 enslaved Africans, Malagasy, and Southeast Asians were sold in the Mascarenes till the British abolition of the trade around 1827 in Mauritius and the early 1830s in Réunion.[19]

British traders conducted a smaller but nonetheless important trade. Like other Europeans and Asians active in South Asia, they exploited periods of hardship, as was the case in 1687 when famine conditions in Madras (Fort St. George) led the British to purchase 665 slaves.[20] Madras may for a time have been favored by English traders in the late seventeenth century, for a report from a few years earlier noted that "a great number of slaves yearly"[21] were being shipped from there to unspecified destinations likely mostly in Southeast Asia. Reflecting the global nature of Indian Ocean slave trading, English traders made at least forty voyages that carried slaves (along with other cargo) from Madagascar to the Americas between 1675 and 1700.[22]

Experiences

There was no universal experience of slavery in the Indian Ocean world. To be a slave varied from the moment of enslavement, by gender and age, and by the social and political context in which the slave lived and worked. As we have seen, in India slaves served as soldiers in armies. Central Asian slaves were purchased for

the same purpose. Domestic slavery was also an important institution and slaves worked in elite households across India as washers, cooks, tailors, and wet-nurses; in some cases, female slaves provided sexual services, performed as musicians and dancers, and managed the *zenana*, the inner domestic quarters of a house in which the women of the family lived.[23]

Asian merchants used African slaves on board their vessels as sailors and to unload cargo. Slaves—African as well as Asian—worked as intermediaries and agents for their masters, often being responsible for organizing the transportation, sale, and distribution of goods into interior areas. This was the case for a twelfth-century Jewish merchant living in Mangalore in India, Abraham Ben Yiju. His Indian slave, Bomma, fulfilled a variety of commercial roles and sailed between Aden and Egypt on behalf of his master.[24]

Among Europeans, slaves were used in a wide array of occupations in homes, fields, gardens, streets, ships, and forts. In the Dutch case, the majority of slaves worked as domestic servants in the households both of Company officials, employees, and free settlers ("burghers"), and of Asian subjects residing in areas under imperial jurisdiction. Slaves worked as cooks, seamstresses, bakers, and valets, built roads and canals, and hauled goods as porters and stevedores at docks and warehouses. Slaves also grew crops such as rice, tobacco, and potatoes in Galle and Colombo in Sri Lanka; worked clove gardens in Ambon and nutmeg plantations in Banda in eastern Indonesia; tended to vineyards in the Cape's wine farms; toiled in tin, gold, and other mines in places like the west coast of Sumatra; and repaired Dutch East Indiamen in Batavia.[25] Slaves were critical to the edifice of colonial life.

How slaves and unfree peoples were acquired and adjusted (or were made to adjust) to bondage—the process of enslavement—is, however, often obscured from view. Yet an occasional glimpse is available to us from the fragments of slaves' lives and from narratives

of enslavement that appear in sources. Many slaves, especially children, were kidnapped and then sold into slavery. Ari, a slave prisoner at the Cape castle in 1706 related how "during his childhood years [in the area] between Surat and Persia, when he was playing on the beach, he was carried off by the Dutch and eventually sold as a slave."[26] Another slave, a young girl who told her story to a British agent at Muscat in Oman in 1841, was playing with two friends in the street in Yādgīr in present-day Karnātaka (India) when two "Arabs" approached the girls with promises of food and money. After agreeing to go with them, the "eight or nine years old" girls were separated before being thrown into a world of slavery that involved journeys of great distances and multiple sales, a not uncommon occurrence. Within the space of approximately eighteen months, the young girl was sold six times as she was trafficked from Hyderabad to Bombay, then Mukalla in Yemen, Sur and Masirah in Oman, and finally to Muscat where she recounted her story.[27] Similar stories characterized the expansion of slaving in East Africa in the nineteenth century.[28]

Capture in battle was another common route into slavery. Among the Rajputs of northern India, women captives served as concubines, dancers, and domestic servants. In other parts of India, male and female captives taken in war performed tasks such as preparing gunpowder in the arsenals of state-controlled forts and tending to horse and elephant stables.[29] In Southeast Asia the Dutch defeat of "rebellious" peoples often involved the signing of treaties with slave clauses whereby a fixed number of slaves had to be transferred as *boete ofte amende* (fine or tribute).[30] Individuals could also enter into servile status, as has been noted, through sale during times of hardship, which was what happened to a ten-year-old girl, "China," who was sold by her mother to a VOC employee at the company's trading post at Nagapattinam on India's Coromandel Coast. Following three transfers of own-

ership, a journey of thousands of miles across the western Indian Ocean, and a change of name, "Rosa" ended up working on the Groot Constantia wine estate at the Cape.[31]

Although slaves could face great uncertainty and were subject to the whims of their owners, the social structures into which they were incorporated could allow them to develop nuanced relationships of kinship and reciprocity with masters, particularly within the space of the household. The great regional variation in experiences of slavery in South Asia, for instance, included the possibility for household slaves (especially women) to improve their status if they had garnered the favor of their masters or forged close relationships with powerful individuals. In elite Rajput households, while the boundaries between the position of wife and concubine were ritually observed, some slaves managed to rise to positions of prominence and were even able to exert considerable influence over their masters, as we find in the eighteenth century with slave-concubine Gulabrai and Vijay Singh of Jodhpur (1752–93).[32]

That these relationships were possible and that complex forms of reciprocity and obligation existed or could develop between unfree peoples and their masters should, however, not create an idea, common in colonial discourse, that slavery in the Indian Ocean was benign. Often contrasted with the well-documented brutalities of Atlantic slavery and the harshness of slave life in the plantation complexes of the Caribbean, Brazil, and elsewhere, slave experiences in the Indian Ocean are characterized as having been comparatively less violent. But the great variety of unfree and servile statuses across the ocean, the different social structures, varying levels of violence and coercion, and the range of labor arrangements that existed throughout its vast waters simply make it impossible to identify a single or representative slave experience.

Transformations

From the mid- to late eighteenth century, the nature, scale, and dynamics of the trafficking of slaves and unfree peoples in the Indian Ocean were transformed. Under the leadership of the Busaidi dynasty, the Persian Gulf kingdom of Oman deepened its involvement in the western Indian Ocean by conquering the island of Zanzibar, to where the Omani capital was shifted in the nineteenth century. Omani political expansion was supported by merchants from the Kachchh region of western India who financed clove plantations along the East African coast that were worked by African slaves under grueling conditions. The presence of Kachchhi assets in Zanzibar reoriented trading routes and established the island as a leading entrepôt in the western Indian Ocean and an important node in the global economy. Equally, growing global demand for pearls from the Persian Gulf and Red Sea created additional labor pressures for divers that were met, in large numbers, by African slaves exported from Zanzibar and elsewhere along the coast from the 1870s.[33]

At the same time, as discussed earlier, French-owned coffee and sugar plantations in Réunion and Mauritius provided a fillip to the growth of the slave trade, especially in Mozambique and East Africa. The French continued to import small numbers of chattel laborers from places such as India, the Persian Gulf, Comoros, Ethiopia, and Southeast Asia but they were vastly outnumbered by the volume of captives brought to the Mascarenes from Mozambique and the Swahili coast.[34] These movements shaped the pluralism of Mauritius that is especially well captured in the photographic work of Shiraz Bayjoo (21–24).

Two other factors led to an expansion in African slave trading in the nineteenth century. The first was growing demand in the southern Atlantic for slaves from the Indian Ocean. Brazilian merchants, from Bahia and especially Rio de Janeiro, purchased large numbers of slaves from

Mozambique between the late 1790s and 1811. But the trade took off in the early nineteenth century after Brazil rapidly reemerged as a major supplier of sugar—and later coffee—to world markets. Nearly 150,000 slaves left the shores of Mozambique for Rio in the second and third decades of the nineteenth century. The second was political changes in Madagascar that led to growing demand for slaves on that island. These were supplied from Mozambique and the annual sale of slaves to Madagascar doubled in the early nineteenth century.[35]

This growth in the Indian Ocean slave trade encountered increasing anti-slavery sentiment and abolitionist pressures from Europe. The British abolished the slave trade within its empire in 1806. The British navy began to patrol in the western Indian Ocean in the 1810s and 1820s where it captured slave-carrying dhows and "liberated" their cargoes, but the British presence was never large enough to put a stop to the trade. New markets also opened up for slaves in the sugar-growing islands of Nosy Bé and Mayotte (which the French had acquired in the 1840s), as well as in Réunion. In the last, the French introduced the engagé labor system in 1854 to mask the ongoing trade in African slaves. Slavery had been abolished officially in the French colonies in 1848. This resulted in around eight thousand engagés being imported into Réunion via Mayotte from Mozambique between 1856 and 1866 alone, while over the second half of the century a total of approximately fifty thousand ostensibly liberated East African and Malagasy slaves and free contractual laborers were recruited to work on Mayotte, Nosy Bé, and Réunion.[36]

Colonial reformers in India, already by the late eighteenth century, had become concerned over the trade in children (proclamations passed in 1789 and 1790 banned slave exports from Bengal and Madras). In the nineteenth century, reformers would also focus on stopping the importation of African slaves into western India. Yet, because of political

expediencies, the British were cautious in their approach to local slave systems. Even after slavery was "delegalized" in India in 1843, and criminalized in 1860, the British were ambivalent and were often supportive of slaveholders' property rights or configured slavery as primarily caste-based, hereditary, and therefore a site for non-interference.[37]

By this time, however, early experiments with indentured labor as a replacement for slaves were successful. This set the stage for a post-emancipation plantation complex that rested on workers from the Indian Ocean and beyond. Well before the large-scale introduction of indentured

3. Indian indentured laborers working on the Uganda Railway, c. 1900 (Gijsbert Oonk, *Asians in East Africa: Images, Histories & Portraits* [Arkel: SCA Producties, 2004], 33).

4. An Indian family in Natal, c. 1888 (South African History Online, https://www.sahistory.org.za/article/indenture-new-system-slavery).

laborers into the Caribbean in 1838, several thousand Indian and Chinese workers were brought to the Mascarenes, where Mauritius served in the mid-1830s as an important test case for the development of indenture.[38] Yet, in the decades that followed, it was Indians who accounted for the overwhelming majority of indentured laborers who were transported throughout the Indian Ocean and the world.[39]

The reasons for the predominance of Indians begin with the precedent set by convict transportation by the East India Company in the late eighteenth and early nineteenth centuries in which tens of thousands of Indian convicts were shipped across the Indian Ocean, in part to meet the demands for labor in British settlements. Convict transportation was one element in a "connected imperial repertoire of repressive coerced labour extraction" in which the interests of both the British state and the East India Company intersected as a "means of putting into motion an alternative unfree labour supply." Used for the construction of infrastructure projects in Singapore, Penang, Arakan, and elsewhere, as well as for commodity production, convicts had been seen for a time as a replacement for slaves and labored alongside them and other workers as part of a much larger workforce.[40] Between 1787 when the first Indian convicts were shipped across the Indian Ocean and the early twentieth century, around one hundred thousand individuals may have been sent to colonial settlements in Southeast Asia and Mauritius, and, after the 1857–58 Indian mutiny-rebellion, to the penal colony in the Andaman Islands. The connections between convictism and indenture were further evident in British officials themselves connecting the two labor trades, in the language they used to describe them, and in how Indians often viewed migration through a prism of incarceration and transportation.[41]

Indenture in the Indian Ocean developed from the mid-nineteenth century as a form of "free" labor mobilization that met the needs of a rapidly globalizing

capitalist order. The recruitment of Indians involved complex arrangements. It utilized local middlemen who traveled to villages in search of laborers, while state support provided other key logistical elements such as emigrant depots and shipping. Other forms of contemporary migrant labor recruitment, especially the *kangani* or *maistry* system that would last well into the twentieth century (it was utilized also within India to recruit labor for tea and other plantations), saw around 1.5 million migrate to Sri Lanka and Malaya to work in the coffee and rubber plantations. The conditions of work for indentured laborers were often poor, involving long hours and exploitative circumstances. Many laborers were caught in a debt trap incurred by charges by plantation owners for subsistence.

In India the systems of recruitment connected indenture to slavery, when in some places laborers were taken on routes that paralleled those that slaves had traveled in earlier centuries. In South India, many indentured laborers were drawn from agricultural slave populations.[42] And while indenture nominally rested upon the freedom of contract, for many laborers the freedom of the market felt very limited indeed.

By 1920 when the indentured system ended, over eight hundred thousand Indians had been taken across the *kālā pānī* ("black water") to a variety of destinations. More than half were shipped to Mauritius where the influx of Indians transformed the population of the island; by the beginning of the twentieth century over 75% of the population was from the subcontinent. As many as 111,000 indentured laborers went to Réunion between the 1840s and 1890, and up to 40,000 were taken to East Africa to construct the Uganda Railway connecting Mombasa with the Uganda Protectorate (fig. 3).

However, it was to the sugar plantations of Natal (fig. 4) that the second largest number (over two hundred thousand) of indentured laborers was taken, in some cases directly from Mauritius that

operated at times as a sub-imperial node within the system.[43] It was, in part, among these workers in Natal that a young Indian barrister from western India, Mohandas K. Gandhi, forged his political philosophy and identity.

In South Africa, indentured laborers joined other Asian and African migrants in the creation of a working class whose solidarities would challenge the excesses of capital in the twentieth century and forge political alliances in the anti-apartheid movement.[44] While in Mauritius, the dramatic change to the population as a result of the large influx of indentured laborers—so-called passenger Indians began to arrive on the island from the late nineteenth century too—gradually marginalized the long histories of African and Malagasy migration and settlement that had preceded indenture. Consequently, in the twentieth century, there were growing calls by Afro-Mauritians for greater political representation amidst contestations over identity politics and the "Hinduization" of society that contributed to silencing their voices.[45] Elsewhere, indentured labor migrants and their descendants have challenged the limits of postcolonial national identities in the Indian Ocean—inflected with elements of religious nationalism that reached heightened levels in Sri Lanka as well as in Southeast Asia—that sought to define exclusionary ideas about natal belonging.

The movement of thousands of slaves and unfree peoples across the waterways of the Indian Ocean over many hundreds of years has profoundly shaped the societies that they entered and ultimately—even though it often entailed struggle—to which they came to belong. The legacies of these movements are complex, multifaceted, and are implicated also in how historical memory and the retelling of the past can privilege one version over another, or indeed be suppressed. Coming to terms with these pasts requires us to acknowledge their multivalent nature and central-

ity to the emergence of a subaltern and cosmopolitan Indian Ocean, defying any single narrative.

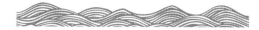

Pedro Machado is associate professor of history at Indiana University, Bloomington. He is the author of several works, including *Ocean of Trade: South Asian Merchants, Africa and the Indian Ocean, c. 1750–1850* (2014), "Views from Other Boats: On Amitav Ghosh's Indian Ocean 'Worlds,'" *American Historical Review* 121, no. 5 (Dec. 2016), and most recently co-edited *Pearls, People, and Power: Pearling and Indian Ocean Worlds* (2019). He is currently at work on a global history of pearl and pearl shell collection and exchange while also developing research on eucalyptus and colonial forestry in the Portuguese Empire in the nineteenth and twentieth centuries.

1 Constraints on space, and the focus of the *Indian Ocean Current* exhibition, mean that I am unable to discuss all of these forms in this essay.

2 Markus Vink, "'The World's Oldest Trade': Dutch Slavery and Slave Trade in the Indian Ocean in the Seventeenth Century," *Journal of World History* 14, no. 2 (June 2003): 131–77; Andrea Major, "Unfree Labor in Colonial South Asia," *Oxford Research Encyclopedia of Asian History*, Apr. 2019, https://doi.org/10.1093/acrefore/9780190277727.013.360.

3 Gwyn Campbell, "Introduction: Slavery and Other Forms of Unfree Labour in the Indian Ocean World," in *The Structure of Slavery in Indian Ocean Africa and Asia* (London: Frank Cass, 2004); Gwyn Campbell, "Slavery in the Indian Ocean World," in *The Routledge History of Slavery*, ed. Gad Heuman and Trevor Burnard (London: Routledge, 2011), 52–63.

4 Pier M. Larson, "African Slave Trades in Global Perspective," in *The Oxford Handbook of Modern African History*, ed. John Parker and Richard Reid (Oxford: OUP, 2013), 67.

5 Edward A. Alpers, "India and Africa," *Oxford Research Encyclopedia of Asian History*, Sept. 2018, https://doi.org/10.1093/acrefore/9780190277727.013.26.

6 Alpers, "India and Africa."

7 Richard M. Eaton provides a useful account of Malik 'Ambar's life in *A Social History of the Deccan, 1300–1761: Eight Indian Lives* (Cambridge: CUP, 2005), 105–28.

8 Pier M. Larson, *Ocean of Letters: Language and Creolization in an Indian Ocean Diaspora* (Cambridge: CUP, 2009), table 1.2; Larson, "African Slave Trades," table 3.1; Richard B. Allen, "Ending the History of Silence: Reconstructing European Slave Trading in the Indian Ocean," *Revista Tempo* 23, no. 2 (May–Aug. 2017): 294–313, 296.

9 Pier M. Larson, "Horrid Journeying: Narratives of Enslavement and the Global African Diaspora," *Journal of World History* 19, no. 4 (Dec. 2008): 431–64.

10 Vink, "'World's Oldest Trade,'" 150–51.

11 Vink, 144; Allen, "History of Silence," 296–97; Hans Hägerdal, "The Slaves of Timor: Life and Death on the Fringes of Early Colonial Society," *Itinerario* 34, no. 2 (Aug. 2010): 19–44.

12 Richard B. Allen, *European Slave Trading in the Indian Ocean, 1500–1850* (Athens: Ohio UP, 2014).

13 Further details in Pedro Machado, *Ocean of Trade: South Asian Merchants, Africa and the Indian Ocean, c. 1750–1850* (Cambridge: CUP, 2014). Allen, "History of Silence," 297.

14 Tatiana Seijas, *Asian Slaves in Colonial Mexico: From Chinos to Indians* (New York: Cambridge UP, 2014).

15 Vink, "'World's Oldest Trade,'" table 4.

16 Allen, *European Slave Trading*, table 1; Remco Raben, "Cities and the Slave Trade in Early-Modern Southeast Asia," in *Linking Destinies: Trade, Towns and Kin in Asian History*, ed. Peter Boomgaard, Dick Kooiman, and Henk Schulte Nordholt (Leiden: KITLV Press, 2008), 135; Allen, "History of Silence," 296–97.

17 Nigel Worden, "Indian Ocean Slaves in Cape Town, 1695–1807," *Journal of Southern African Studies* 42, no. 3 (2016): 389–408.

18 Machado, *Ocean of Trade*, 216.

19 Richard B. Allen, *Slaves, Freedmen, and Indentured Laborers in Colonial Mauritius* (Cambridge: CUP, 1999); Richard B. Allen, "Suppressing a Nefarious Traffic: Britain and the Abolition of Slave Trading in India and the Western Indian Ocean, 1770–1830," *William and Mary Quarterly*, 3rd. ser., 66, no. 4 (Oct. 2009): 873–94, 888.

20 Vink, "'World's Oldest Trade,'" 143.

21 Report cited in Basanta Kumar Basu, "Notes on Slave Trade and Slavery in India during the Early Days of John Company," *Muslim Review* (Calcutta) 4, no. 4 (1930): 22, and quoted in Allen, "History of Silence," 298.

22 Vink, "'World's Oldest Trade,'" 143, 146.

23 Major, "Unfree Labor," 5.

24 Amitav Ghosh, "The Slave of MS.H.6," *Subaltern Studies 7* (1993): 159–220 and *In an Antique Land* (New York: Alfred A. Knopf, 1993) by the same author. See also Elizabeth A. Lambourn, *Abraham's Luggage: A Social Life of Things in the Medieval Indian Ocean World* (Cambridge: CUP, 2018).

25 Vink, "'World's Oldest Trade,'" 160–62.

26 Nigel Worden and Gerald Groenewald, eds., *Trials of Slavery: Selected Documents Concerning Slaves from the Criminal Records of the Council of Justice at the Cape of Good Hope, 1705–1794* (Cape Town: Van Riebeeck Society for the Publication of South African Historical Documents, 2005), 8, quoted in Worden, "Indian Ocean Slaves," 397.

27 *British Parliamentary Papers, Slave Trade*, 25, Class A, 401, quoted in Hideaki Suzuki, "Tracing Their 'Middle' Passages: Slave Accounts from the Nineteenth-Century Western Indian Ocean," in *African Voices on Slavery and the Slave Trade*, ed. Alice Bellagamba, Sandra E. Greene, and Martin A. Klein (Cambridge: CUP, 2013), 314–15.

28 Larson, "Horrid Journeying," 441 discusses Chilekwa, captured as a young boy in present-day eastern Zambia in the 1870s. For other African narratives of enslavement, including the well-known case of Swema, a Yao girl from northwestern Mozambique, who in 1864 was given to a creditor as a pawn to cover a debt that her mother could not repay but who was sold to a passing slave caravan and eventually loaded onto a slaving dhow at Kilwa that was sailing to Zanzibar, see Edward A. Alpers, "The Other Middle Passage: The African Slave Trade in the Indian Ocean," in *Many Middle Passages: Forced Migration and the Making of the Modern World*, ed. Emma Christopher, Cassandra Pybus, and Marcus Rediker (Berkeley: University of California Press, 2007), 20–38.

29 Sumit Guha, "Slavery, Society, and the State in Western India, 1700–1800," in *Slavery & South Asian History*, ed. Indrani Chatterjee and Richard M. Eaton (Bloomington: Indiana UP, 2006), 162–86. The Maratha regime, which had sizeable infantry and cavalry units in western India, does not seem to have used slaves in military roles, drawing instead on freelance local and foreign soldiers.

30 Vink, "'World's Oldest Trade,'" 154.

31 Worden, "Indian Ocean Slaves," 398.

32 Major, "Unfree Labor," 7. Further details are available in Ramya Sreenivasan, "Drudges, Dancing Girls, Concubines: Female Slaves in Rajput Polity, 1500–1850," in Chatterjee and Eaton, *Slavery & South Asian History*, 136–61.

33 Matthew S. Hopper, *Slaves of One Master: Globalization and Slavery in Arabia in the Age of Empire* (New Haven: Yale UP, 2015).

34 Details and references in Machado, *Ocean of Trade*, 217. See also Allen, *European Slave Trading*, 23.

35 Further details in Machado, *Ocean of Trade*.

36 Sidi Ainouddine, "L'esclavage aux Comores: Son fonctionnement de la période arabe en 1904," in *Esclavage et abolition dans l'Océan Indien, 1723–1869*, ed. Edmund Maestri (Paris: L'Harmattan, 2002), 102; Richard B. Allen, "Asian Indentured Labor in the 19th and Early 20th Century Colonial Plantation World," *Oxford Research Encyclopedia of Asian History*, Mar. 2017, https://doi.org/10.1093/acrefore/9780190277727.013.33. *Engagé* involved slaves entering into contracts that technically—but not in practice—turned them into "free" labor, thereby allowing the French in the face of diplomatic pressures to claim that they were adhering to anti-slaving agreements. *Engagé* labor was officially used until 1864, when the French finally discontinued it.

37 Andrea Major, "Enslaving Spaces: Domestic Slavery and the Spatial, Ideological and Practical Limits of Colonial Control in the Nineteenth-Century Rajput and Maratha States," *Indian Economic & Social History Review* 46, no. 3 (2009): 318; and Andrea Major, *Slavery, Abolitionism and Empire in India, 1772–1843* (Liverpool: LUP, 2012), 8–9. The British did sign treaties with Radama I of Madagascar in 1817 and 1820 banning exports from the areas of Madagascar under his control; and in 1822 with Seyyid Said, sultan of Oman, which prohibited the sale of slaves to Europeans at Zanzibar and throughout Omani possessions along the Swahili coast.

38 As noted recently, however, the early importation of indentured Asian labor into Mauritius appears to have been predated by the arrival into Trinidad of Chinese indentured laborers in 1806 but it was on a small scale as only two hundred were shipped to the Caribbean. See Allen, "Asian Indentured Labor."

39 To avoid the idea that indentured labor is reducible to Indian or Asian labor, it is important to note that Africans were sent also as indentured laborers to European colonies in the Caribbean in the nineteenth century.

40 Clare Anderson, "Convicts, Commodities, and Connections in British Asia and the Indian Ocean, 1789–1866," in "Free and Unfree Labor in Atlantic and Indian Ocean Port Cities (1700–1850)," ed. Pepijn Brandon, Niklas Frykman, and Pernille Røge, special issue 27, *International Review of Social History* 64 (Apr. 2019): 205–27, quotes from 207, 210.

41 The work of Clare Anderson is especially important here, e.g.,
 *Convicts in the Indian Ocean: Transportation from South Asia to
 Mauritius, 1815–53* (New York: St. Martin's, 2000); "Convicts and
 Coolies: Rethinking Indentured Labour in the Nineteenth Century,"
 Slavery & Abolition 30, no. 1 (Mar. 2009): 93–109; and *Subal-
 tern Lives: Biographies of Colonialism in the Indian Ocean World,
 1790–1920* (Cambridge: CUP, 2012).

42 This was suggested by Benedicte Hjejle, "Slavery and Agricultural
 Bondage in South India in the Nineteenth Century," *Scandina-
 vian Economic History Review* 15, nos. 1–2 (1967): 71–126; and
 recently developed especially by Allen, e.g., *European Slave Trading*.
 See also Marina Carter, "Slavery and Unfree Labour in the Indian
 Ocean," *History Compass* 4, no. 5 (2006): 800–813.

43 David Northrup, *Indentured Labor in the Age of Imperialism, 1834–
 1922* (Cambridge: CUP, 1995); Allen, "Asian Indentured Labor";
 Alpers, "India and Africa."

44 I should caution that the political and intellectual histories of the
 relationship between India and South Africa are complex and can-
 not be encapsulated by a simple notion of "Afro-Asian" solidarity;
 for an exploration of these histories, see, for instance, Jon Soske,
 *Internal Frontiers: African Nationalism and the Indian Diaspora in
 Twentieth-Century South Africa* (Athens: Ohio UP, 2017).

45 Edward A. Alpers, "Recollecting Africa: Diasporic Memory in the
 Indian Ocean World," in "Africa's Diaspora," ed. Judith Byfield,
 special issue, *African Studies Review* 43, no. 1 (Apr. 2000): 83–99,
 87. More recently, there have been attempts to redress this margin-
 alization of Mauritian Creoles (descendants of the island's largely
 African and Malagasy slave populations) through measures such
 as the creation of the Truth and Justice Commission. For a useful
 and comparative discussion of the heritage of slavery and nation
 building in Mauritius and postapartheid South Africa, see Anne
 Eichmann, "The Heritage of Slavery and Nation Building: A Compar-
 ison of South Africa and Mauritius," in *Slavery, Memory and Identity:
 National Representations and Global Legacies*, ed. Douglas Ham-
 ilton, Kate Hodgson, and Joel Quirk (London: Pickering & Chatto,
 2012), 64–76.

Shilpa Gupta

(b. 1976) lives and works in Mumbai where she studied sculpture at the Sir J. J. School of Fine Arts from 1992 to 1997. Her work has been exhibited at the Berlin, Havana, Kochi-Muziris, Liverpool, Sharjah, and Venice biennials; Kathmandu and Yokohama triennials; Arnolfini—Centre for Contemporary Arts, Bristol; Contemporary Arts Center, Cincinnati; Guangdong Museum of Art, Guangzhou; Kiran Nadar Museum of Art, New Delhi; Louisiana Museum of Modern Art, Humlebæk; MoMA, New York; Mori Art Museum, Tokyo; and Musée de design et d'arts appliqués contemporains, Lausanne, among others.

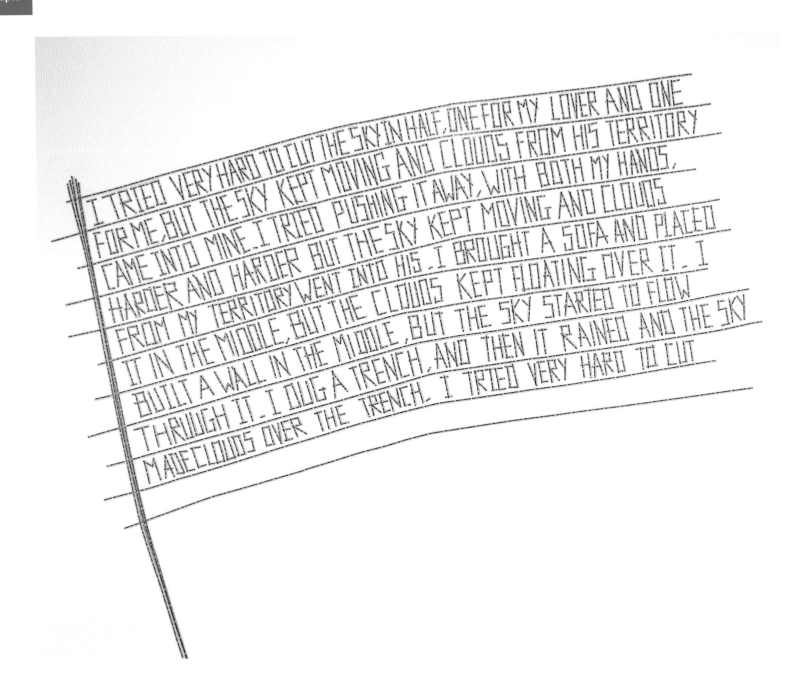

Untitled (There Is No Border Here), 2005–06
wall drawing with self-adhesive tape, 118 x 118 in.

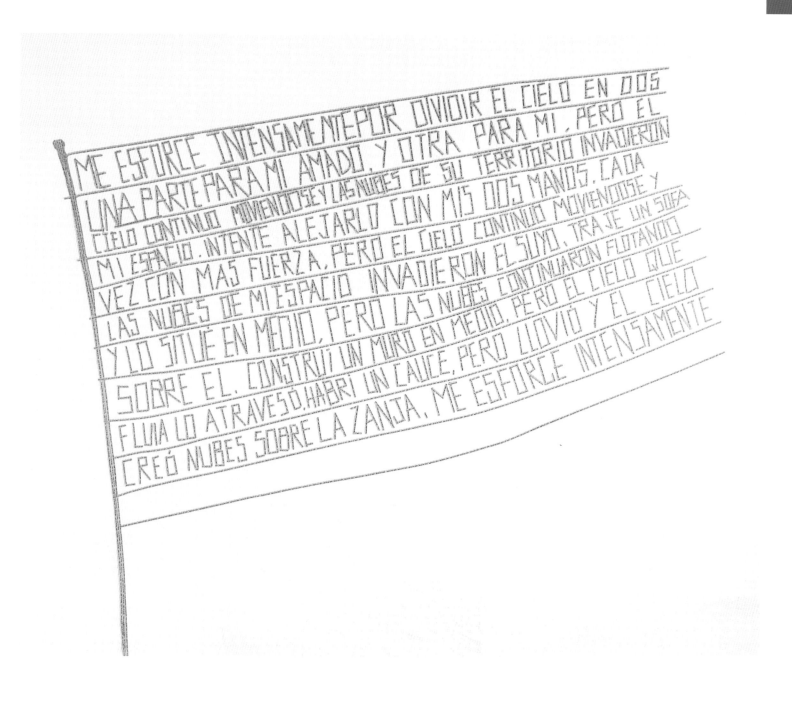

Untitled (No hay frontera aquí), 2005–06
wall drawing with self-adhesive tape, 118 x 118 in.

41

Speaking Wall, 2009–10
interactive sensor-based sound installation: LCD screen, bricks, headphones, 8:00 interaction loop, 118 x 118 x 118 in.
Museum Voorlinden, Wassenaar

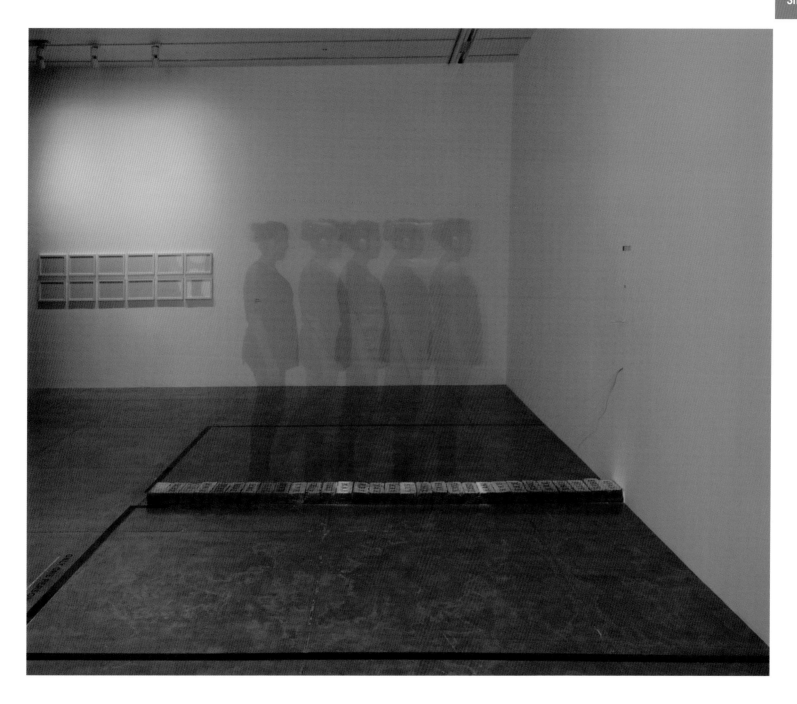

Speaking Wall, 2009–10
interactive sensor-based sound installation: LCD screen, bricks, headphones, 8:00 interaction loop, 118 x 118 x 118 in.
Museum Voorlinden, Wassenaar

Speaking Wall transcription

Step away one step
Go a bit further away
Go back
Step away one step

Stay
I am the wall in your house
that you are unable to see

You walk past me
and you may never know
You came
You took
You left
I continue to bleed

Step a bit closer
Step a bit closer
Closer
Closer
Closer
Step a bit closer
But you are still unable to see me
And the distance is convenient

Beyond this screen
You really don't have to know me
One step back
One more
One step back
One more
One step forward
Move forward
Ok fine
Now you are no longer stepping on the border
Are you not able to see it?
It is on the ground below you

The wind shifted it by a few cms
One step forward
One step forward

So it's fine

So I no longer need
Your ID
No longer need to know
Your name
Your religion
Your sex
and the place you come from
Step a bit closer
A bit closer
Is the place you come from
The place you were born
Or the place you grew up
Or the place you inhabit
Virtually
Mentally
Philosophically
Physically
Step away one step
March forward one step
One step

Yes
Now you are on the line
where I last night made the border
But since it is raining today
It's a bit difficult to see it

Did grand mom come
from your side onto my side
to visit our mother's grave?

Ah, she must have
Still got the keys to the house

What do I do?
She took the keys
And walked
forward a few cms more
And the rain shifted
the border last night

I am no longer able to enter my house

44

BUT YOU ARE STILL UNABLE TO SEE ME

AND THE DISTANCE IS CONVENIENT

NOW YOU NO LONGER STEPPING ON THE BORDER

THE WIND SHIFTED IT BY A FEW CMS

Speaking Wall, 2009–10
interactive sensor-based sound installation: LCD screen, bricks, headphones, 8:00 interaction loop, 118 x 118 x 118 in.
Museum Voorlinden, Wassenaar

45

Fenced Borders

Every summer, people over dinner tables across India and Pakistan spend hours talking and arguing over the taste of mango.

Walking not far, toward the east, stand the alluring mangroves that have captured the imagination and stories of the islands of the Sundarbans swamps, stretching like a band through the two countries of India and Bangladesh, as they dip into the Bay of Bengal.

The acacias of Western Sahara sprawl across the dry sands of the several lengths of barrier gradually built by Morocco through a land left in flux after those who came and left.

Olive is the national tree of Palestine and Israel.

Pecan is relished in Mexico and the USA.

The length of thread is in ratio to the length of fences constructed on different borders.

1:7834000
Fenced Border, West

Mango Tree 1:7834000, 2013
thread and glue on paper, 14 x 21 in.
private collection

Mangrove 1:6235011, 2013
thread and glue on paper, 14 x 21 in.
private collection

Acacia Tree 1:2337358, 2013
thread and glue on paper, 14 x 21 in.
private collection

49

Olive Tree 1:1547703, 2013
thread and glue on paper, 14 x 21 in.
private collection

Pecan Tree 1:3897254, 2013
thread and glue on paper, 14 x 21 in.
private collection

What the Ocean Gives Us to Think

Kalpana R. Seshadri

That which exists, whatever this might be, coexists because it exists.
—Jean-Luc Nancy[1]

Gaia is the name of the Earth seen as a single physiological system, an entity that is alive at least to the extent that, like other living organisms, its chemistry and temperature are self-regulated at a state favourable for its inhabitants....Gaia is an evolving system, a system made up from all living things and their surface environment, the oceans, atmosphere, and crustal rocks, the two parts tightly coupled and indivisible. It is an "emergent domain"—a system that has emerged from the reciprocal evolution of organisms and their environment over the eons of life on Earth. In this system, the self-regulation of climate and chemical composition are entirely automatic. Self-regulation emerges as the system evolves. No foresight, planning, or teleology (suggestion of design or purpose in nature) are involved.
—James Lovelock[2]

Blue

Uncontainable, insuppressible, and unstoppable it pours over the edge acknowledging no frame as a limit (fig. 1). Within our narrow electromagnetic spectrum, it is of high frequency, arriving in short wavelengths. Its essence is to scatter immediately even as it makes appear the sky and the deep sea—the color blue (110–39).

Our planet is blue because more than 70% of the earth's surface is covered by ocean waters. Yet, political and ethical environmentalism, whether expressed through social movements, business practices, or art, as with the Green Party, Greenpeace, or Green Economy, use the color green to signify their concern and solidarity with earth systems. It can be argued that green serves as a metonym

1. Ad Reinhardt (1913–67), *Abstract Painting, Blue*, 1952, oil on canvas, 75 x 28 in. (Carnegie Museum of Art, Pittsburgh, 65.26).

for environmentalism due to the bias of environmentalists toward land-based or terrestrial ecosystems over marine or aquatic systems and beings. Where biodiversity is concerned, such bias could potentially be defended by a simple factoid like the one shared by Sarah Zhang, a writer for the *Atlantic Monthly.* "Why," she asks, "are there so many more species on land when the sea is bigger?" Zhang cites a 1994 article from *Science* by Robert May to give the following answer:

> One reason May and others since have suggested is the physical layout of terrestrial habitats, which may be both more fragmented and more diverse. For example, as Charles Darwin famously documented in the Galapagos, islands are hotbeds for diversification. Over time, natural selection and even chance can turn two different populations of the same species on two islands into two species. The ocean is, in contrast, one big interconnected body of water, with fewer physical barriers to keep populations apart. It also doesn't have as many temperature extremes that can drive diversification on land.[3]

The fact that over 91% of marine species, according to the US National Ocean Service,[4] remain unidentified does not concern Zhang and, given the absence of a tribunal to adjudicate the issue, it need not concern us here either. But, what I find interesting is the way that factoid resonates with the ancient tradition of referring to the Ocean as the symbol of oneness, union, and the dissolution of difference. For instance, all the major Asian religious traditions use the idea of diverse rivers mingling in the Ocean as a concrete metaphor for union with the divine or salvation. There is a rich rhetorical irony in the overuse of this image: as a metaphor for dying, it is also a dying metaphor, in other words, a cliché that betokens a premod-

ern sensibility. Modern critical thought, on the contrary, discovers difference and values distinctions rather than uniformity and oneness. And yet, for conservationists and climate scientists, something of that ancient One of the waters reappears in their reference to "the Ocean" as the primeval source of life that sustains the living[5] by maintaining the homeostasis of the planet's atmosphere. Though not necessarily theological or eschatological, the contemporary earth systems idea of "the Ocean" is also inescapably ontological. By that I mean, that it is implicated in our inquiry into Being or existence.

For critical thought that is open to the perspectives of Gaia or earth systems, evolutionary biology, and climate science, the Ocean/s can well be contemplated in terms of what the philosopher Jean-Luc Nancy theorizes as "being-singular-plural." For Nancy, Heidegger's question about the meaning of being can be understood only as originally and constitutively a "being-with." If concern with Being is Being, Nancy's insistence falls on the "between," the mutuality that is implied in "being-with," because it is "being-with" that affirms the shared commons as the precondition of being. He writes: "It is not the case that the 'with' is an addition to some prior Being; instead, the 'with' is at the heart of Being. In this respect, it is absolutely necessary to reverse the order of philosophical exposition, for which it has been a matter of course that the 'with'—and the other that goes along with it—always comes second, even though this succession is contradicted by the underlying [*profonde*] logic in question here. Even Heidegger preserves this order of succession in a remarkable way."[6]

Let me clarify that Nancy's being-with alludes primarily to an "other" *who* is equally concerned with being. Nevertheless, I suggest that by his own logic (which relies on the topographical metaphor of the deep [underlying/*profonde*]), his between-ness necessarily assumes the co-existence of the non-human, including the mineral, the abiotic, or the so-called inorganic. For, the Ocean is a profound (deep) Commons, and belonging to Gaia it co-exists, rather than pre-exists. As Lovelock says: "Without water there can be no life; and…without life there would be no water. Life enabled the Earth to hold onto its oceans, and they now dominate its surface. As remarkable as the presence of water is the fact that ocean salinity appears never to have exceeded the critical limit for life."[7]

Being singular-plural is being with the Ocean at all times and in all spaces—even inland, in fact, more urgently when we are inland: for we are always in a relation with the Ocean in its/our singular-plurality.

Borders

As this exhibition attests, an ongoing trend in the social sciences and humanities focuses on maritime regions, rather than nation-states, to grapple with transnational exchanges and capitalist globalization. The Indian Ocean is one of the oldest regions for long-distance exchange, followed by the Atlantic system. The oceans in their plurality are fundamentally littoral zones—seas, coastlines, and coastal communities. To contemplate the Ocean as a correlate of ontology necessitates asking the question: In what sense do the oceans exist?

The schoolroom wisdom is that there are five oceans of which the Indian Ocean is the third largest. It is also the second deepest on average after the Pacific, and contains the second deepest trench after the Marianas. On certain hydrographic maps it looks like a lake bound by land on three sides. The boundaries of the oceans, of course, are not marked by natural formations, but are fixed by the IHO (Interna-

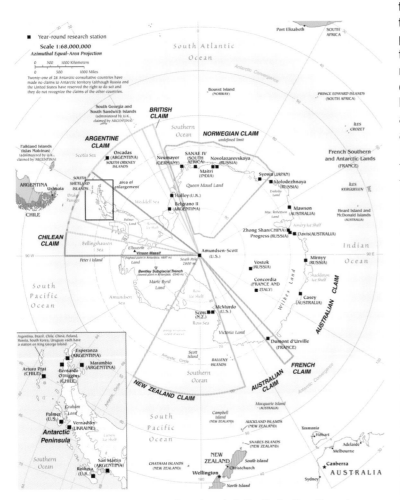

2. Map of the claims made over Antarctic territory, including the Southern Sea region (ASOC/CIA, https://www.asoc.org/advocacy/antarctic-governance).

tional Hydrographic Organization, formerly Bureau). The IHO was established in 1921 by the leading colonial powers of the time, Britain and France, along with eighteen other countries with maritime interests. It describes its objectives in terms of the coordination of hydrographic activities worldwide and standardization of nautical surveys, charts, and other procedures.[8] Where the Indian Ocean is concerned, the IHO in 1953 included the Southern Sea within its boundaries. This was subsequently altered in 2002 (but has not been ratified), with the border now at 60°S, excluding the Southern Sea.[9] Australia apparently objects to the redefinition, and argues to set the border at 67°S. The border dispute is interesting if only because it discloses the epistemology of the five oceans as always already a thought of property, possession, and power (fig. 2). To regionalize the Ocean is to historicize and politicize it, for borders are constitutive of the political.

One does not have to be a sentimentalist to associate borders with exclusion, or view borders, be they checkpoints, walls, or fences, as an invidious concept separating and obstructing the circulation of people and goods. Unsurprisingly, in the context of nation-states, borders on land, water, or air, are represented as sites of war. And yet, the concept of the border as a limit category is necessary for political discourse. Conceptually, the border is not only situated as a spatial limit, it is also at the center of a community's identity. Free market proponents, for instance, oppose all borders on principle for economic reasons. Ultimately, it is not the existence of borders themselves, but how a given border is drawn, understood, held, and guarded that is the substance of politics and history—it is the terrain of articulating justice and struggle. Thus, however problematic or contested given theories of sovereignty and self-sufficiency may be, the border as a concept nevertheless enables the prevalence of the "co-" of co-existence.

Two works in this exhibition engage the problematic status of borders through techniques of self-reflexive representation. Shiraz Bayjoo's *Sea Shanty* (16–20) is a video that was conceived in 2013. The video in the current exhibition is projected on a hessian screen, but if each installation is a unique event, then the elements of the 2016 installation that used the brick walls of Fort Adelaide in Port Louis, Mauritius as a screen is worth reflecting upon. In the film of that installation (fig. 3), a brick wall is clearly visible and the superimposition of the Ocean upon brick creates an unsettling effect.

The doubled representation of the Port Louis display produces an experience of migration as a *mise en abyme* of contexts, potentially signifying the waters of the Ocean as colluding with the walls of separation and oppression. The sailors' rhythmic work song (the shanty or chantey) that accompanies the video carries an ambivalent pathos as all work songs do. The song encourages efficient labor—a gentler whip administered by the workers themselves. Bayjoo's video, by quoting the Ocean footage in terms of walls upon walls, situates this and other of his works within the history of forced migration, exploitative labor, and colonialism.

Shilpa Gupta's 2005–06 work *Untitled (There Is No Border Here)* (40) also addresses some of the contradictions inherent in the concept of the border. The work unambiguously decries "the border" by signifying the violence of the cut at multiple levels. First, we see a flag on the wall, but the flag is made up of words cut out of yellow police tape used to cordon off crime scenes printed not with the familiar words prohibiting entry but with the phrase "there is no border here." The text of the flag speaks of cutting "the sky in half" and the impossibility of maintaining the separation because of the drifting clouds and the common rain. While the shape of a flag attests to the exclusionary function of borders, the words of the text speak of their impossibility and failure. Furthermore, the material substance of the words

(the yellow tape that declares there is no border here) ironizes and subverts the function of separation, thereby suggesting that separations and borders will invariably undo themselves. And yet, there are the letters beyond the texts (meaning itself as only marks on a page, or cuts on a surface) and the spaces between the words that silently claim the originality of difference.

Thus, in their plurality, the five oceans as spatially bounded categories delineate the domain of history and politics, i.e., the contestation or politics of meaning. But, to think the Ocean in terms of its/our singu-

3. Shiraz Bayjoo (b. 1979), *Sea Shanty*, installation view at Port Louis, 2016 (https://vimeo.com/185318785).

lar-plurality invokes the ethics of meaning as first philosophy, i.e., ontology. To cite Nancy again: "No ethics would be independent from an ontology. Only ontology, in fact, may be ethical in a consistent manner."[10]

Complexity/Entanglement

A complex system is an ensemble of sub-systems, whose dynamic behaviors in their interactions and interdependencies produce effects of the whole that cannot be reduced to a sum of its parts. Scientists call these effects an "emergence." Examples include rain forests, neural networks, economies, and of course the earth systems or Gaia herself. For philosophy or critical thinking, complex systems and the concept of emergence offer endless theoretical possibilities and a profound challenge to conventional histories of totality

as a concept that implies a whole and its parts, or an entirety that betokens a sovereign One. It is not surprising therefore that the term that philosophers have taken up to express the implication of the existential and the systemic is "entanglement." Entanglement travels from physics where it describes quantum states across other scientific disciplines to critical thinking, not to serve as an analogy, but to name the singular-plurality of existential reality. In her *Meeting the Universe Halfway*, the quantum physicist and philosopher Karen Barad offers a rigorous explanation of the term "entanglement." Based on her reading of the scientist Niels Bohr and the critical thinker Donna Haraway, she writes:

> The primary ontological unity is not independent objects with independently determinate boundaries and properties but rather what Bohr terms "phenomena."…The neologism "intra-action" *signifies the mutual constitution of entangled agencies.* That is, in contrast to the usual "interaction," which assumes that there are separate individual agencies that precede their interaction, the notion of intra-action recognizes that distinct agencies do not precede, but rather emerge through, their intra-action. It is important to note that the "distinct" agencies are only distinct in a relational, not an absolute sense, that is, *agencies are only distinct in relation to their mutual entanglement; they don't exist as individual elements.*[11]

When the system is not only physically complex (like an ice crystal) but also dynamic and adaptive to stimulus, it exhibits certain "intra-active" characteristics that are remarked upon regularly such as non-linearity, self-organization, exquisite sensitivity to initial conditions

(the butterfly effect), chaos (unpredictability based on a constant), adaptation (adjusting to feedback loops), and emergence (where the system produces effects that exceed the work of its parts). The Ocean's singular plurality is readily evident in the complexity of its physical systems. As with all aesthetic phenomena, it exhibits a geo-metry of repetition and rhythm, a harmony of scale and proportion that generates patterns, symmetries, regularities, and symbioses.[12] The Ocean appears to us as Surf-face. We only ever skim its face. But of course, this geo-metry is not only a phenomenal appearance, it is structural as in: the complex "intra-actions" and symbioses among marine life, the plankton, algae, microbial life and the atmosphere; the complex flows of ocean currents—underwater and on the surface and the fractal shapes of coastlines; the ocean winds as they manage the global climate, weather patterns, and the freshwater cycle. Complexity or Entanglement is a condition of Being as the primary "linking" verb "to be" testifies. Enamored of its surf-face, and given our minuscule time-scales, we have long contemplated the Ocean as an enduring ontological unity. But if the ineluctability of change implicates all Being in its negative as becoming, then the true complexity of the Ocean as a becoming can only be contemplated in its complex adaptive behavior—in its dynamic entanglement. And it is only very recently that we have thought to think of the Ocean as a complex becoming.

Becoming

As a phenomenon appearing to the human eye, the sparkling Ocean is becoming—i.e., it is inordinately beautiful. But, what is the Ocean as a becoming? We do not have to be scientists to consider the chemistry of the ocean waters and how it has over four billion years altered and regulated its levels of salinity and acid-alkaline balance. Without achieving this delicate balance, the Ocean could neither generate nor sustain the conditions for life: for being. Marine ecologists

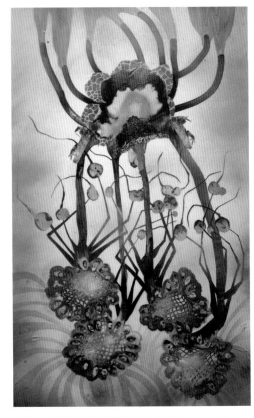

4. Wangechi Mutu (b. 1972), *Botanical Arrangement Limber*, 2011, mixed media collage and paint on Mylar, 51 x 30.5 in.

have drawn our attention to the Ocean's adaptive complexity. That is, we know that this great oceanic body is adapting to new positive feedback loops as it absorbs excessive amounts of carbon dioxide from the atmosphere, thereby lowering the pH of the water. This has profoundly incalculable cascading effects on the entire planetary ecosystem. The question then is: What is the Ocean becoming?

Wangechi Mutu is one of Kenya's most provocative artists. Her distinctive collages, installations, and videos of sea creatures, ovarian tumors, cancer cells, weeds, nets, snakes, mechanical contraptions proliferate in-between forms that wind, swirl, and curl around each other. The collages are convulsive adjacencies of form, color, shape, and texture. They are overlays of illustrations culled from a variety of scientific texts including ethnographic, oceanographic, medical, etc. The

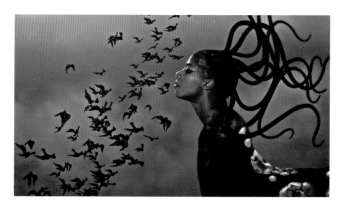

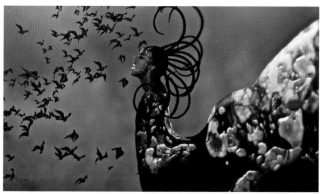

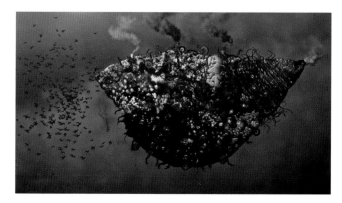

5.1–3. Wangechi Mutu (b. 1972), video stills from *The End of eating Everything*, 2013, animated video (color, sound), 8:10, edition of 6.

example of this undeniably dominant aspect of Wangechi Mutu's work (fig. 4).

In an interview on her video *The End of eating Everything* (figs. 5.1–3), Mutu explicitly links her tumor collages with the state of the earth. It is a profoundly unsettling and startling piece of work that conveys in her own words: "A planet that had erupted into all kinds of problems— that it has blistered and ulcerated and is pulsing. It's alive, but it's also sick. And the tumors had vegetation and blood and women's legs and mechanical bits and pieces….They look like a circular malignant cancer. And the metaphor is that there is something about the way we exist today in our world that is very much cancerous…. So you look at the environment and you look at the way we've developed and what we somehow consider to be civilization is actually ruining this beautiful orb."[14]

In an interview with the author Teju Cole published in the *Guardian* she says: "The ocean is the source of life. We all come from there. I think about these one-celled creatures and I think about the planet. It is related to my obsession with biology, even if it's only a layperson's obsession. The way I visualise what's at the bottom of the ocean is very much to do with how I feel when I'm swimming in the sea."[15] Mutu's preoccupation with complex realities renders a view of the Indian Ocean as a space of intricate entanglements where political and economic history are entwined with the non-human, invisible, apparently formless, yet precise forces of the planet.

Mutu's preoccupation with entanglement and her characterization of the sick orb may appear more planetary in its vision and less connected to regional concerns. Thus, we would be justified in asking what is the relevance of the planet being "sick, blistered, and ulcerated" to the Indian Ocean in particular? Let us consider the state of the waters:

The topic of sea levels rising has been in the news for a while, but in 2017, PBS NewsHour ran a segment titled "Why Is the Indian Ocean Rising So Rapidly?" The author Rashmi Shivni writes: "Since 1880, sea level in the world's oceans has risen about nine inches. But one pocket of the Indian Ocean has puzzled scientists for the last 40 years. The Arabian Sea and the Bay of Bengal rose four inches more than the world's oceans—a total of 13 inches to date. The north Indian Ocean is creeping up its coastlines."[16] The causes are familiar entanglements: thermal expansion due to warmer climate-weaker monsoons that drive heat back into the ocean-melting polar caps. Over two billion people live in Indian Ocean countries. It may not be too early to grieve.

Consider also David Michel's report on the rising waters of the Indian Ocean where he writes in the diction of economics that the Ocean provides vital "ecosystem services" to the tune of $21 trillion annually.[17] Michel's larger point however is that economic complexity can sometimes overwhelm ecological complexities that have evolved over millions of years. In the same report, Michel analyzes the environmental pressures on the Indian Ocean from coastal development. "Domestic sewage, agricultural runoff, and industrial effluents dumped in the sea can cause eutrophication and hypoxia, or act as toxic substances, killing local flora and fauna. Eutrophication (blooms of phytoplankton resulting from the added nutrients in the effluents) and attendant hypoxia (depletion of oxygen in the water) can engender effective dead zones in coastal areas," he writes.[18]

experience of viewing her work is one of inescapable "entanglement," a confrontation with what Donna Haraway playfully terms tentacular being that marks the Anthropocene. Tentacular being then is a homage to the spider *Pimoa cthulhu* and its related etymons that inspires her to rename the Anthropocene as the "Chthulucene."[13] In this exhibition, the collage *I'm too Misty* (92) can be interpreted as a testament to the "Chthulucene." It offers one

57

Holding these observations in mind, how should we interpret Wangechi Mutu's *I'm too Misty*? Who is the "I"? The viewer, or the collaged face that is clearly in distress? Are she/we misty because we are awash in tears? Too misty to see clearly until it is too late, way too late?

Tsunami

One of the wonders of the Ocean is that it is always with itself in its singular-plurality; it is everywhere always in place, thus making it a navigable surface for travel and transportation. In a tsunami, the Ocean is not traveled upon—rather, it travels to land. Tsunami: A Japanese word to say: "harbor wave." How does one speak of the Ocean coming in? First it withdraws, pulls out to a vast distance disclosing the secrets of its floor—life's remnants revealed and exposed for all to see, inviting curiosity, exciting delight. And then, it comes rolling back at the speed of a jetliner.

The Indian Ocean tsunami of 2004 was perhaps the deadliest in recorded history. And it came without warning. We were all too misty to see clearly that it was

6. Time travel map of the 2004 Indian Ocean tsunami; numbers represent hours after the initial event (NOAA, https://celebrating200years.noaa.gov /magazine/tsunami_database/traveltimemap.html).

coming. According to an article published in *National Geographic* citing the US Geological Survey, "it released the energy of 23,000 Hiroshima-type atomic bombs.... By the end of the day more than 150,000 people were dead or missing and millions more were homeless in 11 countries, making it perhaps the most destructive tsunami in history."[19] The eleven countries stretched from Africa to Thailand and the tsunami deluged some small islands in the Indian Ocean (fig. 6). The small island nation of the Maldives was particularly impacted, and holiday resorts, shops, makeshift dwellings, and the villas of the rich were destroyed in one fell sweep.

As political animals, we view the Indian Ocean as an integrated network due to the historical connections forged by trade, print culture, forced and voluntary migrations, and economic activity that transcended languages, ethnicities, religions, and races. As the historian Jerry Bentley suggests: "Sea and ocean basins come into clear focus as units of analysis to the extent that human societies engage in interactions across bodies of water, and they become a less useful focus as societies pursue their interests through other spaces."[20] In other words, the Indian Ocean as a network, or "world," is an accepted and useful epistemological construct only insofar as these interactions have prevailed. Contemporary frameworks of globalization, including world systems theory, and diaspora studies work hard to legitimize the construct through assiduous research.[21] As a premise of historiography, ocean basins greatly enlarge our understanding of the forces that shape cultural and political identity. The evolution of societies and even biological specimens thereby acquire a spatial logic that had hitherto been obscure.

If we think of the Indian Ocean network in strictly anthropocentric terms, we cannot avoid the counterfactual question: In the absence of human interaction and human agency, do these zones withdraw into their original remoteness and isolation? The word "remote" comes from the

Latin *remotus*, past participle of *removere*, to withdraw, or move back.

In a tsunami, the Ocean becomes remote—it withdraws. And when it returns it integrates and connects disparate polities. It binds in an embrace that entangles destinies with shifting tectonic plates as they bump, collide, and slip under each other. The collages of the ocean floor are indeed mysterious—too misty for me.

The Deep Element

To think the Ocean's depth is already a "diving into the wreck." How can we fail to recall those words of Adrienne Rich?

> I go down.
> Rung after rung and still
> the oxygen immerses me
> the blue light
> the clear atoms
> of our human air.
> I go down.
> My flippers cripple me,
> I crawl like an insect down the
> ladder
> and there is no one
> to tell me when the ocean
> will begin.
>
> First the air is blue and then
> it is bluer and then green and
> then
> black I am blacking out and yet
> my mask is powerful
> it pumps my blood with power
> the sea is another story
> the sea is not a question of
> power
> I have to learn alone
> to turn my body without force
> in the deep element.[22]

In 1980, the linguist George Lakoff and his collaborator Mark Johnson presented a powerful argument about human conceptual systems. In *Metaphors We Live By* they argued that our perception and understanding of the world, mediated as these are by concepts, are based on a logic of metaphor. "Metaphor is not

just a matter of language, that is of mere words. We shall argue that, on the contrary, human *thought processes* are largely metaphorical."[23] In other words, concepts like truth and objectivity make sense only within metaphorical systems that are historically and culturally specific. Lakoff and Johnson study various aspects of the interaction between metaphor and cognition including what they term "orientational metaphors." These are metaphors of space and pertain to the crucial function of prepositions (e.g., good is up, bad is down). According to Lakoff, the prepositions attest to our embodied experience of time, space, and other subjective affects. Where understanding itself is concerned, they observe that we speak of it in terms of "seeing" as in "I see what you're saying. It looks different from my point of view. What is your outlook on that"[24] and so on. Truth then is conceptualized as "obscure" or "hidden." It depends upon a concept of depth, having to be "brought to the surface," and "into the light." The conceptualization of truth and morality through the metaphor of depth is evident throughout the history of Western metaphysics from Plato to Heidegger. Lakoff and Johnson suggest that our spatial metaphors derive from our physical, bodily experience of the world—something is in or out, in front, or behind, down, up, or under on the basis of how we are in our bodies. They stress the literal stance of our bodies in space and sensory responses to phenomena; however, what they do not address or account for is the world itself. While our metaphors and our conceptual systems derive from our embodiment, the experience itself is given to us in our interaction with the world, or rather the earth. For instance, without air we could not conceptualize the meaning of "in" and "out." Similarly, our experience of fire and sunlight are responsible for our understandings of light and heat. The earth, its gravitational force, enables a sense of a "here" and "there," up and down, whereas Water, or more precisely, the Ocean gives us to think shallows and depth. Quite simply,

our languages possess signs and concepts to express depth because we/they carry an archival memory of the Ocean. Because the Ocean is deep, it gives us to think "depth," and in-depth. That the Ocean gives us to think depth is "deeply" consequential. Without a concept of depth, we could not conceptualize something called the truth or morality. Without a concept of truth, there can be no thought. To cite Nancy yet again: "No ethics would be independent from an ontology. Only ontology, in fact, may be ethical in a consistent manner."[25]

Ground

Why are we indebted to the Ocean for thought? Is it because there is nothing deeper than the Ocean? The average depth of the Ocean is 12,100 feet/2.29 miles/3.6 km. The deepest part of the Ocean—the Marianas Trench—is about 36,200 feet/6.85 miles/11.03 km. To get a perspective on this, consider that Mount Everest measures 29,022 feet/5.49 miles/8.83 km and could fit into the Marianas with over a mile of water above to spare. And yet, here is the chemist and inventor James Lovelock:

> If we were to model the Earth by a globe 30 centimetres in diameter, the average depth of the sea would be little more than the thickness of the paper on which these words are printed, while the deepest trench would be represented by a dent of one-third of a millimeter.[26]

Let us contemplate this: The earth's crust—its thinnest outermost layer continues to three miles below the ocean floor. The distance to the inner core is 3,958 miles/6,371 km. The inner core itself is 776.714 miles/1,250 km thick. The deepest we have drilled is 7.5 miles/12 km (Kola boreholes). These are massive numbers to confront and the imposing density of rock, stone, magma, and iron-nickel alloy are not easy to think with. In his

limpid meditation *Stone: An Ecology of the Inhuman*, Jeffrey Cohen writes: "The love of stone is often unrequited. An intimacy of long unfolding fails to be apprehended, and the story continues in familiar solitudes, human exceptionalism, and lithic indifference. Withdrawal and remoteness are inevitable themes with any romance of stone, since rock outlasts that which it draws close, that which draws it close, that to which it is strangely bound."[27] The stoicism of stone is unlike water. Stone is an enigma, inscrutable, and impenetrable. And yet, stone cuts and draws forth blood, and it calls us, at least some of us. For those who hear its silent call—the sculptor, the potter, the architect, it yields to *techne*, to the work of art, where it shows itself as what it is not—a thing that speaks.

Hajra Waheed is an installation artist who spent her early life in Dhahran, Saudi Arabia, the home of Saudi Aramco, the country's national petroleum company. Her art is geological and works with found objects, stratigraphic illustrations and maps, and prints. Her preoccupation with the lithosphere records the voice of stone—perhaps as a scream. In her untitled work (152–55) that displays an infographic map, Waheed testifies to the atrocity of boring into the earth to extract the minerals needed for economic growth. Whether it is below the ocean's surface, or deep into the earth's crust, as fossil fuel companies drill for oil and gas, fragile ecosystems are blown into non-existence. The environmental impacts of deep-sea mining and offshore drilling are often overshadowed by drilling, fracking, and mining on land. In her *Strata 1–24* series (156–81), that forms a part of an ambitious ongoing work titled *Sea Change*, she narrates the biography of rock as inscribed by time and collected in the field notes of a protagonist in search of quartz crystals. Quartz, of course, is one of the most abundant minerals on the planet and it is responsible for the formation of igneous and sedimentary rocks. Think granite, sandstone, shale, etc. As viewers, we gaze at Waheed's detailed collages, wandering, wondering—is there

a message, is there a meaning here, a story, a truth?

In an interview conducted by the *National Gallery of Canada Magazine*, Waheed says: "One always hopes that one's practice can reach people and provide an emotional or affective response, even if it simply prompts more questions or elicits lyricism and poetry into one's day. In the end, allowing objects to speak for themselves, allowing histories to infuse one another and viewers to steep in the mystery of interconnected clues, creating just enough tenuousness or uncertainty in order to leave space for viewers to come to the work from their own perspectives and histories—these all remain urgent bottom lines for me, allowing for possibility, imagining and reimagining."[28] What does it mean to allow objects to speak for themselves? Is that the function of art—to let things speak for themselves? To let blue run over the edge? Is that why I am here—to listen to the Ocean speak—as the Indian Ocean?

Kalpana R. Seshadri is professor of English at Boston College where she teaches courses in contemporary theory with a focus on identity and relations of power. She is the author of *Desiring Whiteness: A Lacanian Analysis of Race* (2000), *HumAnimal: Race, Law, Language* (2012), and co-editor of *The Pre-Occupation of Postcolonial Studies* (2000). Seshadri is presently completing a book titled *Posthuman Economics: Earth, Epistemology, and Ethics*. Her current research interests pertain to complex systems theory and environmental ethics.

1 Jean-Luc Nancy, *Being Singular Plural*, trans. Robert Richardson and Anne O'Byrne (Stanford: SUP, 2000), 29.

2 James Lovelock, *Gaia: The Practical Science of Planetary Medicine* (London: Gaia Books, 1991), 11.

3 Sarah Zhang, "Why Are There So Many More Species on Land When the Sea Is Bigger?," *Atlantic Monthly*, July 12, 2017, https://www.theatlantic.com/science/archive/2017/07/why-are-there-so-many-more-species-on-land-than-in-the-sea/533247/.

4 "How Many Species Live in the Ocean?," National Ocean Service, updated June 25, 2018, https://oceanservice.noaa.gov/facts/ocean-species.html.

5 See Michael Lachmann and Sara Walker's essay "Life≠Alive" for a discussion of how the laws of physics and information apply to earth systems. Available in an edited version: *Aeon*, June 24, 2019, https://aeon.co/essays/what-can-schrodingers-cat-say-about-3d-printers-on-mars.

6 Nancy, *Being Singular Plural*, 30–31.

7 Lovelock, *Gaia*, 44.

8 For more detailed information, see International Hydrographic Organization, updated May 8, 2019, http://iho.int/srv1/index.php?option=com_content&view=article&id=298&Itemid=297&lang=en.

9 See International Hydrographic Organization, *Limits of Oceans and Seas*, 3rd ed. (Monte Carlo: Imp. Monégasque, 1953), http://iho.int/iho_pubs/standard/S-23/S-23_Ed3_1953_EN.pdf. Also, International Hydrographic Organization, "The Indian Ocean and Its Sub-Divisions," 2002, http://www.iho.int/mtg_docs/com_wg/S-23WG/S-23WG_Misc/Draft_2002/S-23_Draft_2002_INDIAN_OCEAN.doc.

10 Nancy, *Being Singular Plural*, 21.

11 Karen Barad, *Meeting the Universe Halfway: Quantum Physics and the Entanglement of Matter and Meaning* (Durham: Duke UP, 2007), 33.

12 For a philosophical discussion of geo-metry see Claudia Barrachi, "Numbers of Earth: The Labor of the Intellect in Nature," *Social Research* 68, no. 2 (Summer 2001): 515–46.

13 See Donna J. Haraway, *Staying with the Trouble: Making Kin in the Chthulucene* (Durham: Duke UP, 2016), esp. 30–57.

14 Wangechi Mutu, "I'm Interested in How the Eye Can Trick You," YouTube video, 6:27, posted by Design Indaba, Nov. 21, 2014, https://www.youtube.com/watch?v=lo7I5LUQ2GY.

15 Teju Cole, "Wangechi Mutu: Under the Skin of Africa," *Guardian*, Sept. 25, 2014, https://www.theguardian.com/artanddesign/2014/sep/25/wangechi-mutu-artist-interview-africa-snakes-mermaids.

16 Rashmi Shivni, "Why Is the Indian Ocean Rising So Rapidly?," PBS NewsHour, Nov. 17, 2017, https://www.pbs.org/newshour/science/why-is-the-indian-ocean-rising-so-rapidly.

17 David Michel, "Environmental Pressures in the Indian Ocean," chap. 8 in *Indian Ocean Rising: Maritime Security and Policy Challenges*, ed. David Michel and Russell Sticklor (Washington, DC: Stimson, July 2012), 113–29, https://www.stimson.org/content/indian-ocean-rising-maritime-security-and-policy-challenges.

18 Michel, 115.

19 "The Deadliest Tsunami in History?," *National Geographic*, Dec. 27, 2004, https://news.nationalgeographic.com/news/2004/12/deadliest-tsunami-in-history/.

20 Jerry H. Bentley, "Sea and Ocean Basins as Frameworks of Historical Analysis," *Geographical Review* 89, no. 2 (Apr. 1999): 217.

21 See, for instance, Isabel Hofmeyr, "Universalizing the Indian Ocean," *PMLA* 125, no. 3 (May 2010): 721–29 and "The Complicating Sea: The Indian Ocean as Method," *Comparative Studies of South Asia, Africa and the Middle East* 32, no. 3 (2012): 584–90. Also, Pedro Machado, Sarah Fee, and Gywn Campbell, eds., *Textile Trades, Consumer Cultures, and the Material Worlds of the Indian Ocean: An Ocean of Cloth* (Cham: Palgrave Macmillan, 2018).

22 Adrienne Rich, "Diving into the Wreck," in *Diving into the Wreck: Poems, 1971–1972* (New York: W. W. Norton, 1973), 22–23.

23 George Lakoff and Mark Johnson, *Metaphors We Live By* (Chicago: University of Chicago Press, 1991), 6.

61

24 Lakoff and Johnson, 48.

25 Nancy, *Being Singular Plural*, 21.

26 Lovelock, *Gaia*, 79.

27 Jeffrey Jerome Cohen, *Stone: An Ecology of the Inhuman* (Minneapolis: University of Minnesota Press, 2015), 19.

28 Shannon Moore, "The Intimate and the Infinite: An Interview with Hajra Waheed," *National Gallery of Canada Magazine*, June 5, 2019, https://www.gallery.ca/magazine/artists/interviews/the-intimate-and-the-infinite-an-interview-with-hajra-waheed.

Nicholas Hlobo

(b. 1975) was born in Cape Town and works in Johannesburg. With the end of apartheid in 1994, Hlobo began his career in a climate suffused with a new sense of freedom and national pride. His commentary on the democratic realities of South Africa and concerns with the changing international discourse of art remain at the core of his practice. He creates two- and three-dimensional hybrid objects from ribbon, leather, wood, and rubber detritus; each material holds an association with cultural, gendered, sexual, or ethnic identity and thus reflects the artist's own multifaceted self. Exhibitions in 2019 included *Unyukelo* at the SCAD Museum of Art and *Kiss My Genders* at the Hayward Gallery, London. In 2020, Hlobo will present a solo exhibition at the Center for Contemporary Art, Tel Aviv.

Credits: © 2008, 2017 Nicholas Hlobo
All works appear courtesy of Nicholas Hlobo and Lehmann Maupin, New York, Hong Kong, and Seoul.
Installation views: Yerba Buena Center for the Arts and the San Francisco Museum of Modern Art, 2014 (64–65); Lehmann Maupin, New York, 2018 (66–74)
Photos: Matthew Hermann (66–74)

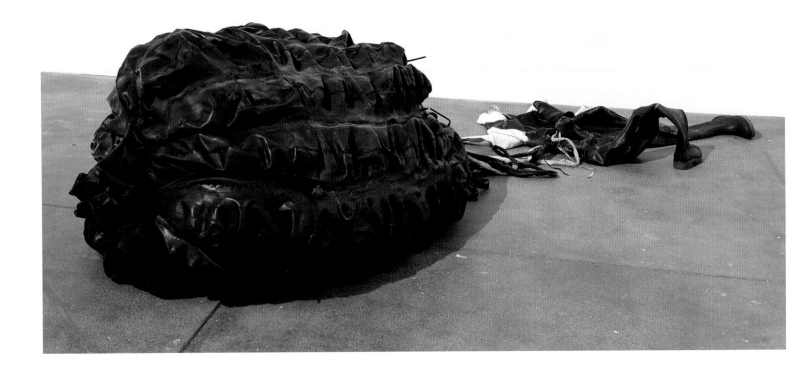

Ngumgudu nemizano, 2008
rubber inner tube, ribbon, rubber boots, and vinyl, c. 47.2 x 39.4 x 47.2 in.
Collection of Midori Yamamura and Luis H. Francia

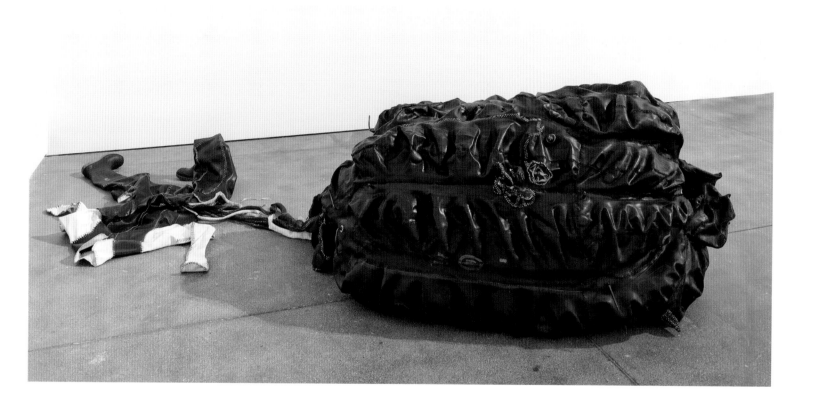

Ngumgudu nemizano, 2008
rubber inner tube, ribbon, rubber boots, and vinyl, c. 47.2 x 39.4 x 47.2 in.
Collection of Midori Yamamura and Luis H. Francia

Nicholas Hlobo

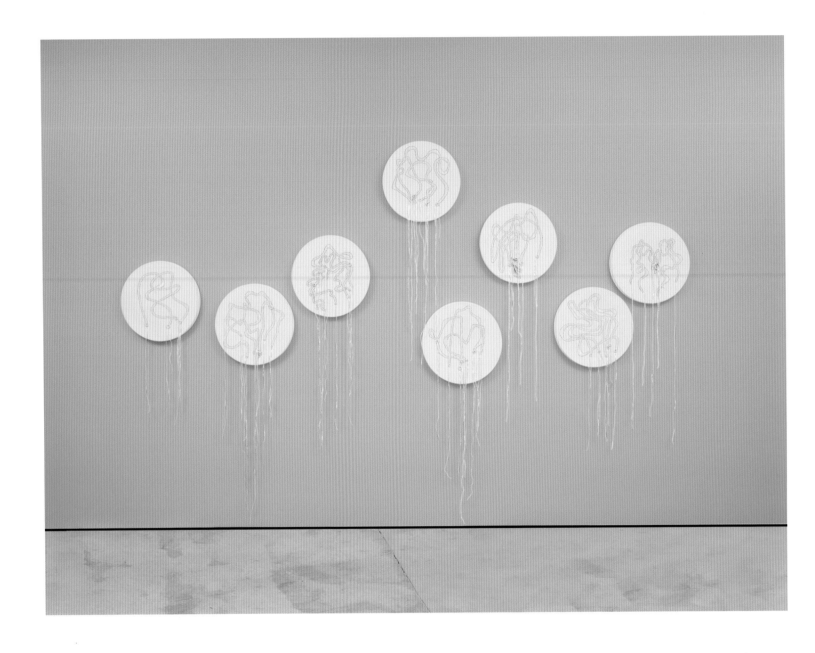

Amatholana asibhozo, 2017
ribbon and leather on canvas, 8 parts, 19.7 (diam.) x 2.1 in. (each)

**66**

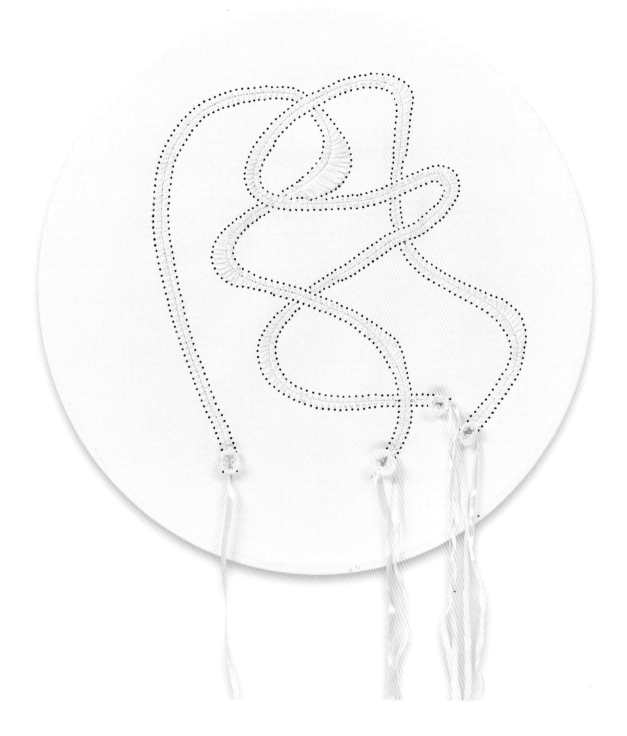

Amatholana asibhozo, 2017 (detail)
ribbon and leather on canvas, 19.7 (diam.) x 2.1 in.

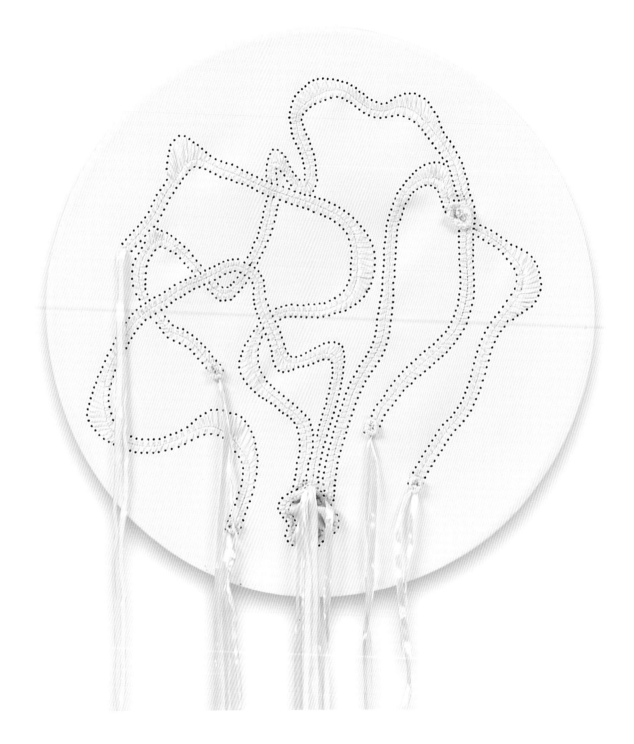

Amatholana asibhozo, 2017 (detail)
ribbon and leather on canvas, 19.7 (diam.) x 2.1 in.

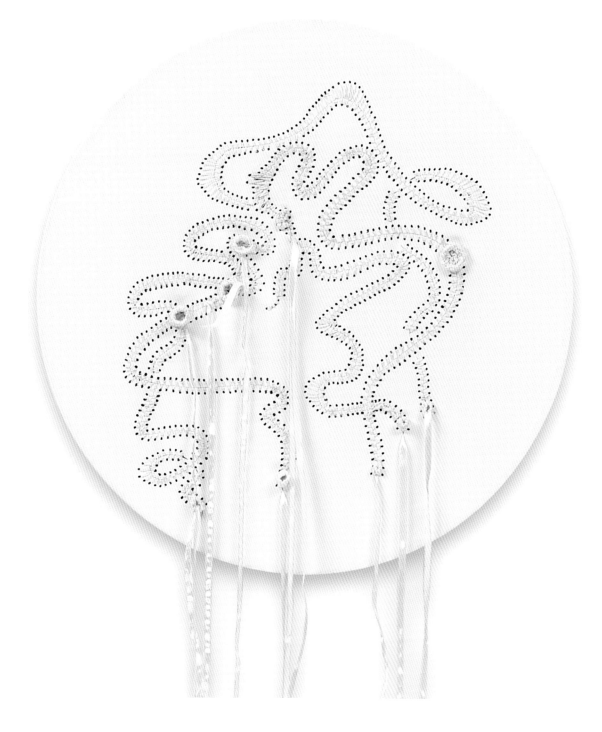

Amatholana asibhozo, 2017 (detail)
ribbon and leather on canvas, 19.7 (diam.) x 2.1 in.

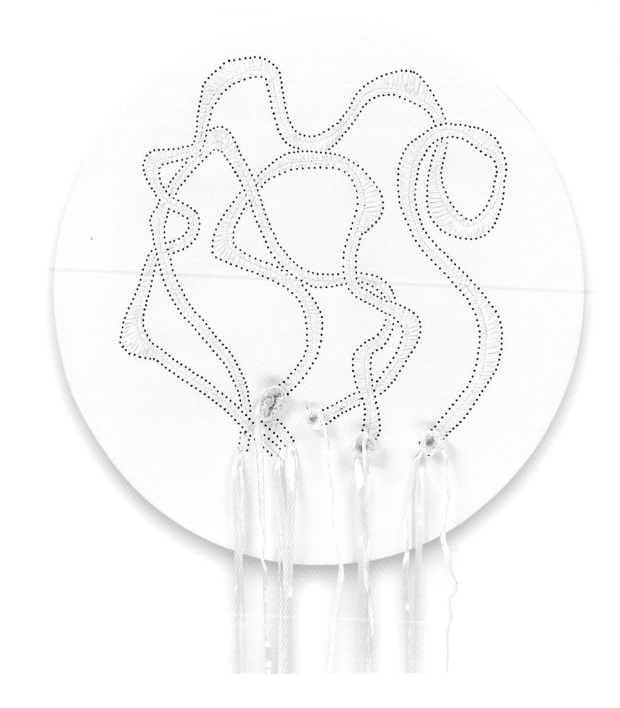

Amatholana asibhozo, 2017 (detail)
ribbon and leather on canvas, 19.7 (diam.) x 2.1 in.

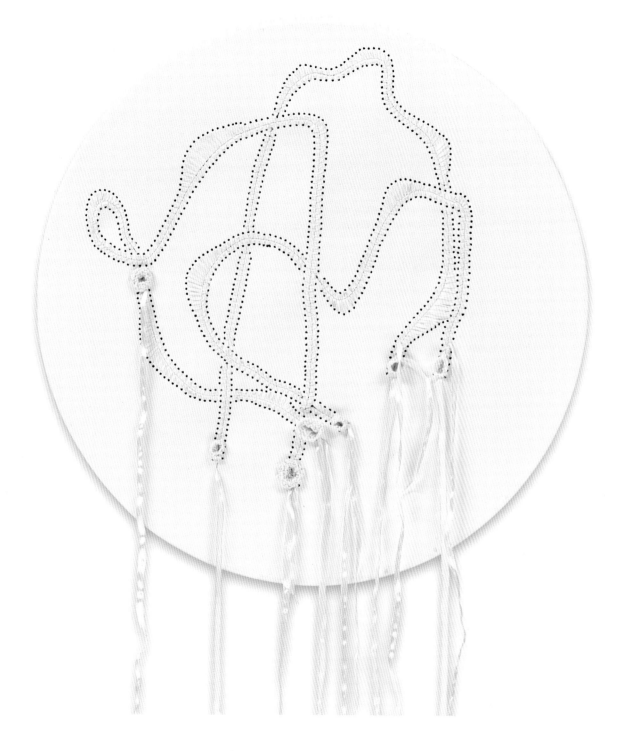

Amatholana asibhozo, 2017 (detail)
ribbon and leather on canvas, 19.7 (diam.) x 2.1 in.

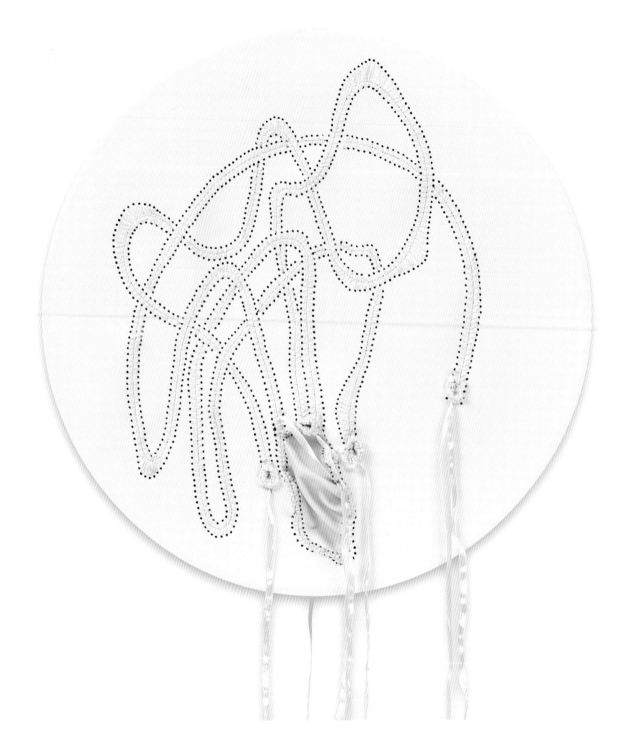

Amatholana asibhozo, 2017 (detail)
ribbon and leather on canvas, 19.7 (diam.) x 2.1 in.

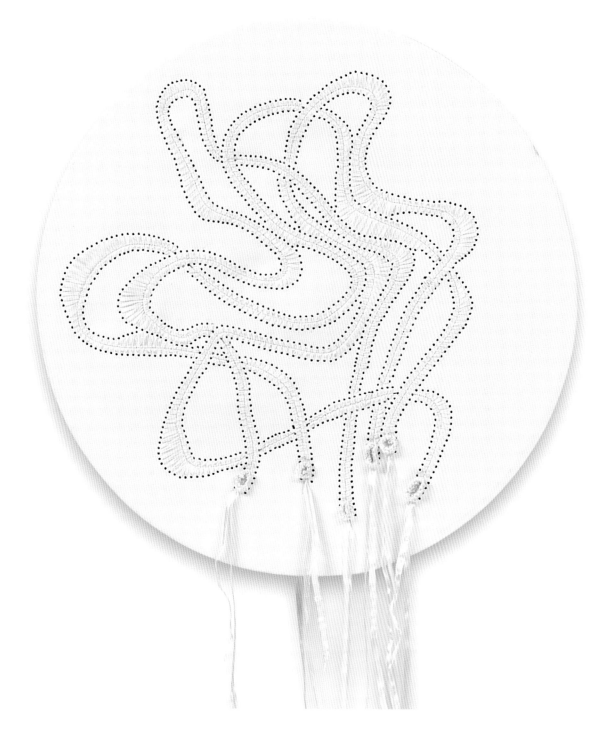

Amatholana asibhozo, 2017 (detail)
ribbon and leather on canvas, 19.7 (diam.) x 2.1 in.

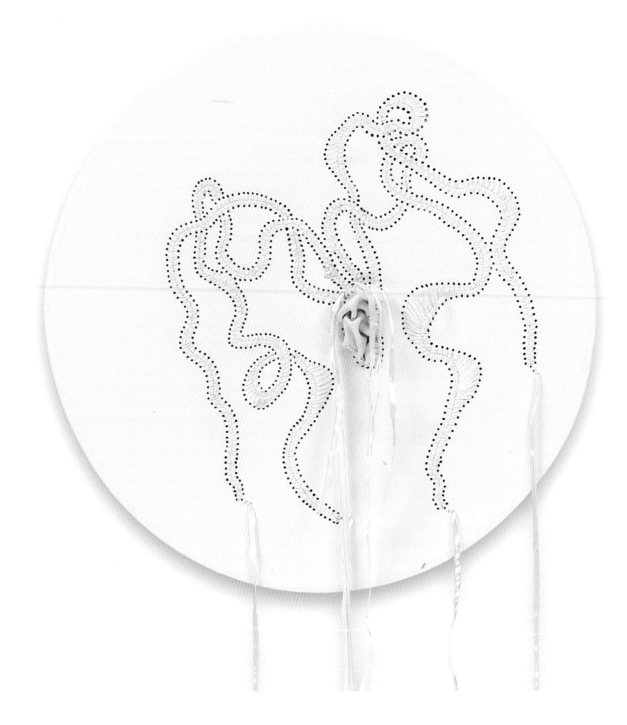

Amatholana asibhozo, 2017 (detail)
ribbon and leather on canvas, 19.7 (diam.) x 2.1 in.

Colonialism's Afterlives and Invocations of Oceanic History

Sana Aiyar

The ocean, Shiraz Bayjoo, suggests, is "not a space of separation but connection."[1] The Indian Ocean is no exception. Its waters have been a muse for artists and scholars who have invoked connections across space and time to interrogate the making of borders, and the messy entanglement of human mobility with nationalist projects of expulsion. Colonialism's afterlife in the Indian Ocean world—territorial nationalism—has produced a politics of belonging and exclusion through its deployment of the categories of the "mobile" (transient) migrant and "indigenous" (always-present) citizen. National belonging, in this framework, is contingent on shifting registers of race, ethnicity, and religion.

Shiraz Bayjoo and Shilpa Gupta reject the territorial rootedness of contemporary nation-states posited on such claims of racial and religious separation and distinction. They turn their gaze outward across the many horizons of oceanic history to repudiate the nationalist conflation of people and their histories with singular, territorial, nationalized spaces. Bayjoo and Gupta draw attention to the artificiality and tyranny of carceral national borders and conceptualize mobility as a form of everyday resistance and resilience. In so doing, they bring into relief the mundane acts of worship, eating, and falling in love that subvert territorial boundaries and connect—rather than separate—spaces and people across the Indian Ocean. Bayjoo's and Gupta's works in *Indian Ocean Current: Six Artistic Narratives* explore many concerns taken up in the growing field of Indian Ocean historiography that, over the last decade, has remapped South Asia and Africa to recover shared histories that have been marginalized in nationalist framings. I turn to some of these in this essay.

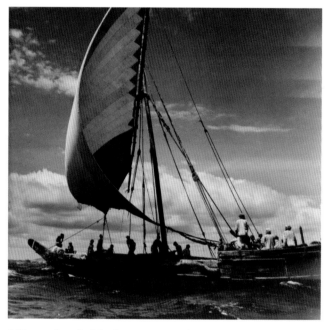

1. Dhow under sail off the Kenyan coast, c. 1950s–60s (Winterton Collection of East African Photographs, Melville J. Herskovits Library of African Studies, Northwestern University, Evanston, 36-1-39).

Empire, Capital, and Labor around the Indian Ocean

When Vasco da Gama sailed from the Atlantic to the Indian Ocean in 1497–98, he passed the southern tip of Africa, rounded the Cape of Good Hope, and moved north up the eastern coast of the continent, dropping anchor in present-day Mozambique, Mombasa, and Malindi before arriving in Calicut on the western coast of India. In eastern Africa, he met merchants from India who had long been plying dhows across the Indian Ocean. These traders survived several centuries of European attempts to establish oceanic and territorial sovereignty under the guise of colonialism (fig. 1).

While the Portuguese militarized trade across the Indian Ocean, fortifying ports such as Mombasa and Goa, Afro-Asian economic, political, and social networks not only continued but scaled up in size and scope. Hindu, Muslim, and Parsi merchants from the western coast of India, many from present-day Gujarat, collaborated with and circumvented Portuguese attempts to establish hegemony in the Indian Ocean.[2] Politically, the Portuguese in eastern Africa were challenged by an expanding Arab-Omani state from the late seventeenth century onward and the migration of Omanis to Zanzibar, which became a cosmopolitan center of culture, trade, and politics over the course of the next

Colonialism's
Afterlives
and
Invocations
of Oceanic
History

century and attracted capital and goods from India. A thriving trade in cotton cloth, ivory, and slaves intimately connected the economies of the littoral realms of the eastern and western Indian Ocean, an entanglement that reverberated deep into the western Indian and East African hinterlands even as the Portuguese, Dutch, French, and the English challenged, and ultimately defeated, territorial empires and chiefdoms in Africa and Asia. As historians Jeremy Prestholdt and Pedro Machado have shown, far from being a reserve of Europeans, "modernity," in the tangible form of capital, consumption, commodities, and cosmopolitanism, was produced by African and South Asian traders and consumers in the interregional Indian Ocean world from the mid-eighteenth century onward.[3]

European empire building changed the economic, political, and social flows of these oceanic currents. By arming their ships in the late fifteenth century, the Portuguese militarized the Indian Ocean world; by establishing an empire over which the sun never set in the nineteenth century, the British colonized the Indian Ocean world. European modernity brought within its purview oceanic trade and territorial expansion, replacing, in the process, the cosmopolitanism of littoral polities and societies with singular notions of political sovereignty. This, in turn, brought with it racial hierarchies that categorized people and communities along a civilizational ladder of "progress." From western to eastern Africa, across islands in the Atlantic, Pacific, and Indian Oceans, the British steadily expanded their territorial reach. With every new colony a dizzying array of communities were turned into imperial subjects who were fitted into discrete colonial racial categories.

Moreover, in every colony annexed to the empire, a new commodity was cultivated that secured Britain's economic and political dominance in the world. During the high noon of colonialism, from the mid-nineteenth century to the First World War, India, the jewel in the crown, pro-

duced opium, tea, and other agricultural goods to fuel Britain's industrialization, becoming, along the way, the market for the metropole's manufactured goods. British Guiana, Mauritius, Trinidad, and Fiji came with sugar plantations while East Africa provided cloves and coffee. The profitability of South Africa's coal, diamond, and gold mines was replicated in Burma's rice-growing lower delta, Malaya's rubber plantations, and Ceylon's teas and spices. The exploitation of nature's bounty required the development of export-oriented cash crops and infrastructure that connected the hinterland to the ports.

The keys to success in this British colonial economy that came to dominate the Indian Ocean were capital and labor. India supplied both. Empire scaled up mobility across the Indian Ocean and close to twenty-nine million sojourners and migrants from India circulated across these waters between 1830 and 1930. As historian Sugata Bose has noted, for the British Empire and its colonial subjects, the Indian Ocean had a hundred horizons.[4]

In 1497–98 Vasco da Gama had relied on a merchant from India to sail from Malindi to Calicut. Europeans continued to extract local knowledge and resources well after the "age of discovery." Despite their cartographical and technological prowess in the nineteenth century, by which time the Indian Ocean had been turned into a "British Lake," the British found themselves completely dependent on the material and political capital of merchants from India to make inroads into East Africa and Burma.[5] Rajat Kanta Ray and Sugata Bose have described these traders as "intermediary capitalists" who operated at three overlapping levels as investors, exporters, and middlemen. As bankers and moneylenders, they provided credit to both European empire builders and local cultivators entering the cash crop economy.[6] The lower delta in Burma, for example, became the largest producer of rice in the world by the late nineteenth century due to the capital provided by

Chettiar bankers, a community of entrepreneurs from southern India. In eastern Africa, Gujarati petty shopkeepers linked the informal bazaars and trading centers in the hinterland to the colonial economy with their willingness to engage in barter and trade in currency, providing coins for local Africans to pay taxes. Larger scale shopkeepers and traders stocked their shops in colonial towns with goods acquired on consignment from merchants who imported and exported agricultural and manufactured goods from the ports of Bombay, Mombasa, and Rangoon. Ports and railways that brought the interior closer to the coast developed at a rapid pace, and as the British taxpayer began to complain about the costs of empire, these intermediary merchants stepped up to provide capital for infrastructure projects such as the building of the East Africa railways. Despite the loss of political sovereignty, the colonization of the Indian Ocean created unrivaled opportunities for merchants and traders from British India to reap profits from overseas ventures to their east and west. Kenya and Burma, in particular, were considered the "America of the Hindu," as Gujarati and Chettiar capitalists became complicit and willing partners in the spread of British rule in these colonies where they positioned themselves as "sub-imperialists."[7]

Capital alone did not ensure the development of the colonial economy in the Indian Ocean, nor its profitability. The sugar, rice, tea, and rubber plantations as well as the mines, railways, and ports were built on the backs of laborers. The lucrative sugar plantations in Mauritius, among other locations, were entangled in the dark web of slavery in the Atlantic and Indian Oceans. In 1833, Britain banned slavery, equating modernity with civilization, and civilization with freedom and equality. The economic profitability of its colonial enterprise, however, depended on the availability of cheap, but now free, labor. Having distanced themselves from the "uncivilized" procurement of labor through slavery, the British colonial state introduced

a new system of labor within and beyond the Indian Ocean—that of indenture.[8] The availability of large numbers of landless Indians solved the colonial conundrum of ensuring Britain's overseas expansion as not only a profitable enterprise but also a civilizing mission that promised freedom and equality for the colonized. Rather than coercing and enslaving humans, indenture was cast as a voluntary, legally bound system of labor recruitment that provided wages for a fixed number of years. Its advocates also claimed that indenture served to "civilize" both the laborers themselves who were otherwise landless—and therefore suspect—and indigenous populations in the colonies whose labor was either unavailable or unaffordable.

In 1838, the first ships carrying indentured laborers from India left for Mauritius. By 1911, close to 1.3 million laborers, some of whom were returning emigrants, affixed their thumb impressions to labor agreements that were illegible and often incomprehensible to them, boarded ships in Calcutta and Madras, and sailed to Fiji, Mauritius (fig. 2), Guiana, Trinidad, Natal, and Kenya.

A larger number, close to twenty-eight million, the majority of whom were uncontracted seasonal laborers, traveled shorter distances across the Bay of Bengal, to Malaya, Ceylon, and Burma.[9] Although slave labor was outlawed across the British Empire, the institutions of slavery, particularly the ships that treated slaves as cargo and the plantations themselves—complete with overseers who determined the payment and, in many cases, the non-payment of wages, the quantity of work, and meted out violent punishment—were not dismantled. Deception, coercion, and desertion took on a new legality that bound indentured laborers to plantations, quite literally, while uncontracted laborers circulating in the Bay of Bengal were left entirely to the mercy of their recruiters and employers who operated with absolutely no state oversight. Contemporary critics in Britain and India, the laborers themselves, and later-day historians have argued that

indenture was a "new system of slavery." The transience of "free" labor in Malaya, Ceylon, and Burma empowered recruiters and employers to provide no housing or rations, leaving large numbers impoverished and in debt in conditions that were arguably even worse than those who were indentured. Free or indentured, migrant laborers from India in colonies across the Indian, Atlantic, and Pacific Oceans were entangled in the colonial project, producing commodities and building the infrastructure that consolidated British rule across the world. Although we associate the violence of colonialism with the spectacle of the wars of conquest of the nineteenth century and the counter-insurgencies of the twentieth century, it was the violence of everyday life on the plantations, which has been captured so evocatively by Gaiutra Bahadur and others, that embodied the racial, gendered, and class-based tensions of European modernity.[10]

Colonialism's Afterlives

Religion and Resilience

While "slavery" has been a recurring trope in descriptions of indentured labor and underscores the human cost of European modernity and its imperial and capital expansion, the Indian Ocean has provided historians and artists a horizon from which to recover the agency and humanity of the colonized. For Shiraz Bayjoo, this is a project "of recouping an individual and collective identity beyond colonial narratives."[11] He locates the "lateral connections" across the Indian Ocean that enable such a recovery in Mauritius, his homeland and the site of his work. In a series of photographs titled *Extraordinary Quarantines*, he invokes a history of the everyday acts of resistance and the resilience of African slaves and indentured laborers from India who were settled in Mauritius by the French and the English. Bayjoo's work borrows its title from a former British governor who described Mauritius to Mark Twain as "a land of extraordinary quarantine"—an

island where English ships were forced into quarantine by the French colonial government, and a place with a "very small; small to insignificance" population of "East Indian[s]", "mongrels," "negroes," "French," and "English." It was a place where one could find "all kinds of mixtures" and "every shade of complexion."[12]

While the ships that were quarantined were allowed to leave after a mandated

2. "Hill Coolies Landing at the Mauritius" (*Illustrated London News* 13 [Aug. 6, 1842]: 193).

twenty days, Bayjoo's work draws attention to those who were in permanent quarantine on the island. The historical and sacred geography of his homeland is evocatively captured in this series of photographs. *Extraordinary Quarantines #38* (23) is an image of the Indian Ocean, of waves crashing against the rocks, emphasizing the centrality of the ocean to the history of the island that was settled by waves of migrants—French, African, English, and Indian. The gray image of an opulent grave in *Extraordinary Quarantines #40* (24) contrasts with the vividly colored, modest graves in *Extraordinary Quarantines #12* (21), a juxtaposition deployed to remind us of the colonial state and the unnamed slave and indentured labor on which it was built. It is in *Extraordinary Quarantines #15* (22) in a photograph of a large Hindu deity, Hanuman, that Bayjoo

Colonialism's
Afterlives
and
Invocations
of Oceanic
History

celebrates the resistance and resilience of the indentured laborers whose descendants constitute the majority of the population of Mauritius today. Colonialism's afterlife in Mauritius, in Bayjoo's framing, is its plural cultural inheritance that is inseparable from oceanic history. The permanently quarantined African, Indian, and Creole laborers for whom Mauritius became home, some by force, others by fate, together created a cosmopolitan island nation defined by its inhabitants' "ancestral cultures."[13]

Hanuman, in Bayjoo's photograph, is a large, imposing statue dressed in red, towering toward the sky—the iconic Hindu deity carrying a mountain in the palm of his left hand. The location of this statue is Grand Bassin Lake in the mountains about 1,800 feet above sea level. Referred to as "Ganga Talao" in a direct invocation of the Ganges, the most sacred river in India for Hindus, Grand Bassin is the most "prestigious Hindu sacred place in Mauritius," and, indeed, the Indian Ocean world outside of South Asia.[14] Over four hundred thousand pilgrims, the majority from Mauritius itself, visit Ganga Talao every year in February to celebrate Shivratri, a popular Hindu festival. A number of Hindu temples surround the lake, mirroring temple complexes in northern India. Since the early twentieth century, Ganga Talao has been managed by a number of voluntary Hindu associations with links to similar organizations in India such as the Hindu Mahasabha and the Vishwa Hindu Parishad (World Hindu Council). The Indian government has also been involved in maintaining and expanding Ganga Talao since the 1970s, acknowledging its emotive and connective centrality to the large Hindu diaspora in Mauritius. In 1972, "holy water" from the Ganges was flown to Ganga Talao in a special vessel to legitimize the diasporic origin myth that located the Ganges as the lake's source. Mathieu Claveyrolas argues that this marked the "ritual transfer of Hindu territory and identity" from the Indian homeland, conferring

upon Ganga Talao the status of a "sacred place"[15] within an oceanic Hindu world.

Almost a century earlier, in 1898, a group of Hindu pilgrims led by Pandit Giri Gossayne had walked to Ganga Talao following the pandit's dream that in the land of extraordinary quarantine, there existed a sacred lake whose waters flowed directly from the Ganges.[16] Within the next two decades, Grand Bassin became the site of annual pilgrimage for increasingly large numbers of Hindu worshipers. What appears to be a mundane site of worship in Bayjoo's work is in fact a symbol of resistance. The majority of the Hindu population in Mauritius consisted of indentured laborers until the system came to an end during the First World War. Although nominally free, in contrast to the slave labor whose jobs they now performed, their movement was severely restricted. The annual pilgrimage to Ganga Talao was simultaneously an escape from the plantation, the realization of their dreams of "return" to their homeland, and the making of a diasporic enclave and identity that allowed indentured laborers and their descendants to rebuild in Mauritius all that they had lost by boarding ships in Calcutta and Madras.[17]

Religion offered labor migrants ties that bound diasporic communities together, providing a sacred and communal space for resistance. At the same time, anticolonial nationalists in India built up a campaign against the system of indenture itself, especially after the return to India of Mohandas K. Gandhi, who had spent close to two decades in South Africa.[18] While the plantation economies of British Guiana, Trinidad, Fiji, and Mauritius came under fire for the mistreatment of indentured laborers, immigration restrictions on merchants and traders from India in white settler colonies such as Kenya and South Africa further emboldened nationalists to criticize the racist discourse that positioned Indians as inferior and less civilized than Europeans.[19] Indenture ended with the outbreak of the First World War, and Indian nationalists turned their attention

to attaining independence from the British. The depression of 1929–30 created a glut in labor markets across the Indian Ocean, slowing the rate of emigration from India.

Race and Resistance

The legacy of indenture continues in Guiana, Mauritius, Fiji, and Trinidad where "Indians" form a majority or close to a majority of the population, living in diasporic enclaves that simultaneously include and exclude. Colonialism's afterlives—the racial and religious borders built by Indians in these postcolonial nations—have been interrogated in the literature of V. S. Naipaul and scholarship of Anjali Prabhu and others who expose the limits of diasporic imaginations.[20] While Mauritius has attempted to reconcile the racial trappings of its Indian, African, and Creole population by embracing "ancestral culture" in defining its nationhood at the moment of decolonization, a different fate met Indian migrants in settler colonies.

Merchants and traders from India acted as sub-imperialists in the early days of colonial rule in eastern Africa at the turn of the century. European settlers in Kenya and South Africa, however, wanted to convert these areas into "white man's country," similar to settler colonies in Australia, New Zealand, and North America. Pointing to India's own colonial subjugation, Europeans argued that Indians were a racially distinct group, below Europeans in the civilizational hierarchy and not equal nor effective partners in the imperial project. By the early 1910s, they began to argue that far from being a civilizing influence, the Indian presence in East Africa was detrimental to the indigenous population who, in their telling, needed to be Christianized—and thereby civilized—to fulfill Britain's imperial vision. In response, led by Gandhi in South Africa and a number of Muslim merchants in East Africa, middle- and upper-class migrants distanced themselves from indentured laborers and demanded parity with European settlers based on Indian civilizational achieve-

ments that they carried with them across the Indian Ocean to Africa. Just as Hindu migrants in Mauritius established a sacred connection with the Ganges, merchants and traders invoked the ancient commercial and political glory of their Indian homeland to argue for political and economic equality with Europeans in East Africa, a land they claimed to have "developed" for decades before Europeans arrived on the scene.[21]

The civilizational claims made by these merchants, who assumed the leadership of diasporic Indian communities in South and East Africa in the early twentieth century, marked them as distinct from, and more "modern" than, Africans.[22] At the same time, building on these trade networks, petty shopkeepers established small shops selling everyday goods to Africans and bought their agricultural produce (fig. 3).

African shopkeepers, dependent on the colonial state for capital, could not compete with the Indians who turned to larger merchants for loans and merchandise. At the same time, the colonial government in East Africa employed skilled and semi-skilled Indian laborers in their many infrastructure projects, while African labor was employed only in unskilled work that paid much less. This pattern of commerce and wage labor created diasporic economic monopolies and enclaves that were, in effect, racial borders that Africans could not cross. By the interwar years, as unskilled African labor organized into unions and anticolonial resistance mobilized into mass movements of elite nationalism and subaltern revolution, Indians became the target of a cry to make "Africa for Africans." Everyday skirmishes in the overcrowded and underdeveloped non-European areas of colonial cities took on an increasingly racialized framing as clashes between Indian shopkeepers and their African customers and accidents involving Indian car owners and African pedestrians escalated into violent affrays and melees.[23]

On the other side of the Indian Ocean a discourse of indigeneity emerged in

Burma where more than thirteen million seasonal migrants from India cycled through between 1840 and 1930.[24] From the mid-nineteenth century onward, the British had gradually annexed different regions of Burma and attached them, administratively, to British India. Capital and labor crossed the Bay of Bengal into the Arakan and Rangoon. The latter was the busiest port of immigration in the world at the time, rivaling New York.[25] Indian migrants constituted the majority of the population of Rangoon, while an already large, Bengali-speaking Muslim community in the Arakan increased in number with the now-closer administrative association of Burma with Bengal and India (fig. 4). The 1930s opened and closed with the outbreak of violence in Rangoon and the lower delta against Indian labor accompanied by a rising discourse of nationalism. Arguing for the separation of Burma from India as the first step toward independence, Burmese nationalists deployed the language of race and religion to distinguish Burmans from Indians. They imagined their nation as Buddhist and Burmanese, rendering migrants from India permanent outsiders.[26]

In East Africa and Burma, the specter of the migrant was used to define the nation racially as one in which Indians were unwanted guests. Space and race mapped together at the moment of decolonization, and within the first few years of independence the euphoria of freedom gave way to disillusionment as it became clear that colonialism's afterlives had yielded independent states but had not eliminated the structural inequalities of empire.

In Kenya and Uganda, Indians were singled out as colonial hangovers who were preventing "real" citizens from gainful employment and economic progress. Unlike Mauritius's embrace of the pluralism of its colonial-born citizens, East African nationalists ignored the long history of migration in the Indian Ocean that predated colonial rule and deployed the recurring trope of the Indian migrant as an

anachronistic presence in the nation who was unwanted, unwelcome, and complicit in the colonial subjugation of Africans. The postcolonial state in Kenya moved to squeeze shopkeepers out of the country, while in Uganda Idi Amin issued an expulsion order shortly after his military coup in 1971 giving Indians ninety days to leave the country. In Uganda, especially, this expulsion was carried out by the military amidst the threat of real and perceived violence.

Colonialism's
Afterlives
and
Invocations
of Oceanic
History

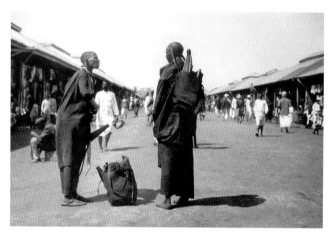

3. Indian Bazaar (Biashara Street), Nairobi, 1906 (@KResearcher/Twitter).

4. Mogul Shia Masjid (built 1914–18), 91 30th Street, formerly known as Mogul Street, Rangoon (author's photo).

Colonialism's

Afterlives

and

Invocations

of Oceanic

History

Race, Religion, and Remapping the Nation

The late 1960s and early 1970s saw the voluntary and involuntary exodus of Indians from East Africa. Some returned to India, but the majority became twice migrants in Britain, bringing the empire, quite literally, home to the metropole.[27]

In Burma, a 1962 expulsion order pushed the small remaining Indian com-

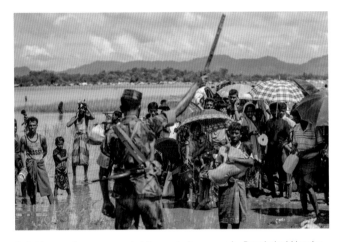

5. Rohingya refugees prevented from entering camps by Bangladeshi border guard, Oct. 2017 (Dar Yasin/Associated Press).

munity out of the country. Two decades later, the Muslim, Bengali-speaking community in the Arakan, the Rohingya, were rendered stateless as they were excluded from the list of citizens in the constitution of Myanmar in 1982. The government of Myanmar insists on referring to them as Bengali, not Rohingya. This nomenclature allows them to argue that the Rohingya are Bangladeshi migrants, illegally living in Myanmar (fig. 5). In what the UN has called a military-backed campaign of "ethnic cleansing," more than half a million have left their homeland to which they make a claim going back three to four generations. The Rohingyas' claims of territorial belonging, and the Myanmar government's disavowal of the same, have underscored a deeply entangled crisis of mobility, migration, identity, and nationalism involving Myanmar, Bangladesh, India, and Pakistan.

While decolonization in eastern Africa and Burma was accompanied by the making of racial boundaries within national territories that marked certain groups as not belonging, colonialism's afterlives in South Asia are deeply entangled with the many cartographical experiments of the British in the region and the making of religious boundaries by postcolonial nationalists (figs. 6–7).

The frontiers of British India in the mid-nineteenth century extended from present-day Pakistan to Myanmar. British India included the people and territories of a number of large empires of the early modern world, as well as smaller kingdoms, chiefdoms, and communities that resisted these centralizing empires. By 1947 three nations were partitioned out of British India: India, Pakistan, and Burma; and a fourth, Bangladesh, was created in 1971. Decolonization brought political sovereignty to the people of South Asia, but, as David Ludden has pointed out, "creating national territory meant carving up...imperial spaces and networks."[28] This was a process that was "traumatic," as nationalist projects in all four countries continually deployed history to define these nations along shifting registers of religion, language, and ethnicity—an endeavor fraught with violence and expulsion, as it broke up networks and neighborhoods, and imposed carceral boundaries that restricted mobility in borderlands that for centuries had been home to mobile communities rendering their homelands perilous.[29]

Shilpa Gupta's works *Speaking Wall* and *Fenced Borders* (42–51) capture this trauma, memorializing not only critical events in South

Asia's history such as the Partition of 1947, but also reminding us of the historical conjunctures at which separation is produced. In so doing, she emphasizes the constructed nature of borders that renders people and community outsiders, as migrants who do not belong. While we think of migrants as mobile, unrooted, and transient yet visible, *Speaking Wall* and *Untitled (There Is No Border Here/No hay frontera aquí)* (40–41) repeatedly invoke the artificiality, transience, and invisibility of the border *rather than the migrant*. The border is wiped out by the rains and it is invisible to the communities living in borderlands. The specter of Partition looms large in Gupta's work, as she draws attention to the "fractured geography of South Asia," as described by Iftikhar Dadi.[30]

Invocations of History

Partition is a central paradigm of historical and nationalist thought in South Asia. It is a conceptual category that has produced postcolonial state projects of populist exclusion. In India, Pakistan, Bangladesh, and Myanmar, competing historical narratives have been used to

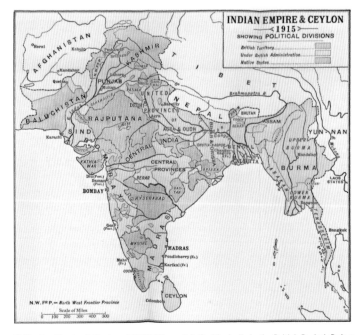

6. "Indian Empire & Ceylon, 1915" (Vincent A. Smith, *India in the British Period: Being Part Three of the Oxford History of India* [Oxford: Clarendon, 1920], facing 786).

Colonialism's
Afterlives
and
Invocations
of Oceanic
History

legitimize the making and unmaking of colonial-era boundaries that were nationalized along ethnic and religious lines. It was this process, rather than mobility itself, that created "migrants" in South Asia as communities were—and continue to be—evicted from their homelands amidst national discourses that artificially construct histories of "authentic" nationhood along singular religious and territorial lines. At the same time, histories of mobility themselves are used to gloss over the human trauma and violence of decolonization. On the other hand, Partition has also enabled the states' critics, including activists, historians, and artists to interrogate and challenge discourses of non-belonging in projects of recovery—of a shared South Asian past—and memorialization. A series of trees outlined in Gupta's *Fenced Borders* speaks directly to this history. *Mango Tree* (47) is a reminder of the common

7. Map of South Asia. It is worth noting that the UN includes Myanmar (Burma) as part of Southeast Asia, not South Asia. This regional boundary is reflected in South and Southeast Asian historiography (United Nations Geospatial Information Section, Map No. 4140 Rev 4 [Dec. 2011]).

geography, climate, and culture of India and Pakistan that is evident in the everyday eating habits of the people of South Asia and their love of the mango, the fruit of the gods, that provides some respite in the blistering heat of the summer in northern South Asia. In *Mangrove* (48) Gupta draws our attention to the stubborn roots of the trees that grow in the Sundarbans in the borderland between Bangladesh and India, uniting the territories of these two nations at their very foundation. *There Is No Border Here* similarly celebrates the resilience of people and cultures and their resistance to the endeavors of the nation-state to separate territories and people.

"Modernity," as David Ludden succinctly put it, "consigned human mobility to the dusty corners of archives that document the hegemonic space of national territorialism. As a result, we imagine that mobility is border crossing, as though borders came first, and mobility, second. The truth is more the other way round."[31] In their invocations of oceanic history and colonialism's afterlives, Shilpa Gupta and Shiraz Bayjoo return to this truth. Rather than conceptualize mobility as border crossing and separation, mobility, for Bayjoo, facilitates connections across space and time. Through mobility, Bayjoo reaches back to the enslaved and indentured past of Mauritius to celebrate the cosmopolitan, multicultural present of the nation, emphasizing India's proximity—rather than distance—from the island across the Indian Ocean. For Gupta, too, mobility provides an entry point into emphasizing connections over separation. Eschewing the temptation to conflate mobility with migration and migrants with border crossing, Gupta critiques the border itself for *creating* migrants. Her work reveals the transience and invisibility of the border that produces violence

at the historical conjunctures at which migrants are made in the moment of their expulsion. Simultaneously, in underscoring the artificiality of the border, even as she recognizes its potential tyranny, Gupta's work refuses to succumb to the hegemony of such divisions, alluding to the shared history and homelands of those on either side. This affectively and effectively establishes proximity and intimacy, rather than distance, between India, Bangladesh, and Pakistan.

The twin forces of capitalism and racializing ideologies of civilizational hierarchies reached their nadir in the form of European modernity and colonialism in the nineteenth century, as the tensions of empire manifested in the mapping of race and religion onto place and people, a discourse inherited by postcolonial nations in Africa and South Asia. Far from being a moment that ended with the departure of European colonists, decolonization remains an ongoing process across the Indian Ocean, as nationalist projects have tried to manage and contain oceanic mobility by raising the specter of the "outsider" to expel "migrants" and delimit "national" territory and cultures with carceral borders. Together, Bayjoo's and Gupta's works interrogate colonialism's afterlives in Mauritius and South Asia in their invocations of oceanic history that was constituted by mobility. In so doing, they celebrate the resistance and resilience of the intimately entangled lives of communities across the Indian Ocean that colonial and postcolonial states have tried, unsuccessfully, to disentangle.

Colonialism's
Afterlives
and
Invocations
of Oceanic
History

Sana Aiyar is associate professor of history at the Massachusetts Institute of Technology. Her work on mobility and migration across the Indian Ocean remaps South Asia by examining intimately connected histories of the region with Africa and Southeast Asia. Her first book, *Indians in Kenya: The Politics of Diaspora* (2015) focuses on the relationship between African and Indian anticolonial politics in colonial Kenya and its immediate aftermath. Her current book manuscript, *The Partition of 1937: Recovering Burma's South Asian History*, uses partition as a metaphor to include Burma in the history and historiography of South Asia through a study of migrations and religious geographies across India and Burma.

1 Shiraz Bayjoo and Denise Clarke, "When the Painterly Meets the Political," Arts Cabinet, June 7, 2019, https://www.artscabinet.org/editorial/when-the-painter-meets-the-political.

2 For more on the Portuguese in the Indian Ocean, see Sanjay Subrahmanyam, *The Portuguese Empire in Asia, 1500–1700: A Political and Economic History* (London: Longman, 1993). Amitav Ghosh's *In an Antique Land* (New York: Alfred A. Knopf, 1993) also invokes this deep history of circulation across the Indian Ocean.

3 Jeremy Prestholdt, *Domesticating the World: African Consumerism and the Genealogies of Globalization* (Berkeley: University of California Press, 2007) and Pedro Machado, *Oceans of Trade: South Asian Merchants, Africa and the Indian Ocean, c. 1750–1850* (Cambridge: CUP, 2014).

4 Sugata Bose, *A Hundred Horizons: The Indian Ocean in the Age of Global Empire* (Cambridge: Harvard UP, 2006). See also Sunil S. Amrith, *Crossing the Bay of Bengal: The Furies of Nature and the Fortunes of Migrants* (Cambridge: Harvard UP, 2013) and Thomas R. Metcalf, *Imperial Connections: India in the Indian Ocean Arena, 1860–1920* (Berkeley: University of California Press, 2007).

5 Sana Aiyar, *Indians in Kenya: The Politics of Diaspora* (Cambridge: Harvard UP, 2015) and Fahad Ahmad Bishara, *A Sea of Debt: Law and Economic Life in the Western Indian Ocean, 1780–1950* (Cambridge: CUP, 2017).

6 Bose, *Hundred Horizons*, 72–121 and Rajat Kanta Ray, "Asian Capital in the Age of European Dominance: The Rise of the Bazaar, 1800–1914," *Modern Asian Studies* 29, no. 3 (July 1995): 449–554.

7 Aiyar, *Indians in Kenya* and Michael Adas, *The Burma Delta: Economic Development and Social Change on an Asian Rice Frontier, 1852–1941* (Madison: University of Wisconsin Press, 1974).

8 Hugh Tinker, *A New System of Slavery: The Export of Indian Labour Overseas, 1830–1920* (New York: Institute of Race Relations, Oxford UP, 1974); Madhavi Kale, *Fragments of Empire: Capital, Slavery, and Indian Indentured Labor Migration in the British Caribbean* (Philadelphia: University of Philadelphia Press, 1998); and David Northrup, *Indentured Labor in the Age of Imperialism, 1834–1922* (Cambridge: CUP, 1995).

9 Amrith, *Crossing the Bay*, 28, 104.

10 Gaiutra Bahadur, *Coolie Woman: The Odyssey of Indenture* (Chicago: University of Chicago Press, 2014). Amitav Ghosh, *Sea of Poppies* (London: John Murray, 2008) beautifully captures the political and human toll of indenture. For an autobiographical account of indenture, see Totaram Sanadhya, *My Twenty-One Years in the Fiji Islands & The Story of the Haunted Line*, ed. and trans. John Dunham Kelly and Uttra Kumari Singh (Suva: Fiji Museum, 1991).

11 Bayjoo and Clarke, "Painterly Meets the Political."

12 Mark Twain, *Following the Equator: A Journey around the World*, vol. 2 (New York: Harper and Brothers, 1899), 294.

13 See Patrick Eisenlohr, "Mediality and Materiality in Religious Performance: Religion as Heritage in Mauritius," *Material Religion* 9, no. 3 (2015): 328–48.

14 Mathieu Claveyrolas, "From the Indian Ganges to a Mauritian Lake: Hindu Pilgrimage in a 'Diasporic' Context," in *Pilgrimage and Political Economy: Translating the Sacred*, ed. Simon Coleman and John Eade (New York: Berghahn, 2018), 21–39, 30.

15 Claveyrolas, 32.

16 Claveyrolas, 30–31.

17 For more on religious festivals and sacred geographies in the diasporic context, see Frank Korom, *Hosay Trinidad: Muharram Performances in an Indo-Caribbean Diaspora* (Philadelphia: University of Pennsylvania Press, 2002); Sunil S. Amrith, "Tamil Diasporas across the Bay of Bengal," *American Historical Review* 114, no. 3 (June 2009): 547–72; and Prabhu P. Mohapatra, "'Following Custom'? Representations of Community among Indian Immigrant Labour in the West Indies, 1880–1920," *International Review of Social History* 51, no. 14 (Dec. 2006): 173–202.

18 For details, see Joseph Lelyveld, *Great Soul: Mahatma Gandhi and His Struggle with India* (New York: Alfred A. Knopf, 2011) and Ramachandra Guha, *Gandhi before India* (London: Allen Lane, 2013).

19 See John Dunham Kelly, *A Politics of Virtue: Hinduism, Sexuality, and Countercolonial Discourse in Fiji* (Chicago: University of Chicago Press, 1991), and Aiyar, *Indians in Kenya.*

Colonialism's

Afterlives

and

Invocations

of Oceanic

History

20 V. S. Naipaul, *A House for Mr. Biswas* (1961) (London: Penguin, 1992); Anjali Prabhu, "Representation in Mauritian Politics: Who Speaks for African Pasts?," *International Journal of Francophone Studies* 8, no. 2 (Aug. 2005): 183–97.

21 For details see Aiyar, *Indians in Kenya.*

22 For an account of Gandhi's sub-imperialist and divisive politics in South Africa see Ashwin Desai and Goolam H. Vahed, *The South African Gandhi: Stretcher-Bearer of Empire* (Stanford: SUP, 2015). See also Antoinette M. Burton, *Brown over Black: Race and the Politics of Postcolonial Citation* (Gurgaon: Three Essays Collective, 2012) for a critique of Indians' racializing discourse.

23 For the 1949 riots in Durban, see Jon Soske, *Internal Frontiers: African Nationalism and the Indian Diaspora in Twentieth-Century South Africa* (Athens: Ohio UP, 2017).

24 Amrith, *Crossing the Bay.*

25 Thant Myint-U, "Myanmar, an Unfinished Nation," Nikkei Asian Review, June 17, 2017, https://asia.nikkei.com/Politics/Myanmar -an-unfinished-nation.

26 Sana Aiyar, *The Partition of 1937: Recovering Burma's South Asian History* (forthcoming).

27 See Aiyar, *Indians in Kenya* and Anneeth Kaur Hundle, "Exceptions to the Expulsion: Violence, Security and Community among Ugandan Asians, 1972–79," *Journal of Eastern African Studies* 7, no. 1 (Feb. 2013): 164–82 and Edgar Taylor, "Asians and Africans in Ugandan Urban Life, 1959–1972" (PhD diss., University of Michigan, 2016).

28 David Ludden, "The Tragedy of the Nation: History and the Rohingya Crisis" published as "Perilous Homelands: The Rohingya Crisis and the Violence of National Territory," *Daily Star*, Apr. 1, 2019, https:// www.thedailystar.net/in-focus/news/perilous-homelands-1722988.

29 Ludden, "Perilous Homelands."

30 Iftikhar Dadi, "Frayed Geographies and Fractured Selves: Shilpa Gutpa's *Untitled* (2014–15)," in *My East Is Your West: Collateral Event Venice Biennale 2015* (Venice: Gujral Foundation, 2015), 70–75, http://shilpagupta.com/web/about/bibio/2016/id.htm.

31 David Ludden, "Presidential Address: Maps in the Mind and the Mobility of Asia," *Journal of Asian Studies* 62, no. 4 (Nov. 2003): 1057–78.

Wangechi Mutu

(b. 1972) was born in Nairobi and trained at Yale (MFA sculpture, 2000). In her paintings, collages, films, performances, and sculptures she dissects, reconstitutes, and recontextualizes images to construct new ways of looking at what we have already seen, or highlights what we have never actually perceived. Her work has been the subject of numerous solo shows, including *Wangechi Mutu: A Fantastic Journey* (2013–14) and exhibitions at Museum of Contemporary Art, Sydney; Musée d'art contemporain de Montréal; Deutsche Guggenheim, Berlin; Art Gallery of Ontario, Toronto; and Museum of Contemporary Art San Diego, among others. Mutu is the recipient of many awards and her work was included in the 2019 Whitney Biennial and the Metropolitan Museum of Art's façade exhibition *Wangechi Mutu: The NewOnes, will free Us* (2019–20).

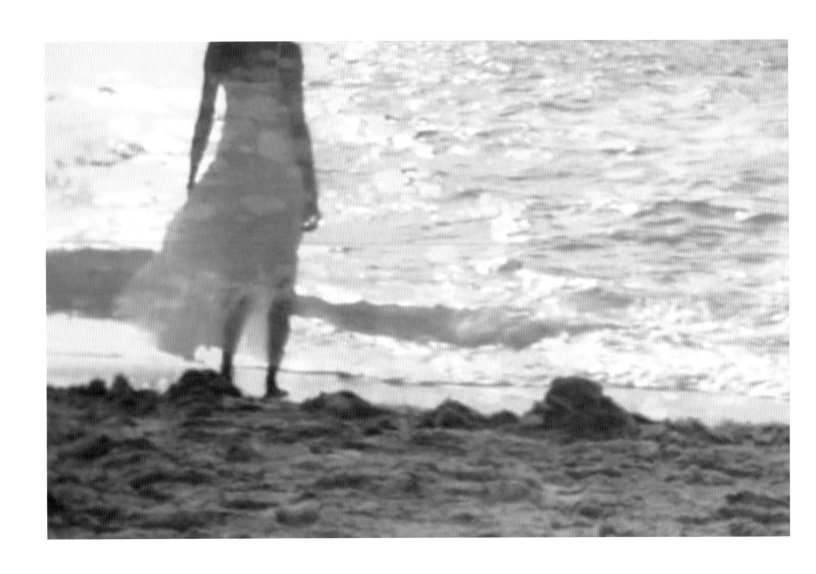

Amazing Grace, 2005
digital video, 7:06 (video still)

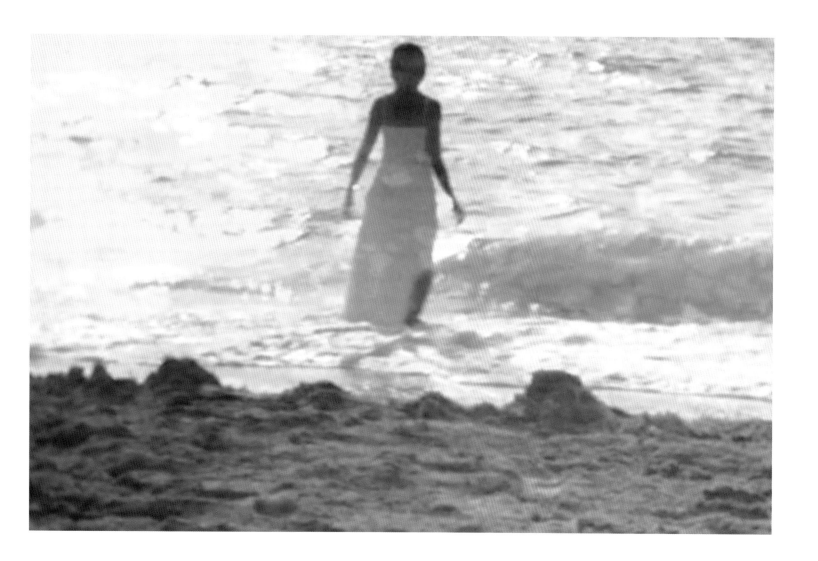

Amazing Grace, 2005
digital video, 7:06 (video still)

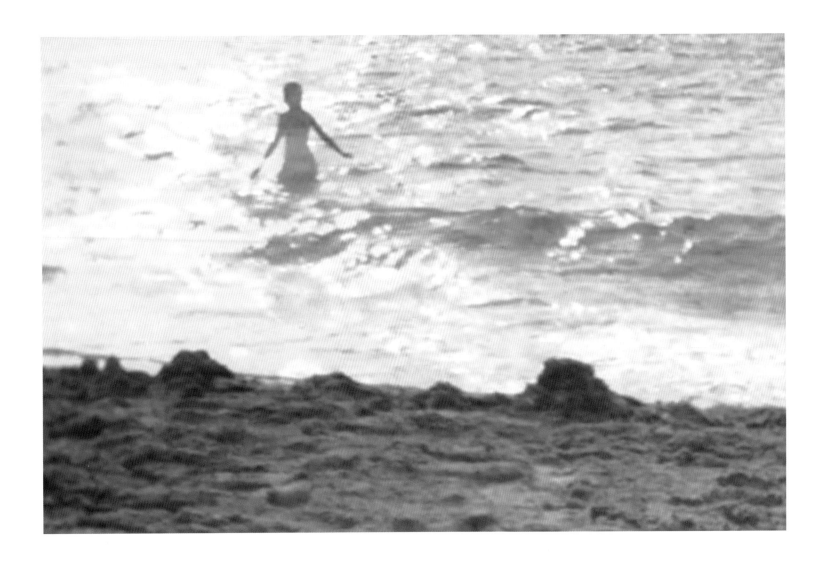

Amazing Grace, 2005
digital video, 7:06 (video still)

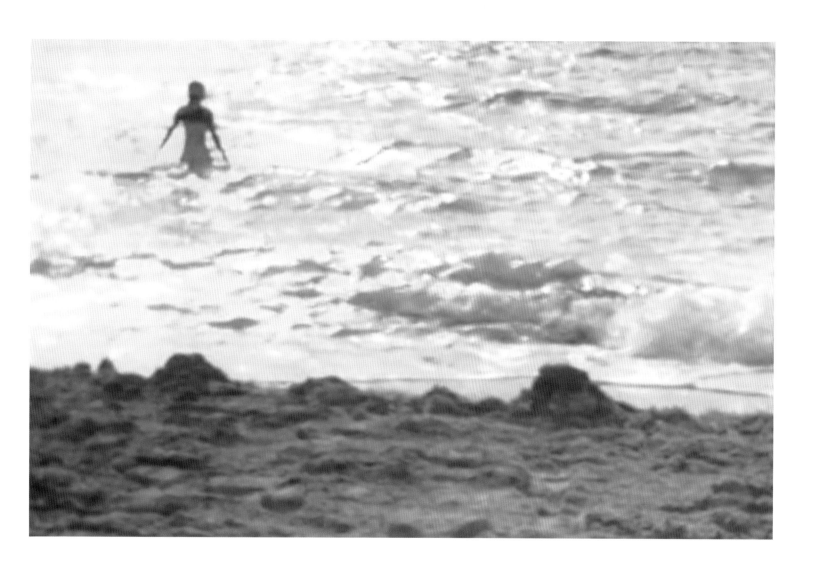

Amazing Grace, 2005
digital video, 7:06 (video still)

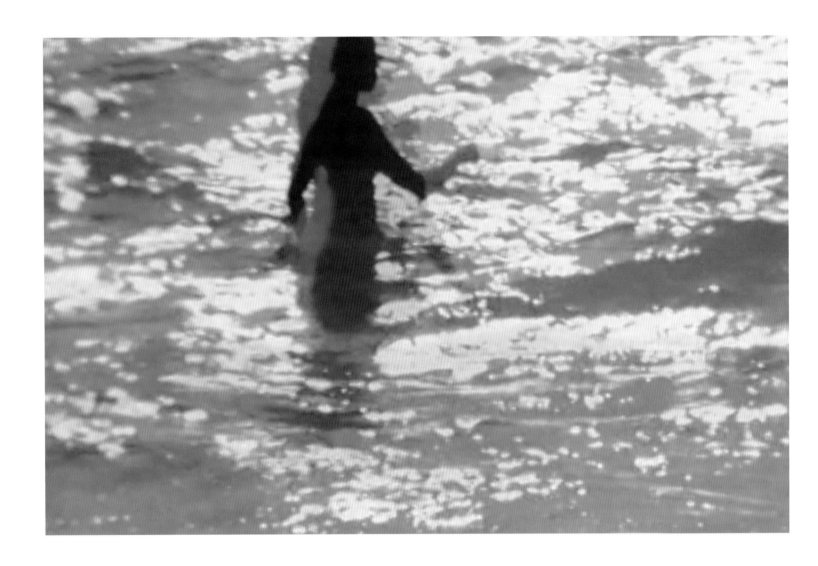

Amazing Grace, 2005
digital video, 7:06 (video still)

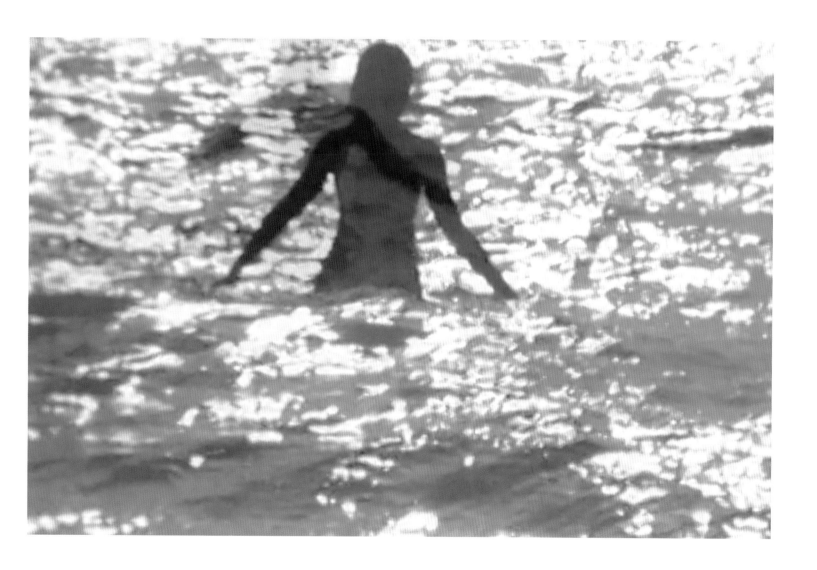

Amazing Grace, 2005
digital video, 7:06 (video still)

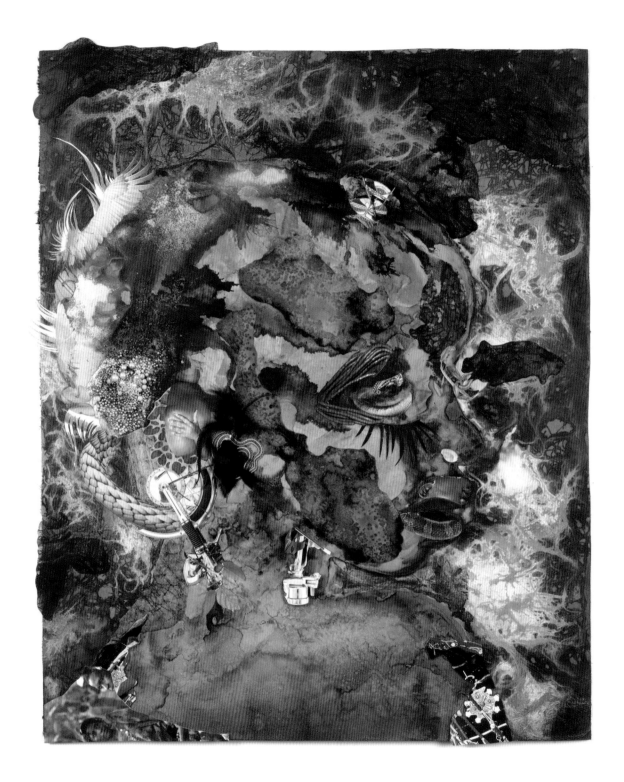

I'm too Misty, 2015
collage painting on linoleum, 40 x 33 in.

The Indian Ocean after 1945

Bérénice Guyot-Réchard

An ocean crowded with warships. An unsuspecting fish pierced by a harpoon. A submarine slinking off the coastline. Explosions shaking the earth. The images Penny Siopis uses in *She Breathes Water* (104–9) generate unease, unsettling our image of the Indian Ocean as a tropical Eden—a paradise that is, as such, out of time.

The chasm between Siopis's film and the popular imagination reveals the need to understand the historical junctures, breaks, and ripples that have fashioned the region. Like many of the works in *Indian Ocean Current: Six Artistic Narratives*, these images speak of conflict and destruction, of extraction and exploitation, and, above all, of constant motion. Since 1945, maritime environments have been the setting for imperial designs, dreams of postcolonial solidarity, the assertions of nation-states, efforts to control the movement of people, the transport of goods in the biggest ships ever seen, and the extraction of the sea's bounty. The Indian Ocean as we know it is the result of the interaction between human aspirations and its watery realms. And of the myriad forms of violence that often accompany the human thirst for power.

Life and Death of the British Lake

The contemporary Indian Ocean has been shaped by global conflict. In the early twentieth century the region was a colonial sea, its rim and sea-lanes dominated by the British Empire and, in places, by the Dutch, the French, and the Portuguese. Japan's conquest of Southeast Asia in 1940–42 ripped apart these structures of dominance. With Singapore, the Sunda Straits, and the Andaman Islands under its control, Tokyo held the keys to the "British Lake." For the next four years, Japan challenged the Allies for dominance of the Indian Ocean's ports, islands, and routes—all vital cogs for the war effort.[1]

After Japan's defeat in 1945, European powers were poised to resume their political positions across the Indian Ocean. The British Empire was resurgent, while France and the Netherlands were set on the reconquest of Indochina and the Dutch East Indies. Yet the military debacle of World War II had taken a huge psychological and political toll and tarnished the prestige of Europeans. War and Japanese occupation had electrified anticolonial nationalist and communist movements from India to Malaysia. As global conflict gave way to decolonization, the Indian Ocean's political map morphed from a congeries of imperial networks and dependencies into a jigsaw of independent states.[2]

The end of colonial rule in the Indian Ocean was, no matter the ruling power, a protracted and heterogeneous phenomenon. Decolonization's momentum and shape were neither predetermined nor unidirectional. Several decades separate India and Pakistan's independence in 1947 from that of Mozambique, Djibouti, and the Seychelles in the late 1970s, not to speak of Brunei in 1984. In some cases, as in Ceylon and French India, there were peaceful constitutional transitions. Others, such as Kenya's, Vietnam's, and Indonesia's, came on the backs of violent anticolonial struggles, often many years in the running. In places like the Indian subcontinent, Singapore, and Malaysia, or the Comoros, independence meant partitions and separations. The success of anti-imperial nationalisms should not obscure the existence of "loyalist" forces either.[3] In this and many other ways, freedom had its fair share of ambiguities.

Nor did decolonization mean the end of the European presence in the Indian Ocean. France successfully kept a sovereign foothold in the southwest, using La Réunion and Mayotte to legitimize itself as a hybrid presence, at once indigenous and external to the region.[4] The British Empire did not abandon its ambitions in the Indian Ocean either. Initially, it re-centered its old Indian core to places like East Africa and Malaya and rebuilt its Singapore and Hong Kong fortresses. When transfers of power could not be avoided, it cast old ties afresh, modernizing the Commonwealth. London deployed technological,

strategic, and economic expertise or arms sales as levers of influence. It also did some administrative reshuffling, like that which wrested control of the Persian Gulf's micro-states from Delhi in the waning days of British India. As the maintenance of territorial dominions became increasingly unrealistic, Britain focused on securing a network of bases in coastal and island states, from which it could project military power when needed.[5] Some of its plans, in Balochistan and the Andaman and Nicobar Islands for instance, came to nothing. But it did manage to hold on to Trincomalee in Ceylon, the Indian Ocean's preeminent naval base and one of the world's finest natural harbors (fig. 1). This, among other factors, ensured the Royal

1. Commonwealth navies training in Trincomalee Harbor, Apr. 1952 (Imperial War Museums, Admiralty Official Collection, A 32103).

2. Performing postcolonial solidarity. The Bandung Conference in action, Apr. 1955 (National Archives of the Republic of Indonesia, 550420 FP 31).

Navy's continued importance in the Indian Ocean.[6]

This postwar British position was vulnerable to the changing political climate in the Indian Ocean. After a left-wing government came to power in Ceylon in 1956, London abandoned Trincomalee. A decade later, it announced its goal to withdraw "east of Suez," accepting a reduced role as a regional power rather than an Indian Ocean or global one. The retreat was never total, even after the return of Hong Kong to China in 1997. Yet London's acceptance of the new order showed that the British Lake's demise had really taken place.[7]

The Postcolonial Sea

The end of European supremacy coincided with the Cold War and the rise of solidarity movements among newly independent states of the Indian Ocean and beyond. Historians now believe that the Cold War was much more than a European and North American affair structured around Great Power blocs and nuclear deterrence. It was a global conflict, an ideological clash between mutually exclusive visions of modernity fought over swaths of the planet that, as they emerged from colonization, were debating what societies to build out of its ashes. All around the Indian Ocean rim, the Soviet Union and the United States vied for influence with development aid, technological assistance, educational and scientific exchanges, and counter-insurgency training and arms sales. This Cold War was waged on the economic front and through cultural diplomacy as much as through arms.[8]

Decolonization had its own momentum, however. In 1955, Sukarno of Indonesia invited leaders from twenty-nine Asian, Arab, and African nations to Bandung, a city that had once epitomized the genteel façade of Dutch colonialism. Statesmen famous for their contributions to the global movement for decolonization were there—Nasser from Egypt, Nehru from India, Zhou Enlai from China—alongside representatives from countries still under

colonial rule, like the Gold Coast (Ghana) (fig. 2). The significance of the event did not escape contemporaries. A new world was being willed into being at Bandung. A world where African, Arab, and Asian nations long denied self-determination and a voice in international affairs would now speak out, freely and collectively.[9]

Bandung was only the most publicized of dozens of initiatives that strove to transform the international order in the name of anti-imperialism, anti-racism, and non-alignment.[10] Afro-Asianism was one of them, and it energized far more than statesmen and freedom fighters. From western Africa to Melanesia, from Arabia to China, intellectuals, artists, and activists for racial and gender equality came together under the banner of Afro-Asianism and formed professional associations, organized conferences, and published tracts on the issues of the day. Trade unionists mobilized across borders; the Afro-Asian Writers' Bureau re-imagined world literature, rejecting Eurocentrism; lawyers traveled the world to defend human rights; the Afro-Asian Journalists' Association pushed for the collaborative production of news.[11] The geographical center of much of this solidarity was the Indian Ocean.

From the late 1960s, decolonization and the Cold War conspired to give the Indian Ocean a key role in postcolonial struggles. The superpowers' naval presence in its waters was growing. Nuclear submarines sporting US and Soviet colors cruised its underwater highways. Warships increasingly visited its ports. Washington looked to build bases at choke points like the tip of South Africa, and Moscow eyed similar installations in the Horn of Africa.[12]

Seeing the ocean that lapped their coastlines turn into a Cold War theater elicited strong reactions in the nations that ringed it. (It also raised the possibility of the South African regime, now pursuing apartheid, being further propped up by its Western allies.) Anglo-American indifference to these concerns was demonstrated before Mauritius's independence in 1968.

London removed an archipelago north of it, the Chagos, from the island-state's control, expelled local inhabitants, and signed an agreement with Washington for a major base on the Chagos island of Diego Garcia (fig. 3). Chunks of the Seychelles were thrown in as well. This was a denial of postcolonial sovereignty and self-determination—one that would enable the US to build, with British help, a strong military presence right in the heart of the Indian Ocean.[13]

The Indian Ocean became a front line of Afro-Asian activism. Following Sri Lanka (Ceylon's new name), the group began advocating for an Indian Ocean "zone of peace." In 1971–72, Afro-Asian nations won an ad hoc UN committee to look into the demilitarization of the ocean, part of a series of initiatives aimed to safeguard different regions of the world from superpower competition and the threat of nuclear war. Maritime spaces were at the center of these efforts, and for good reason. As the cartoon "One Wave Higher Than the Last" suggests (fig. 4), the sea had long been central to the project of European imperialism, perhaps nowhere more so than in the British Lake.[14]

Pragmatic considerations lay behind the Indian Ocean zone of peace. The proposal came at a time of growing turmoil among Afro-Asian nations. There were rivalries among some of its members, such as between India and China, and imbalances of power between large and small countries. Moreover, the group overlapped awkwardly with the Non-Aligned Movement's ambition to trace a third course away from the logic of Cold War blocs. Afro-Asian countries were not all partisans of non-alignment. Some paid lip service to it, others actively rejected it and pursued formal alliances with the Soviet or American camps. Most had idiosyncratic and contingent interpretations of it. These tensions and contradictions between the two major strands of postcolonial solidarity magnified in the 1970s and 1980s, fraying unity among the countries that formed the bulk of the Indian Ocean rim.

As a consequence, there was no agreement on what an Indian Ocean peace zone would look like, or indeed why it was being demanded. Official support often masked deep ambivalences. The new Association of Southeast Asian Nations (ASEAN) thought that the power vacuum that would stem from a zone of peace would be more destabilizing than a low-level balance of power. India hesitated for other reasons. The peace zone could re-affirm its leadership of the Afro-Asian and non-aligned movements and secure its oceanic backyard. Yet Delhi also needed a US presence to deter China and it did not want to see its expanding navy hamstrung by demilitarization. But for neighboring countries like Sri Lanka, Indian hegemony was no more appealing than that of more distant nations.[15]

In other words, the Indian Ocean zone of peace proposal was attractive because it offered a glue of solidarity among a group struggling to retain it. It died a slow and silent death, swept away alongside Soviet-US competition by the end of the Cold War in the 1990s. But it arguably kept alive some consciousness of the Indian Ocean as a space of common dreams for the countries surrounding it.

Who Moves, Who Belongs

The biggest obstacle to these dreams came from internal forces. The borders erected in the Indian Ocean had an exclusionary logic that, for those on the receiving end, could be a devastating form of violence. While engagement across borders and collective action flourished among intellectual elites, on a more plebeian level it was another story. The 1940s to the 1970s saw a breakdown, or at least a redirection, of ties that had bound together different shores of the ocean. Afro-Asian ideals were being undercut by one of the key things they were meant to forge: strong, assertive postcolonial states.

In *Madagascar* (28) and *Ma Coeur 2* (27), Shiraz Bayjoo encases Madagascar and La Réunion in heavy gold frames. These frames simultaneously imprison

and protect. They enclose the land while shielding it from external threats. The turquoise encircling the islands echoes that of a lagoon, a chunk of sea more connected to land than to the open ocean. Indeed, decolonization generalized the notion that the state should be strong, hold exclusive authority over a well-defined, rooted group of people, and do all this within a bounded territory—in short, the territorial state. The inside and the outside, the foreign and the domestic, were

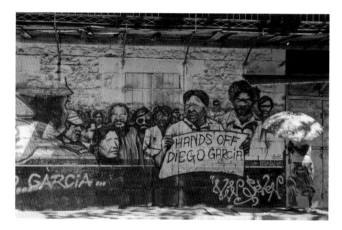

3. "Hands Off Diego Garcia," Mahébourg, Mauritius, Aug. 19, 2013 (Kim Sanghera/Flickr).

4. Miao Ti, "One Wave Higher Than the Last" (*Peking Review* 9, no. 4 [Jan. 21, 1966]).

meant to be neatly separated, telling Us from Them.[16]

This social and political ideal has seldom existed, yet it was now to be established within the bounds of former colonies. For the diverse societies around the Indian Ocean, shaped by millennia of exchange, interaction, and mixing, this proved a challenging and restrictive

5. Ugandan Asians expelled by Idi Amin Dada arrive at Stansted Airport, Sept. 18, 1972 (Getty Images).

model of politics and society. The rise of nationalism had already led to restrictions on migration in different Indian Ocean colonies in the 1930s. With independence, borders hardened even further. As colonial subjecthood gave way to postcolonial citizenship, who belonged and who did not—and policing this—became a fault line that divided the Indian Ocean world.

Passports were a visible symbol of this narrowing. So were the citizenship laws that accompanied them. Treaties and border checks enshrined the dividing lines between and within former empires as national borders, further differentiating citizens from outsiders. Migration routes were curtailed. In contrast to the mass circulation of people around the Indian Ocean in the late nineteenth and early twentieth centuries, the scale of migration plummeted. Communities whose sense of belonging rested on cross-oceanic ties saw the networks that sustained them reconfigured and dismantled. People con-

tinued to move, but now that movement largely took place within the borders of a nation-state.

Most of these new states were multi-cultural polities, yet the degree to which they acknowledged this varied. Even when countries imagined themselves pluralistically, as in Malaysia, India, or Mauritius, postcolonial citizenship was precariously perched between a focus on territory (and who resided there) and a focus on ethnicity, race, and civilization. In many places, linguistic, ethnic, or religious minorities came under pressure. People of Indian and Chinese descent faced increasing discrimination in many locales. At times rejection burst into outright violence, for example when dictatorships came to power in Burma and Indonesia in the 1960s (where pogroms echoed earlier anti-Indian and anti-Chinese riots) and in Uganda under Idi Amin Dada (1971–79, fig. 5). In Zanzibar, the merger with Tanganyika led to the massacre of Indian merchants and the Arab-speaking elite. In Sri Lanka, Sinhalese-speakers gradually marginalized the Tamil minority.[17]

For some, the tensions between citizenship's ethno-cultural and territorial logics formed a double-bind. In the decades after independence, minority groups with a diasporic or transoceanic sense of belonging were bracketed out of the nation by governments back in the "homeland."[18] At the same time, they found themselves relegated to the margins of their postcolonial homes—their aspirations disregarded, their identities negated, their agency suppressed. The new map of the Indian Ocean, as it were, was closing down on them. The tragedy of the Rohingya—Muslim inhabitants of Burma's Rakhine state, stripped of their rights, murdered, assaulted, and driven out of their homes by the army and Buddhist nationalism—is perhaps the starkest example of this.[19]

Internal conflicts broke out around the Indian Ocean, from civil wars like that in Sri Lanka (1983–2009) to all manners of independence and autonomy movements.

Some people chose to leave. East Africa's Indian communities thus dwindled rapidly after decolonization. Many went not to India (they thought it had rejected them) but to English-speaking countries. Their decision was based not just on Africanization policies in Kenya or Tanzania but also on the fact that, with the end of empire, the right of non-white people to settle in the United Kingdom would soon be restricted.[20]

Between the 1940s and the 1970s, the back-and-forth exchanges that had woven entire maritime sub-regions into being, like the Bay of Bengal, quietly disappeared. New regions appeared in the political and popular imagination. No "Southeast Asia" had existed prior to the Second World War. It first appeared on the maps of US decision-makers, aided by universities, then worked its way into the minds of educated publics. These new mental maps privileged land over sea and stressed the territorial state; the latter had the good grace to stop where another one started. Cold War imperatives and local states' preoccupations combined to make this a comfortable reality for many people, but not all.

Migration flows resumed in the late twentieth century, responding to new forms of globalization and altered conditions at home. The decline of agriculture and the rise of the service industry are now major push-and-pull factors. These new migratory waves have distinct contours. Much is made of the attraction of the United States and other Western countries for highly skilled, highly educated Asian, African, or Arab migrants—including by their home countries. Intra-Indian Ocean movement is less feted but just as important. All around South and Southeast Asia, poor and low-skilled migrants travel to the oil-rich states of the Gulf to work, turning the barren coast into some of the most futuristic cities on earth. Often performed in dire conditions and without secure rights, their labor enables the survival of their families at home, and indeed of entire regional economies. Yet if the sea

had, in between host-land and home-land, mediated people's experiences before 1945, today it is the internet, wire transfers, and airplanes that do so.[21]

Of Oil and Containers

The exclusion, surveillance, and discrimination that minorities or poor migrants have often experienced since the 1940s remind us of the violence that states can visit upon people. Economic transformations have been equally Janus-faced. The Indian Ocean's historical role in international trade has not disappeared since 1945; if anything, it is now enhanced. Air travel might have spelled the end of oceanic voyages as the primary mode of passenger transport, but planes have not been able to displace the central role of ships in the global economy. Ships continue to carry 80–90% of global trade (and 60–70% of its value), and their importance is particularly great for developing economies.[22]

In the process, the shipping industry has metamorphosed. Gone are most tramp ships and small carriers that lined the docks of Durban, Bombay, and Jakarta in the 1950s. Container ships and bulk carriers have taken their place, along with chemical tankers and other specialized vessels. Some of them are so big as to defy imagination. The ULCC-class tankers that carry crude oil from the Gulf to Asia and Europe measure well over four hundred meters in length (fig. 6).

Yet the fundamental difference is not one of size but one of type, and we owe this to a very old thing: the box. In the mid-1950s, an American entrepreneur started to move cargo not in bulk but packed in standardized containers, to hasten loading and unloading and integrate shipping with land-based transport systems. From the 1960s, containerization spread. Much as the steamship before it, containers changed the rules of long-distance transport. Shipping costs, a bane for global trade, went down. Supply chains became more fluid, increasing efficiency.[23]

There were other innovations. Tankers were created for oil and coking coal, lifebloods of the postwar economy—their size increasing along with the trade itself. Specialized ships began to move things hitherto too dangerous to carry, such as chemicals. Ports had to adjust. They became increasingly mechanized, standardized, specialized, and eventually automated (with attendant pressures on dock workers). Raw materials lost their dominant position in global trade, displaced by manufactured and semi-manufactured goods. This revolution at sea and in the ports did not just accompany new and explosive forms of globalization. It made it possible.[24]

The Indian Ocean's routes and choke points became more important than ever (fig. 7). If sailing ships were in thrall to the cycles of the monsoon, today's vessels require expertly managed traffic lanes, increasing the strategic importance of zones where shipping concentrates.[25] Avoiding accidents and blockages depends on technologies that can chart a three-dimensional path above the sea floor—something Hajra Waheed's *Untitled (MAP)* echoes, with its impression of a bumpy ocean floor striated by radar soundings (152–55).

As oil came of age as the world's major source of energy, the Straits of Hormuz and the Bab-el-Mandeb filled with tankers. In the 1950s, raw materials traveled mostly in one direction and much of the shipping traffic headed to Europe and other Western nations. Toward the last decades of the century, surging economic growth elsewhere, especially in eastern Asia, gradually shifted the epicenter of the world economy. Trade among the circle of Western industrialized countries (and Japan) went from one-half of world trade in 1980 to approximately one-third in 2011.[26]

This shift owes something to twentieth-century struggles to change the rules of global transport. For much of the century, global shipping remained dominated by companies headquartered in

the West. Few countries around the Indian Ocean had their own merchant fleets. This exposed them to the vagaries of shipping rates decided in faraway places like London, where cartels set prices, often with crippling consequences for the developing economies of countries like Sri Lanka or Tanzania.[27] Ships were increasingly registered under the ownership of small

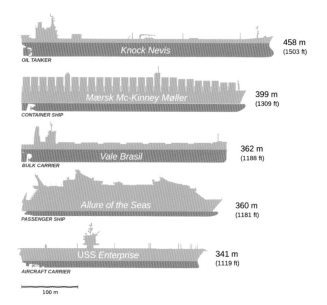

6. Sea monsters. Size comparison between five of the longest ships of their type (Delphine Ménard/Wikipedia [CC BY-SA 2.0]).

nations, but "convenience flags" scarcely hid where the true centers of power lay. Many ports serving national economies were underdeveloped, or even in the hands of former colonial rulers.

By the late 1960s, many developing countries around and beyond the Indian Ocean were campaigning for radical change. In the United Nations, the "Group of 77" used its numerical strength to advocate a New International Economic Order.[28] On the shipping front, the group used the United Nations Conference on Trade and Development (popularly known as UNCTAD) to force, from the early 1970s, the reform and regulation of the shipping cartels. Both initiatives were eventually undermined.[29] The "UNCTAD code" for shipping was at least ratified by

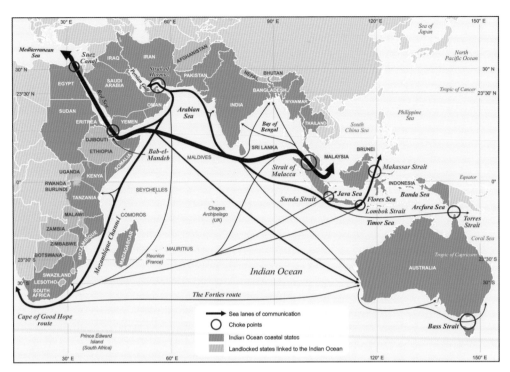

7. Maritime webs. "West-East-West SLOCs Traversing the Indian Ocean" (Denis Venter, "India and Africa: Maritime Security and India's Strategic Interests in the Western Indian Ocean," in *Fluid Networks and Hegemonic Powers in the Western Indian Ocean*, ed. Iain Walker, Manuel João Ramos, and Preben Kaarsholm [Lisbon: Centro de Estudos Internacionais, 2017], fig. 3).

many industrialized nations after 1985, and since then several countries, notably in Asia, have become major players in maritime transport. However, dreams of a New International Economic Order collapsed in the 1980s under the weight of Western pressure and growing divergences among Afro-Asian economies.

Here lay perhaps the greatest fissure in Afro-Asia or the Third World. Global economic restructuring had different meanings on different shores of the Indian Ocean. Parts of the Asian littoral have been great beneficiaries of these changes; Africa's share of the global pie, meanwhile, has decreased.[30] The interests of oil- and gas-producing states starkly diverge from those of other countries. Economic connections between the eastern and northern Indian Ocean and the Pacific are increasing. A tangible sign of this reconfiguration is the port of Singapore. The city-state leveraged its two-centuries-old position as a global nexus of trade to become the world's biggest port

in 2004, only to lose it to Shanghai shortly thereafter. We still know little about how this reconfiguration was fought for politically by the countries that once comprised the Third World. What seems clear is that the Indian Ocean's ports and lanes were part of the struggle to reform the unequal distribution of economic power across the world.

Frontiers of Sovereignty, Spaces of Extraction

This struggle was heightened by the Indian Ocean's transformation into a key frontier for state-building and resource exploitation after 1945. For the last century or so, the open sea has become the preoccupation of states and non-state actors in unprecedented ways. From the seashore to the deep sea, from the water column to the seabed, from the fish in it to the humans crossing it and the oil underneath it, the waters of the Indian Ocean have turned into a space to lay claim to, to use, to defend, to demarcate. Simply put,

humankind has never had so much to do with the sea.

Our ability to know the sea, let alone its resources, was long limited. Nineteenth-century explorations launched the idea of an unclaimed world awaiting exploitation and mastery, but they skirted the Indian Ocean. A pioneering Anglo-Egyptian expedition in the 1930s notwithstanding, the ocean's immensity remained beyond human knowledge. The region's exploration truly began after the 1950s. Technological advances such as the refinement of diving and scanning equipment and underwater film made it possible. People could go deeper and stay longer beneath the surface. With the International Indian Ocean Expedition of 1959–65, the age of expeditions began. Fourteen countries participated, from the United States, France, and Australia to rim nations like India. This fostered marine science in several Indian Ocean countries, from the subcontinent to Indonesia and Thailand. The financial and technological costs of such exploration nevertheless meant that Indian Ocean states generally struggled to take the lead.[31]

New technologies generated new ideas and possibilities for the extraction and exploitation of the ocean's bounty, just as economic growth fueled demand for it. The build-up of offshore oil platforms began, together with the mining of the seabed. Industrialized countries began to use new fishing trawlers, bigger and increasingly mechanized. Japanese boats, which had traveled far and wide across the South China Sea, Indonesian waters, and the Bay of Bengal in the 1930s and 1940s, made their return alongside other major fishing nations.[32]

Indian Ocean nations too wished to harness the resources of the waters around them; they were experiencing rapid population growth and an attendant pressure to feed people. Increasing global demand for fish also meant lucrative export markets (fig. 8). Between the 1950s and 1970s, a race for fishing grounds took place in Southeast Asian waters, Thailand

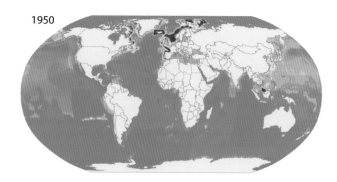

1950

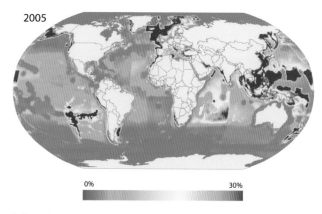

2005

0% 30%

8. Spatial expansion of the world's fisheries, 1950–2005 (Sea around Us, http://www.seaaroundus.org/spatial-expansion/).

leading the way. In India, Gujarat and the southern states of Kerala and Tamil Nadu spearheaded fisheries development. Mechanization and motorization, often enabled by both regional and international cooperation agreements for investment and technological assistance, played a role in the expansion of the fishing frontier. So did fishermen, who invested in more "traditional" boats and gear and formed active national as well as transnational associations.[33]

Unequal access to maritime resources was only one area of tension between industrialized countries and the postcolonial nations of the Indian Ocean's rim. Under the mare liberum principle, the high seas belonged to no one. They could thus be used by anyone, anyone with the capacity to do so at least. The ocean's bounty could be exhausted before local nations built their own shipping industries. Territorial waters were not of much help: they only extended to three miles at sea.

That three-mile zone was precisely the limit from which, at one time, ships could be fired upon from shore. Gunboat diplomacy had been deployed by Western powers from Madagascar to Guangzhou in colonial times, and it was no thing of the past. In 1971 the US sent an aircraft carrier within sight of Calcutta to help Pakistan against India during Bangladesh's war of independence. The "freedom of the seas" and the rest of the international maritime order largely worked in favor of the powerful, whether nations or commercial entities.

Maritime issues took center-stage internationally. From 1958, UN Conferences on the Law of the Sea (UNCLOS) took place to forge an international maritime order (fig. 9). For many Indian Ocean countries, this was an occasion to build their sovereignty at sea. In general, they pushed for the extension of territorial waters, for which twelve miles eventually became the norm. Indonesia and the Phil-ippines fought a twenty-five-year struggle to be recognized as "archipelagic states." Their territorial waters would now extend from one end of the archipelago to the other, regardless of distance.[34] In 1974, Afro-Asian nations introduced a new concept to assert sovereignty over maritime resources off their coast (without extending territorial waters, which would hinder navigation): the Exclusive Economic Zone (EEZ). The "law of the sea" signaled the will of states, not least postcolonial ones, to control and assert themselves at sea. As country after country declared layered sets of maritime zones and boundaries in the late twentieth century, the Indian Ocean became a space of sovereign ambitions.

The ocean cannot be controlled in the same way as land, however. The flag-making words of Shilpa Gupta's *Untitled (There Is No Border Here/No hay frontera aquí)* (40–41) sing of a sky that refuses to be divided and pushes back against humankind's would-be borders. Those words apply with equal force to the sea. Boundary-making at sea faces constant hurdles. In the process, new conflicts emerge. The South China Sea and the Gulf of Thailand are the objects of fierce inter-state competition, affecting bilateral relations. These

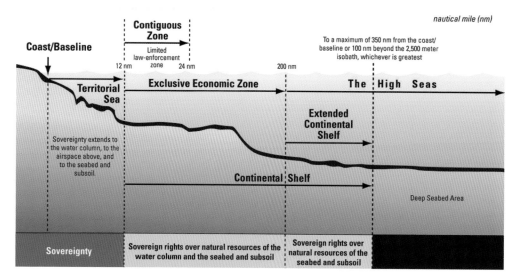

9. Slicing up the ocean. Maritime zones under UNCLOS (1982) (Charles H. Norchi, "The South China Sea Arbitration," July 28, 2016, https://mainelaw.maine.edu/faculty/south-china-sea-arbitration/maritime-zones/).

tensions have an untold human cost. Somalis take to "piracy" in order to affirm their legitimacy and find a livelihood. Burmese and Cambodian migrants are sold into slavery to work on Thai fishing boats. Elsewhere, fishermen straying beyond an invisible boundary end up jailed, tortured, and deprived of their livelihood—forgotten victims of the India-Pakistan political conflict or Thai-Indonesian resource competition.[35]

Yet the primary victim of this phenomenon is the ocean itself. Halfway between dead jellyfish and grenade-like mass of rubber, plastic, and God-knows-what, Nicholas Hlobo's grotesque *Ngumgudu nemizano* (64–65) is not the stuff of nightmare but of reality. The rich fisheries in Southeast Asian waters have been almost entirely exhausted—their sea cucumbers over-harvested, their seahorses stolen to furnish overseas aquariums, their sharks bled alive to feed the appetite for delicacies in East Asia. The rest of the Indian Ocean could soon follow. The transformation of the ocean into a resource and sovereignty frontier is harming us all.

In the 2016 installation of *Sea Shanty* in Mauritius (fig. 3, 55), Shiraz Bayjoo uses the walls of Port Louis's Fort Adelaide as a canvas on which the life of a corner of coast is projected, the sound of waves crashing in the background; amidst all this plays a song that English mariners once used when going about their work. The rhythmic rumble of the ocean overpowers the sailors' loud singing. Bayjoo makes us feel the pulsating weight of the Indian Ocean's colonial and imperial past, only to remind us that the ocean's "deep structures," as the historian Michael Pearson calls them, somehow find a way to reassert themselves.[36]

Sea Shanty (16–20) also reads as a sign of the ocean's simultaneous presence and absence in our lives. The people of the Indian Ocean seldom travel by sea anymore, regardless of their wealth. Coastal societies for whom the ocean was a way

of life are losing out to mechanized fishing or left ashore by depleted fishing grounds. Migrants taking to boats to seek refuge or simply a better life, like the Rohingya, are refused entry. The port city of old is gone. The ports are there all right, but sequestered behind barbed wire, highways, and checkpoints—cities unto themselves that few humans enter, out of sight and out of mind.

In other ways, the twenty-first century has an obsession with the ocean. Our curiosity about it has not waned since the 1950s, when *The Silent World*, an underwater documentary shot largely in the Indian Ocean and its sister seas, astonished contemporaries. The Indian Ocean's past as a connector of cultures, goods, and people is being recovered not just by historians but by private citizens, organizations, and governments. A ninth-century shipwreck of an Arab dhow that sunk while carrying all manners of Chinese luxury goods is the pride of Singapore's Marine Life Park. In 2010, a replica made the same 3,100-mile voyage from Oman.

This awareness comes with a powerful undertow of fear for the ocean's survival and thus, for our own. In this way, the uncomfortable duet between human dreams and the violence they have often unleashed since 1945—on each other, between neighboring states, and not least on the Indian Ocean itself—perhaps finds its full expression. Yet as the sea's pushback in *Sea Shanty* suggests, the ocean's very vitality also offers the possibility of hope.

Bérénice Guyot-Réchard is a historian of South Asia and the Indian Ocean and is currently senior lecturer/associate professor in contemporary international history at King's College London. Her work focuses on the legacies of decolonization on the world as we know it today, particularly in terms of international politics. She has written extensively on Sino-Indian relations and on the strategic borderlands between India, Tibet, and Burma, most notably in *Shadow States: India, China and the Himalayas, 1910–1962* (2016). She is currently working on the geopolitics of the Indian Ocean since 1945.

1 Ashley Jackson, *Of Islands, Ports and Sea Lanes: Africa and the Indian Ocean in the Second World War* (Warwick: Helion, 2018).

2 Christopher Bayly and Tim Harper, *Forgotten Wars: The End of Britain's Asian Empire* (London: Allen Lane, 2007); Rana Mitter, "Nationalism, Decolonization, Geopolitics and the Asian Post-War," in *The Cambridge History of the Second World War: Volume 3*, ed. Adam Tooze and Michael Geyer (Cambridge: CUP, 2015), 599–621; Frederick Cooper, *Africa since 1940: The Past of the Present* (Cambridge: CUP, 2002).

3 David M. Anderson and Daniel Branch, "Introduction," in "Allies at the End of Empire: Loyalists, Nationalists and the Cold War, 1945–76," ed. David M. Anderson and Daniel Branch, special issue, *International History Review* 39, no. 1 (2017): 1–13.

4 Christian Bouchard and William Crumplin, "Two Faces of France: 'France of the Indian Ocean'/'France in the Indian Ocean,'" *Journal of the Indian Ocean Region* 7, no. 2 (2011): 161–82.

5 Daniel Gorman, "Britain, India, and the United Nations: Colonialism and the Development of International Governance, 1945–1960," *Journal of Global History* 9, no. 3 (Nov. 2014): 471–90; Chris Madsen, "The Long Goodbye: British Agency in the Creation of Navies for India and Pakistan," *Journal of Imperial and Commonwealth History* 43, no. 3 (2015): 463–88; Christopher Prior, "'This Community Which Nobody Can Define': Meanings of Commonwealth in the Late 1940s and 1950s," *Journal of Imperial and Commonwealth History* 47, no. 3 (2019): 1–23; Poppy Cullen, "Operation Binnacle: British Plans for Military Intervention against a 1965 Coup in Kenya," *International History Review* 39, no. 5 (2017): 791–809.

6 Peter John Brobst, *The Future of the Great Game: Sir Olaf Caroe, India's Independence, and the Defense of Asia* (Akron: University of Akron Press, 2005); Ashley Jackson, "The Royal Navy and the Indian Ocean Region since 1945," *RUSI Journal* 151, no. 6 (2006): 78–82.

7 Saki Dockrill, *Britain's Retreat from East of Suez: The Choice between Europe and the World?* (London: Palgrave, 2002); P. L. Pham, *Ending*

"East of Suez": The British Decision to Withdraw from Malaysia and Singapore, 1964–1968 (Oxford: OUP, 2010).

8 Odd Arne Westad, *The Global Cold War: Third World Interventions and the Making of Our Times* (Cambridge: CUP, 2005); Vijay Prashad, *The Darker Nations: A People's History of the Third World* (New York: New Press, 2007).

9 Christopher J. Lee, ed., *Making a World after Empire: The Bandung Moment and Its Political Afterlives* (Athens: Ohio UP, 2010); Naoko Shimazu, "Diplomacy as Theatre: Staging the Bandung Conference of 1955," *Modern Asian Studies* 48, no. 1 (Jan. 2014): 225–52.

10 "Visualisation," Afro-Asian Networks: Transitions in the Global South, https://afroasiannetworks.com/visualisation; Su Lin Lewis and Carolien Stolte, "Introduction," in "Other Bandungs: Afro-Asian Internationalisms in the Early Cold War," ed. Su Lin Lewis and Carolien Stolte, special issue, *Journal of World History* 30, nos. 1–2 (June 2019): 1–19.

11 Afro-Asian Networks Research Collective, "Manifesto: Networks of Decolonization in Asia and Africa," *Radical History Review* 131 (May 2018): 176–82; Hong Liu and Taomo Zhou, "Introduction," in "Bandung Humanism and a New Understanding of the Global South," ed. Hong Liu and Taomo Zhou, special issue, *Critical Asian Studies* 51, no. 2 (2019): 141–43.

12 Frank Broeze, "Geostrategy and Navyports in the Indian Ocean since c. 1970," *Marine Policy* 21, no. 4 (July 1997): 345–62.

13 David Vine, *Island of Shame: The Secret History of the U.S. Military Base on Diego Garcia* (Princeton: PUP, 2009).

14 Christopher J. Lee, "The Indian Ocean during the Cold War: Thinking through a Critical Geography," *History Compass* 11, no. 7 (2013): 524–30.

15 Yogesh Joshi, "Whither Non-Alignment? Indian Ocean Zone of Peace and New Delhi's Selective Alignment with Great Powers during the Cold War, 1964–1979," *Diplomacy & Statecraft* 30, no. 1 (2019): 26–49.

16 Liisa Malkki, "National Geographic: The Rooting of Peoples and the Territorialization of National Identity among Scholars and Refugees," *Cultural Anthropology* 7, no. 1 (Feb. 1992): 24–44; John Agnew, "The Territorial Trap: The Geographical Assumptions of International Relations Theory," *Review of International Political Economy* 1, no. 1 (Spring 1994): 53–80.

17 Sunil S. Amrith, *Migration and Diaspora in Modern Asia* (Cambridge: CUP, 2011); Gijsbert Oonk, *Settled Strangers: Asian Business Elites in East Africa (1800–2000)* (Delhi: Sage, 2013).

18 Itty Abraham, *How India Became Territorial: Foreign Policy, Diaspora, Geopolitics* (Stanford: SUP, 2014).

19 Michael Charney, "The Misuses of Histories and Historiography by the State in Myanmar: The Case of Rakhine and Rohingya" (paper presented at International Conference on Protection and Accountability in Burma, Barnard College, Columbia University, Feb. 8–9, 2019).

20 Sana Aiyar, *Indians in Kenya: The Politics of Diaspora* (Cambridge: Harvard UP, 2015).

21 Jeremy Prestholdt, "Locating the Indian Ocean: Notes on the Postcolonial Reconstitution of Space," *Journal of Eastern African Studies* 9, no. 3 (Oct. 2015): 440–67.

22 United Nations Conference on Trade and Development (UNCTAD), *50 Years of Review of Maritime Transport, 1968–2018: Reflecting on the Past, Exploring the Future* (New York: United Nations Publications, 2018), 4.

23 Marc Levinson, *The Box: How the Shipping Container Made the World Smaller and the World Economy Bigger* (Princeton: PUP, 2008).

24 Espen Ekberg, Even Lange, and Andreas Nybø, "Maritime Entrepreneurs and Policy-Makers: A Historical Approach to Contemporary Economic Globalization," *Journal of Global History* 10, no. 1 (Mar. 2015): 171–93.

25 Kimberley Peters, "Deep Routeing and the Making of 'Maritime Motorways': Beyond Surficial Geographies of Connection for Governing Global Shipping," *Geopolitics* (2019): 1–22.

26 UNCTAD, *Maritime Transport*, 8–9.

27 Michael B. Miller, *Europe and the Maritime World: A Twentieth-Century History* (Cambridge: CUP, 2012).

28 Nils Gilman, "The New International Economic Order: A Reintroduction," *Humanity: An International Journal of Human Rights, Humanitarianism, and Development* 6, no. 1 (Spring 2015): 1–16.

29 Ekberg, Lange, and Nybø, "Maritime Entrepreneurs."

30 UNCTAD, *Maritime Transport*, 8–9.

31 Helen M. Rozwadowski, *Fathoming the Ocean: The Discovery and Exploration of the Deep Sea* (Cambridge: Belknap Press of Harvard UP, 2008); A. A. Aleem and S. A. Morcos, *The John Murray/MABA-HISS Expedition versus the International Indian Ocean Expedition in Retrospect* (Paris: UNESCO Reports in Marine Science, 1985), 31.

32 William M. Tsutsui, "The Pelagic Empire: Reconsidering Japanese Expansion," in *Japan at Nature's Edge: The Environmental Context of a Global Power*, ed. Ian Jared Miller, Julia Adeney Thomas, and Brett L. Walker (Honolulu: University of Hawaii Press, 2013), 21–38.

33 John G. Butcher, *The Closing of the Frontier: A History of the Marine Fisheries of Southeast Asia, c. 1850–2000* (Singapore: Institute of Southeast Asian Studies, 2004); Subir Sinha, "Transnationality and the Indian Fishworkers' Movement, 1960s–2000," *Journal of Agrarian Change* 12, nos. 2–3 (Apr. and July 2012): 364–89.

34 John G. Butcher and R. E. Elson, *Sovereignty and the Sea: How Indonesia Became an Archipelagic State* (Singapore: National University of Singapore Press, 2017).

35 Ted L. McDorman, "International Fishery Relations in the Gulf of Thailand," *Contemporary Southeast Asia* 12, no. 1 (June 1990): 40–54; Charu Gupta and Mukul Sharma, "Blurred Borders: Coastal Conflicts between India and Pakistan," *Economic and Political Weekly* 39, no. 27 (2004): 3005–15; Kate Hodal and Chris Kelly, "Trafficked into Slavery on Thai Trawlers to Catch Food for Prawns," *Guardian*, June 10, 2014, https://www.theguardian.com/global-development/2014/jun/10/-sp-migrant-workers-new-life-enslaved-thai-fishing; Jatin Dua, *Captured at Sea: Piracy and Protection in the Indian Ocean* (Berkeley: University of California Press, 2019).

36 Michael Pearson, *The Indian Ocean* (London: Routledge, 2008).

Penny Siopis

(b. 1953) lives in Cape Town where she is honorary professor at the University of Cape Town. She works in painting, installation, and film/video. Key solo exhibitions include her survey shows *This Is a True Story: Six Films (1997–2017)*, Zeitz Museum of Contemporary Art Africa, Cape Town (2018); *Penny Siopis: Films*, Erg Gallerie, Brussels (2016); *Time and Again: A Retrospective Exhibition*, South African National Gallery, Cape Town and Wits Art Museum, Johannesburg (2014–15); and *Three Essays on Shame*, Freud Museum, London (2005). She has participated in the Prospect New Orleans triennial and the biennials of Gwangju, Havana, Johannesburg, Sydney, Taipei, and Venice.

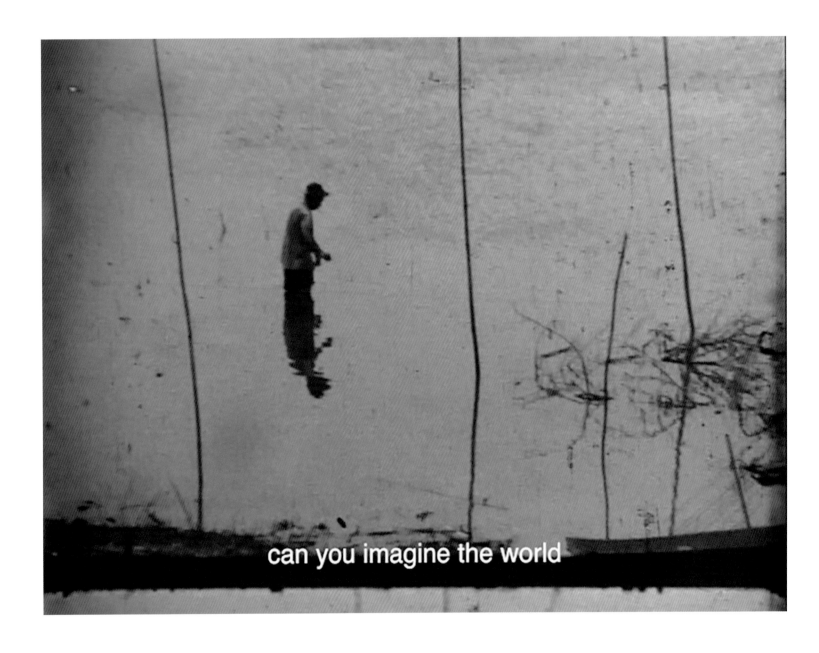

She Breathes Water, 2019
digital video, 5:12 (video still)

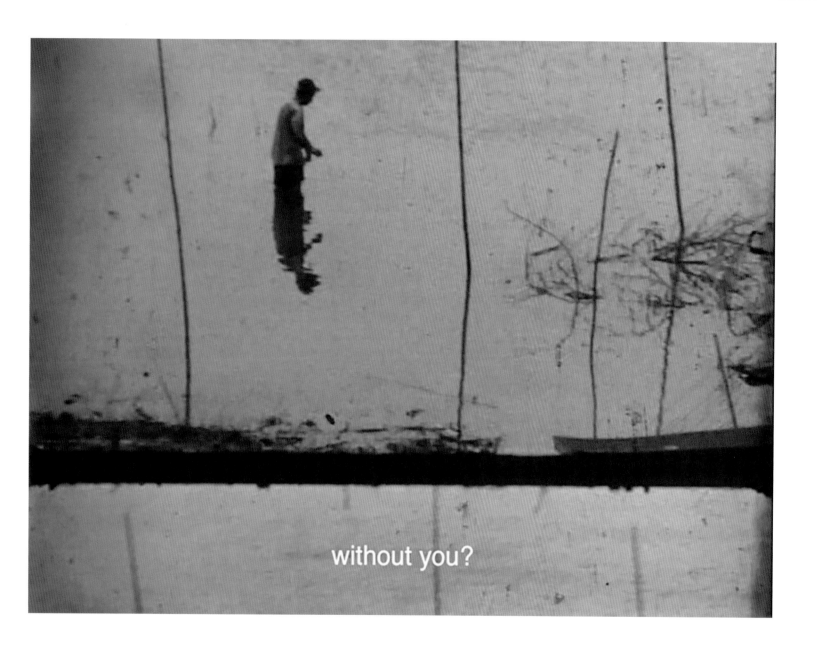

without you?

She Breathes Water, 2019
digital video, 5:12 (video still)

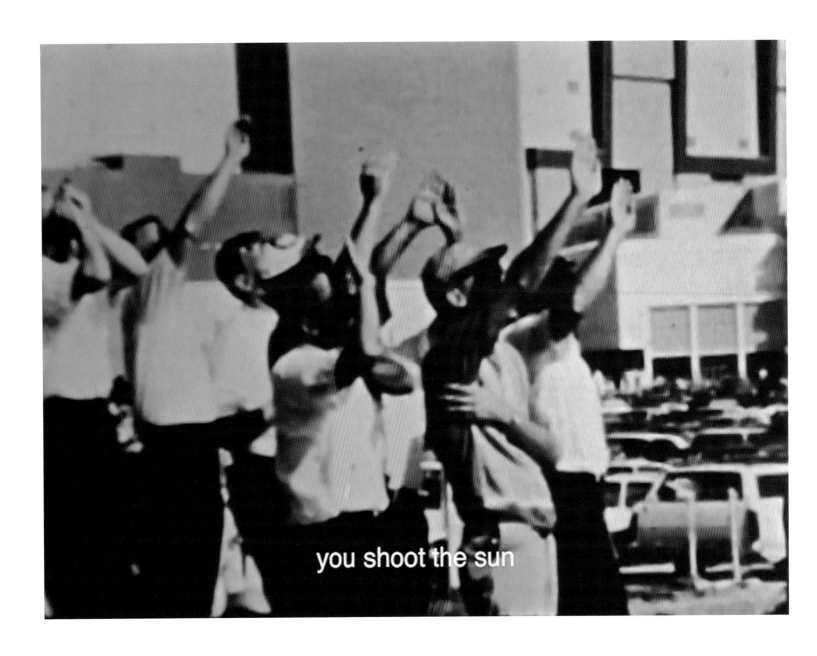

you shoot the sun

She Breathes Water, 2019
digital video, 5:12 (video still)

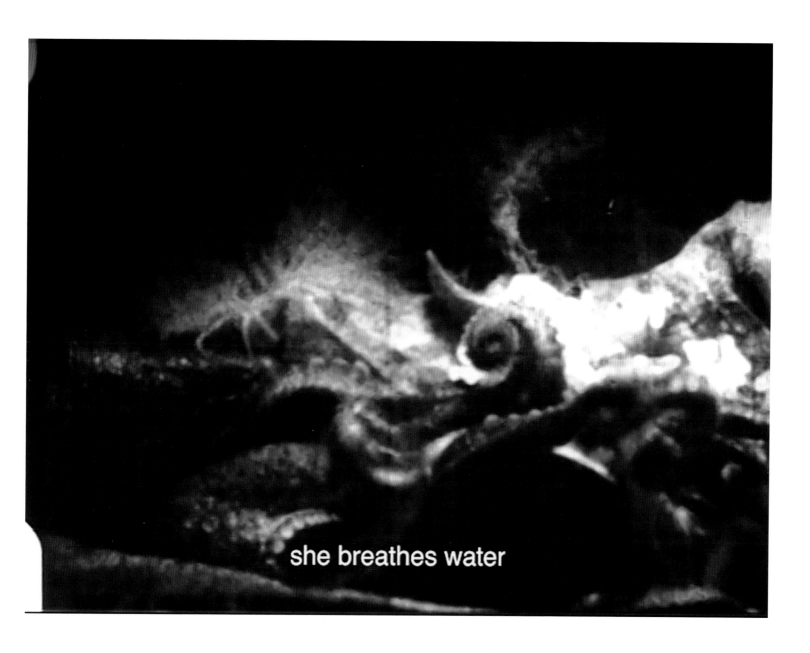

she breathes water

She Breathes Water, 2019
digital video, 5:12 (video still)

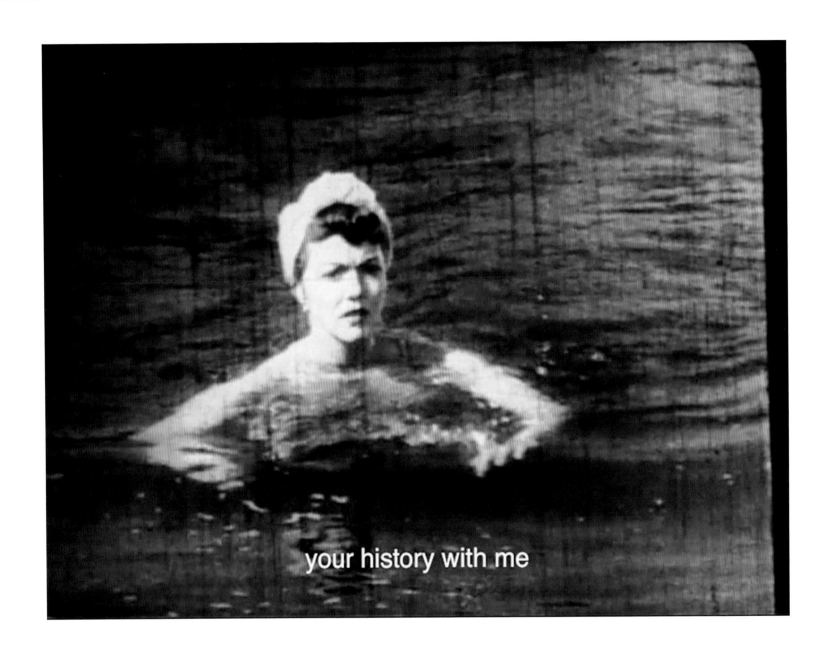

your history with me

She Breathes Water, 2019
digital video, 5:12 (video still)

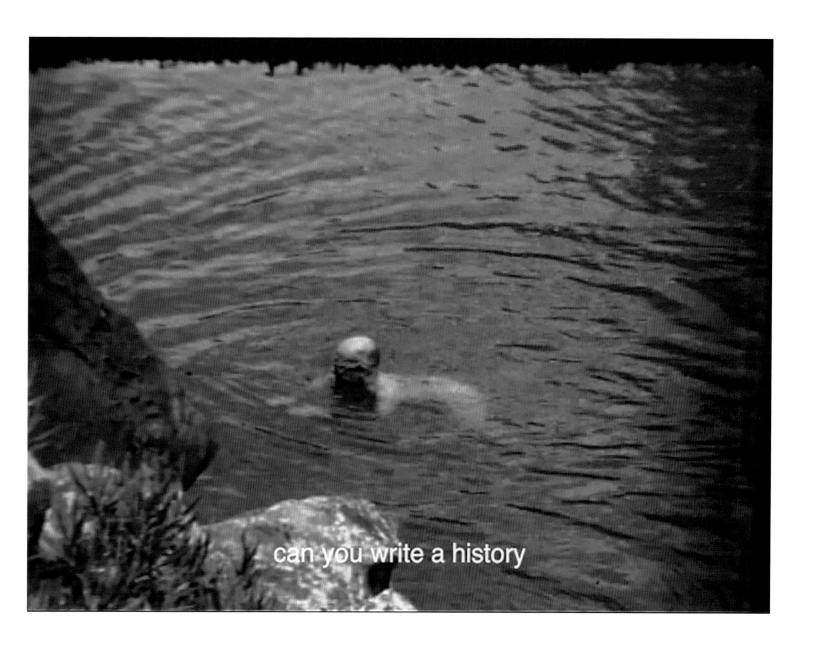

She Breathes Water, 2019
digital video, 5:12 (video still)

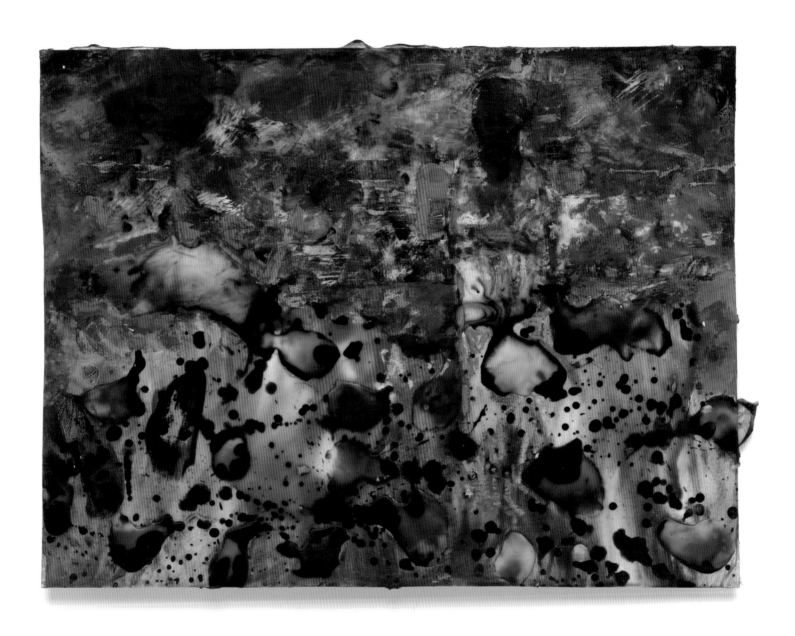

Warm Waters [3], 2018—19
glue, ink, and oil on paper, 9.1 x 11.8 in.

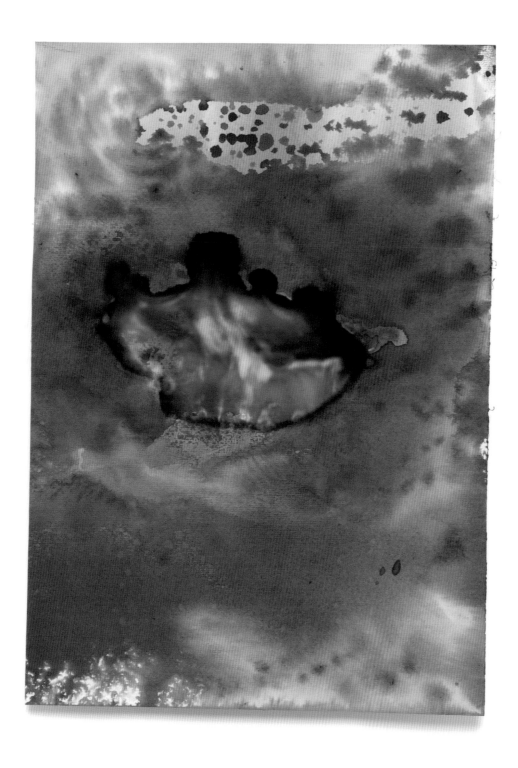

Warm Waters [5], 2018–19
glue, ink, and oil on paper, 12.2 x 8.7 in.

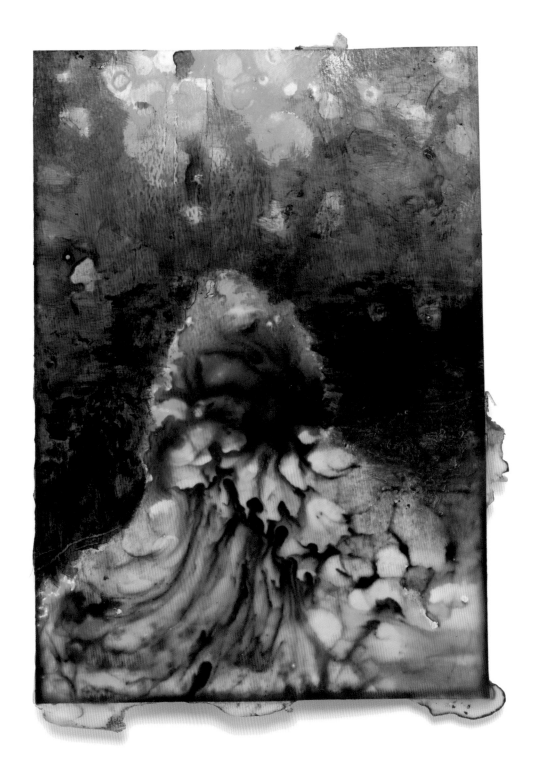

Warm Waters [7], 2018–19
glue, ink, and oil on paper, 11.6 x 8.3 in.

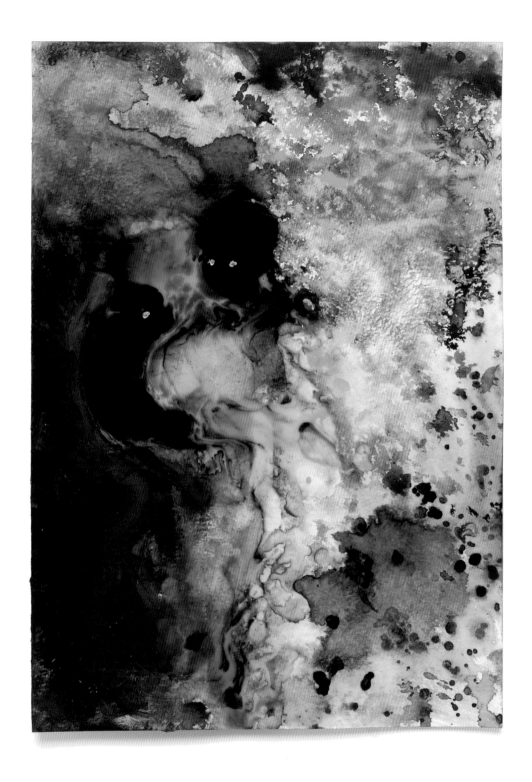

Warm Waters [8], 2018–19
glue, ink, and oil on paper, 13.2 x 9.3 in.

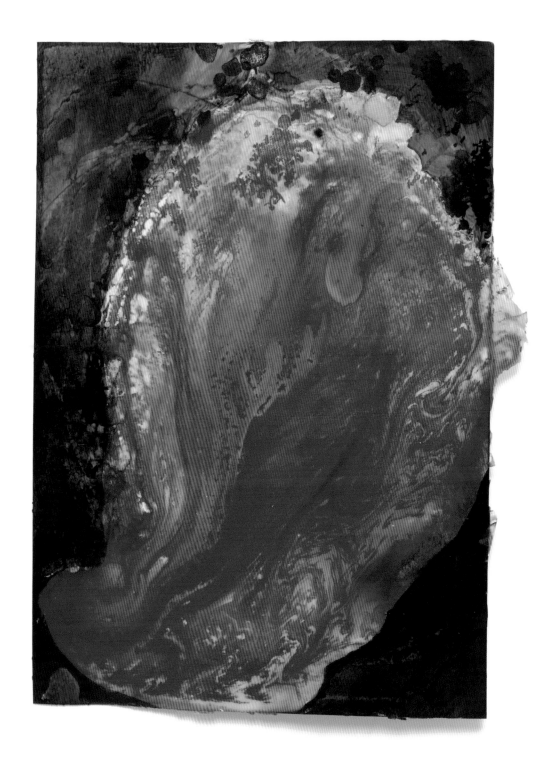

Warm Waters [9], 2018–19
glue, ink, and oil on paper, 11.6 x 8.3 in.

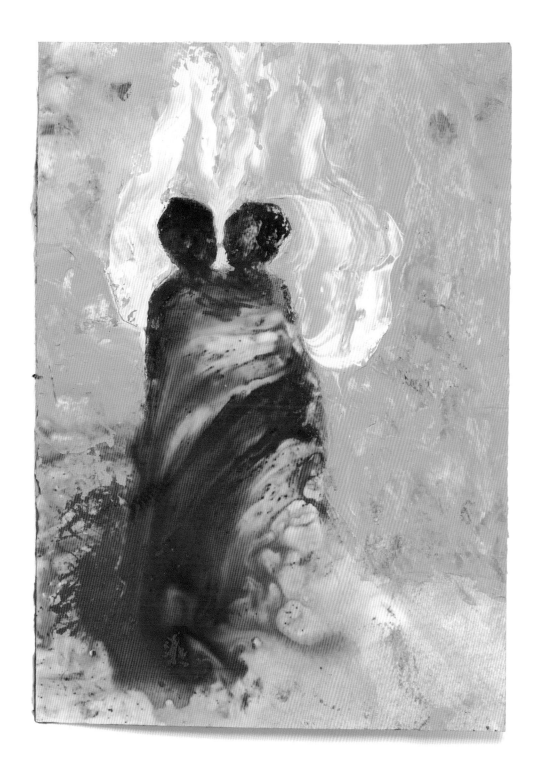

Warm Waters [11], 2018–19
glue, ink, and oil on paper, 11.6 x 8.3 in.

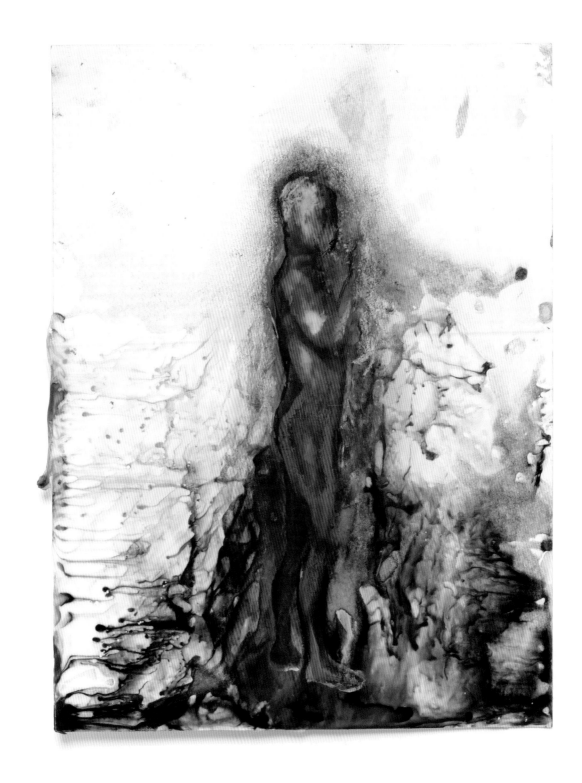

Warm Waters [17], 2018—19
glue, ink, and oil on paper, 11.8 x 8.9 in.

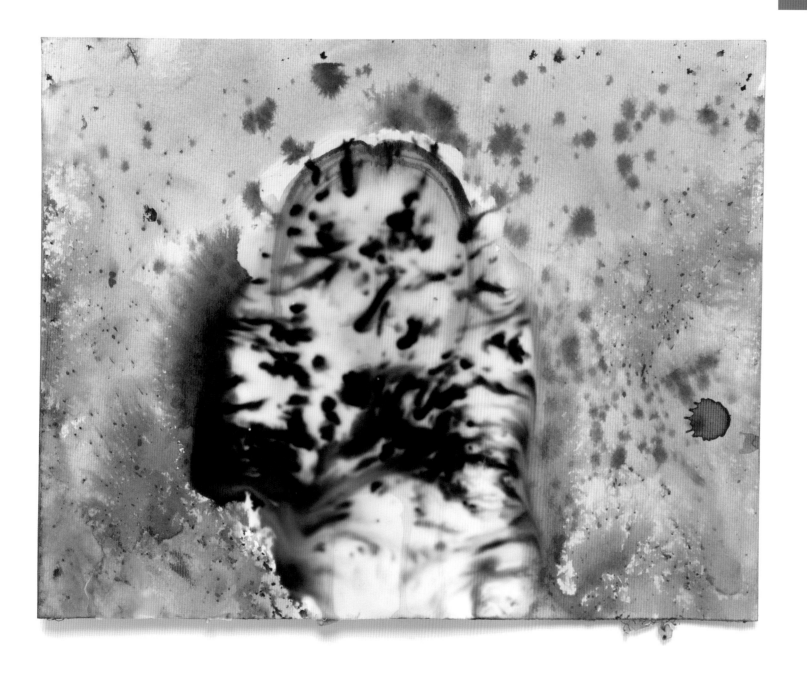

Warm Waters [18], 2018–19
glue, ink, and oil on paper, 9.4 x 12 in.

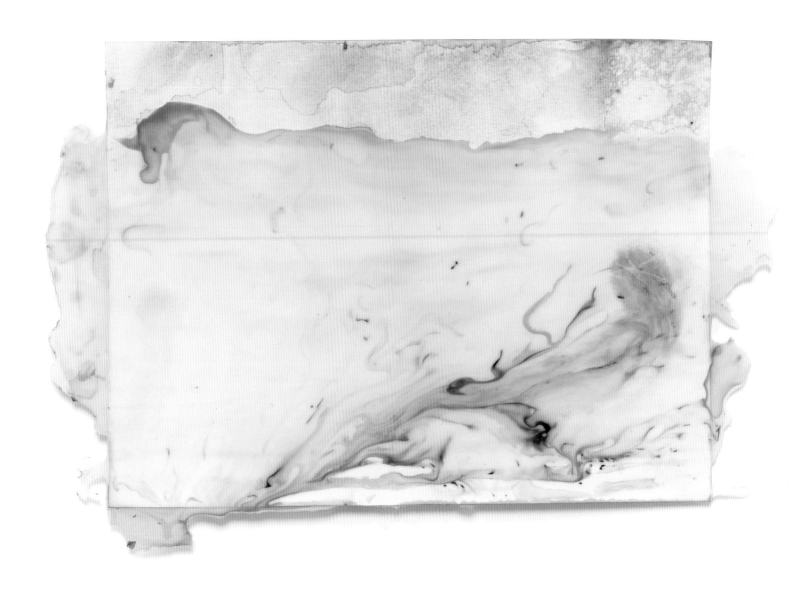

Warm Waters [20], 2018—19
glue, ink, and oil on paper, 8.9 x 11.8 in.

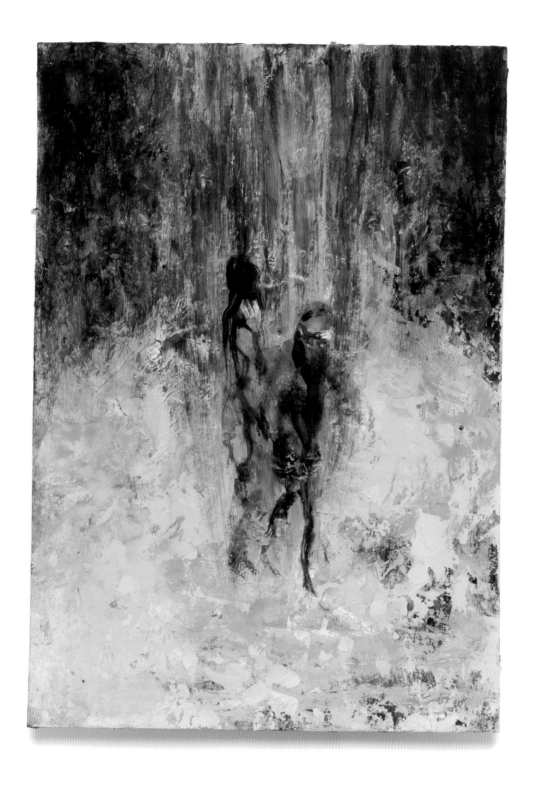

Warm Waters [24], 2018–19
glue, ink, and oil on paper, 11.6 x 8.5 in.

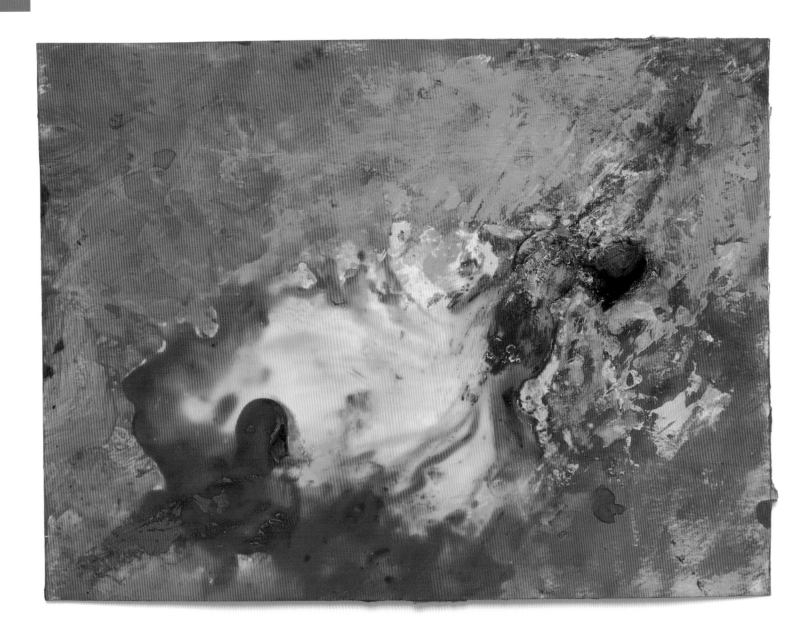

Warm Waters [27], 2018—19
glue, ink, and oil on paper, 9.1 x 11.8 in.

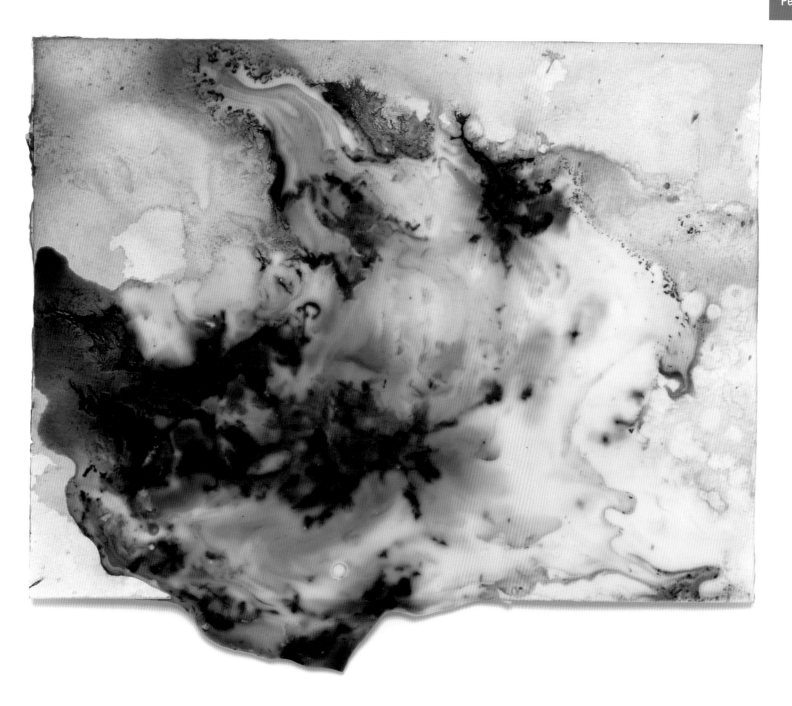

Warm Waters [28], 2018–19
glue, ink, and oil on paper, 9.1 x 11.8 in.

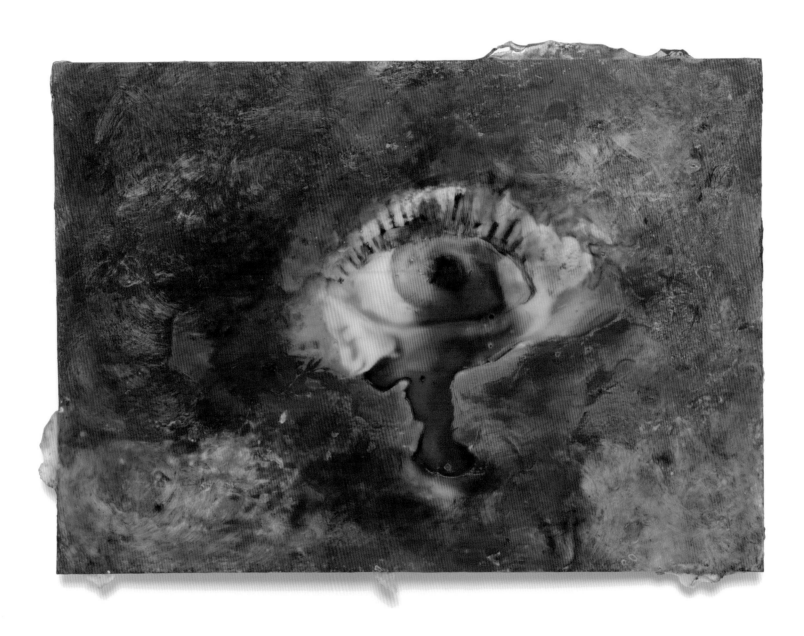

Warm Waters [29], 2018—19
glue, ink, and oil on paper, 8.3 x 11.4 in.

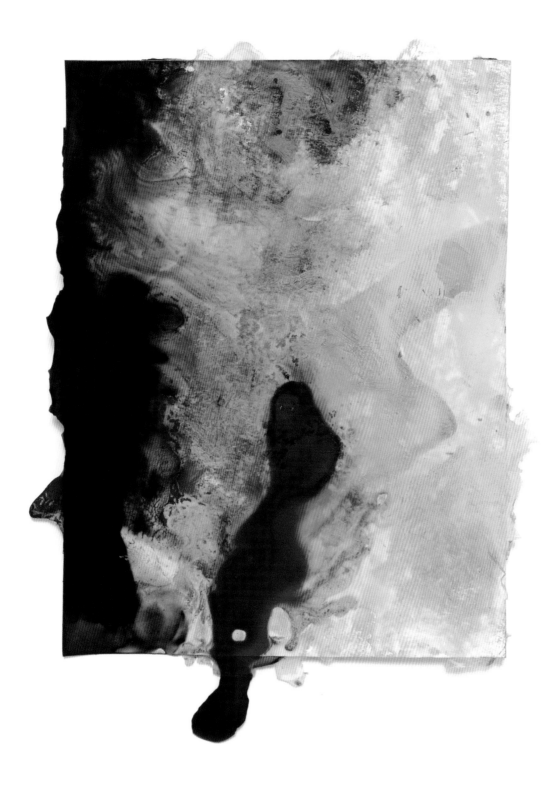

Warm Waters [30], 2018–19
glue, ink, and oil on paper, 11.8 x 8.9 in.

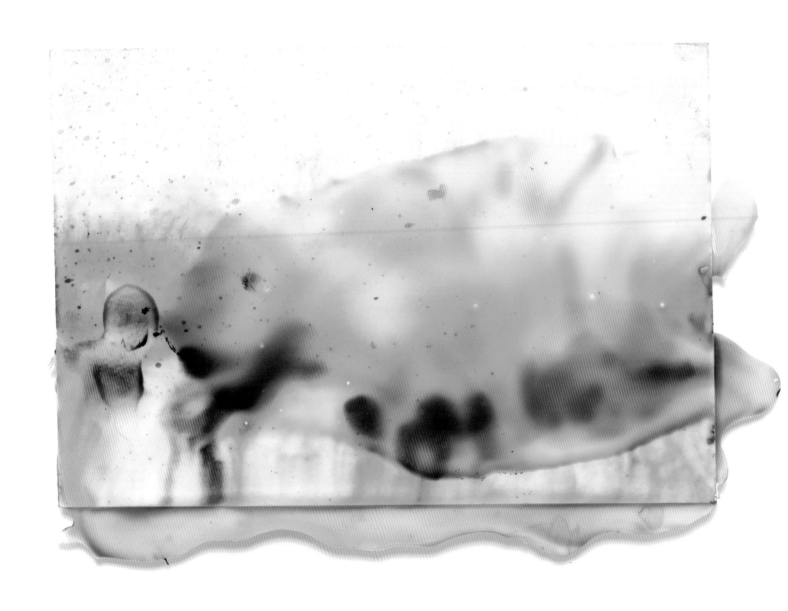

Warm Waters [35], 2018–19
glue, ink, and oil on paper, 7.2 x 10.8 in.

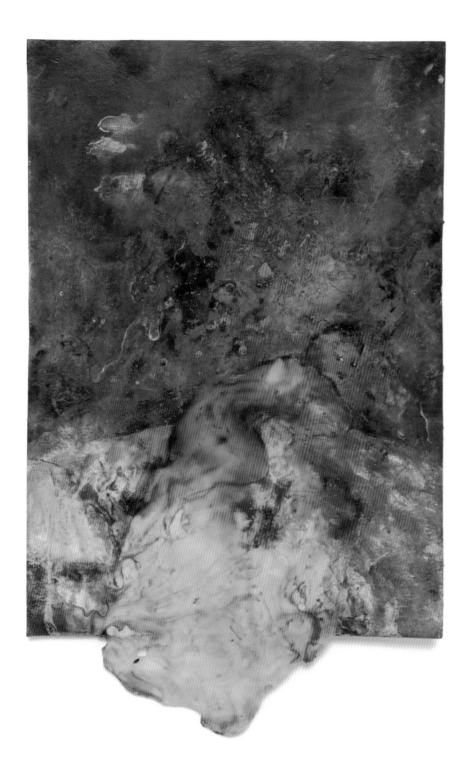

Warm Waters [36], 2018–19
glue, ink, and oil on paper, 16.3 x 11.6 in.

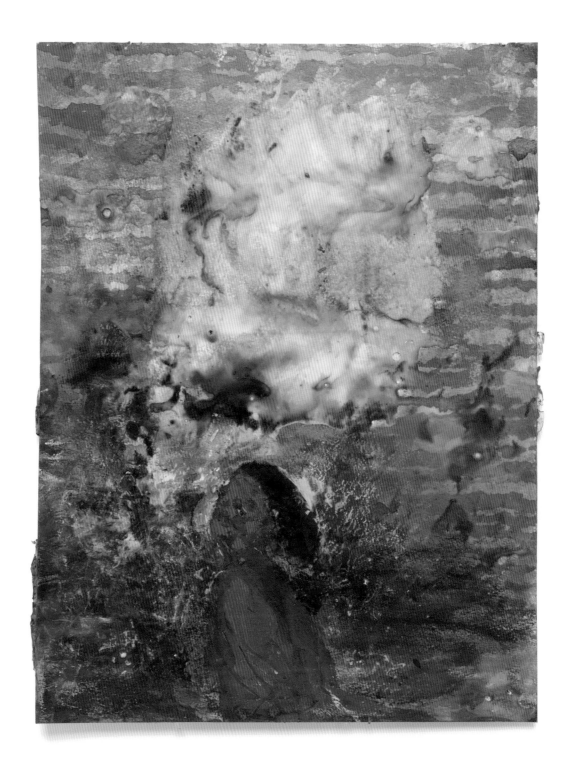

Warm Waters [39], 2018–19
glue, ink, and oil on paper, 15.6 x 11.8 in.

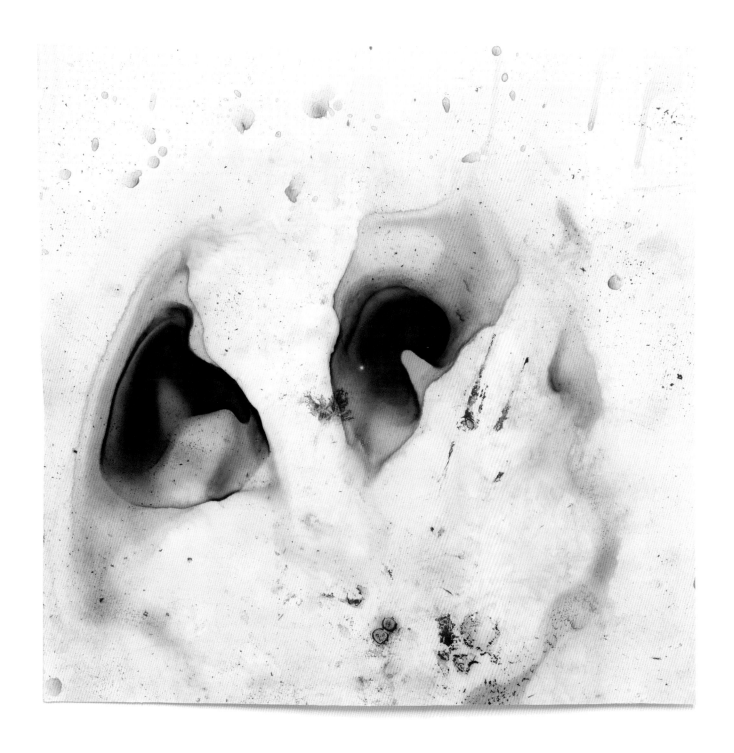

Warm Waters [40], 2018–19
glue, ink, and oil on paper, 15.6 x 15.9 in.

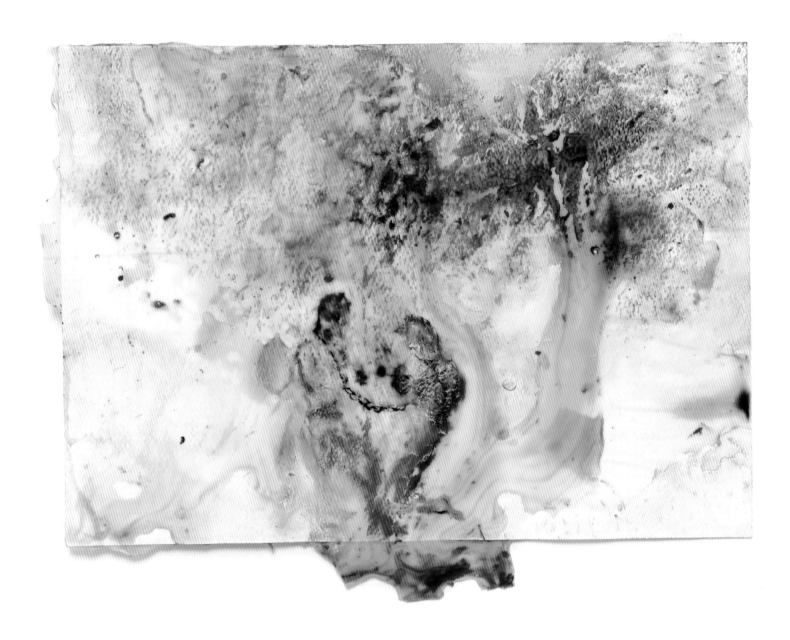

Warm Waters [43], 2018–19
glue, ink, and oil on paper, 11.6 x 16.5 in.

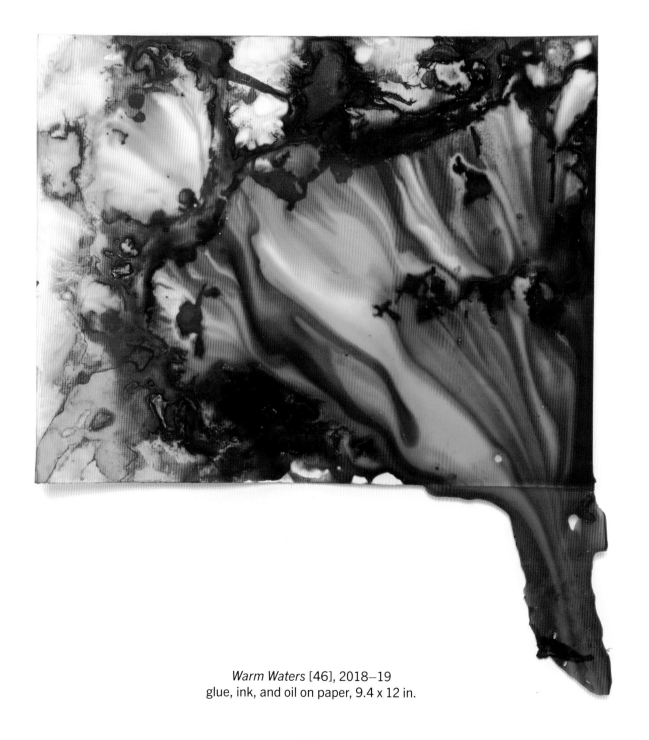

Warm Waters [46], 2018–19
glue, ink, and oil on paper, 9.4 x 12 in.

129

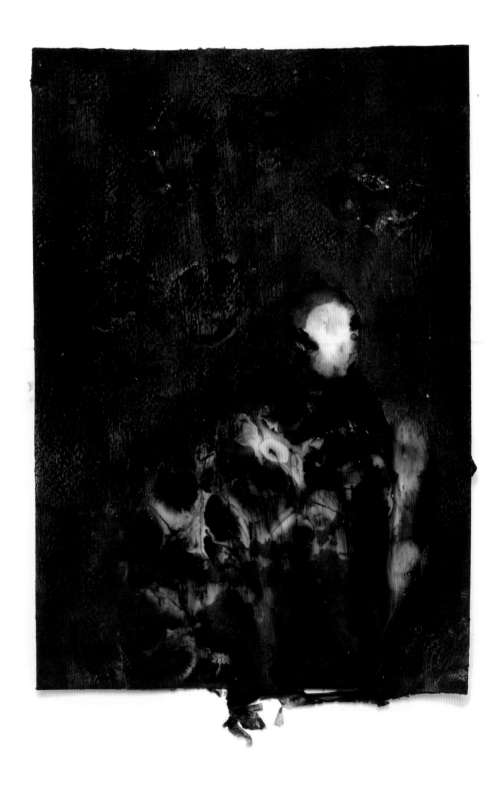

Warm Waters [47], 2018—19
glue, ink, and oil on paper, 10.2 x 8.1 in.

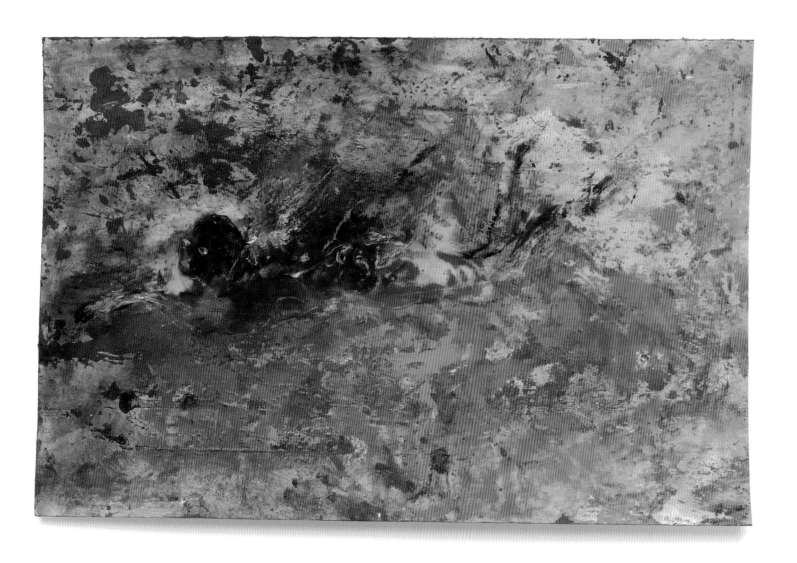

Warm Waters [51], 2018–19
glue, ink, and oil on paper, 10.2 x 15.6 in.

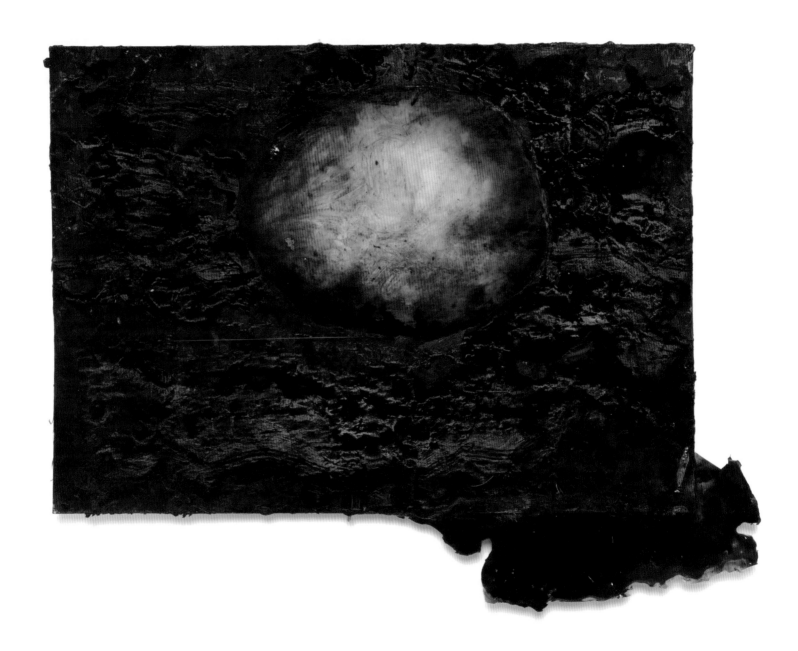

Warm Waters [52], 2018—19
glue, ink, and oil on paper, 8.7 x 11.6 in.

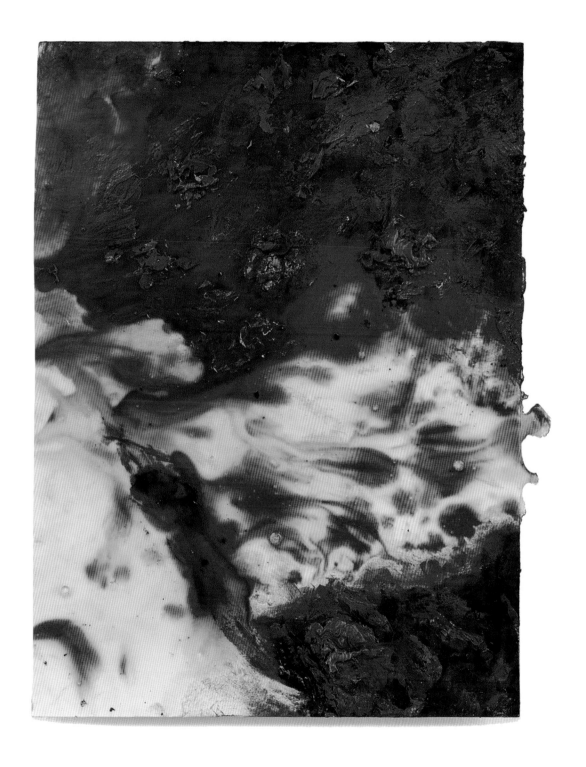

Warm Waters [56], 2018–19
glue, ink, and oil on paper, 12 x 8.9 in.

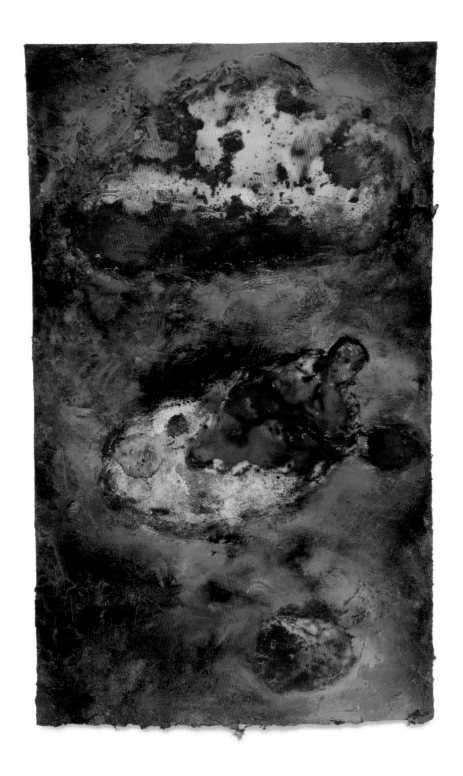

Warm Waters [57], 2018–19
glue, ink, and oil on paper, 17.9 x 11 in.

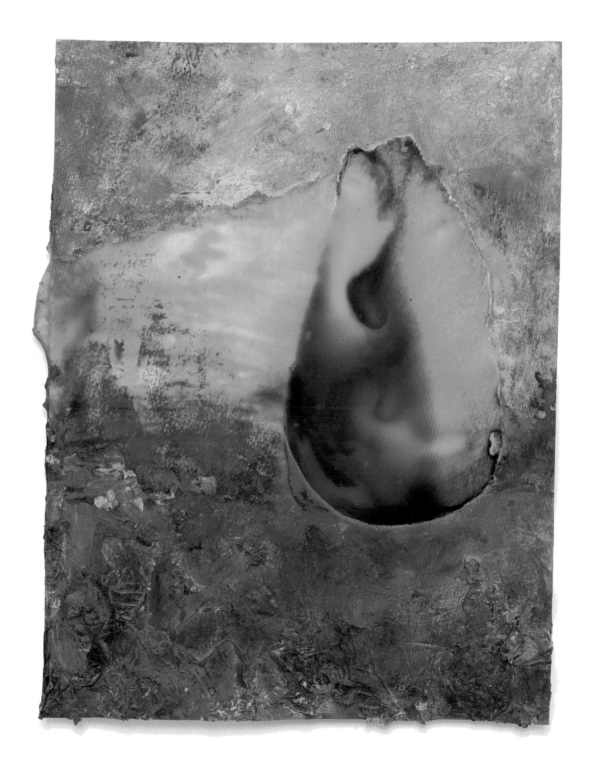

Warm Waters [59], 2018–19
glue, ink, and oil on paper, 11.6 x 8.9 in.

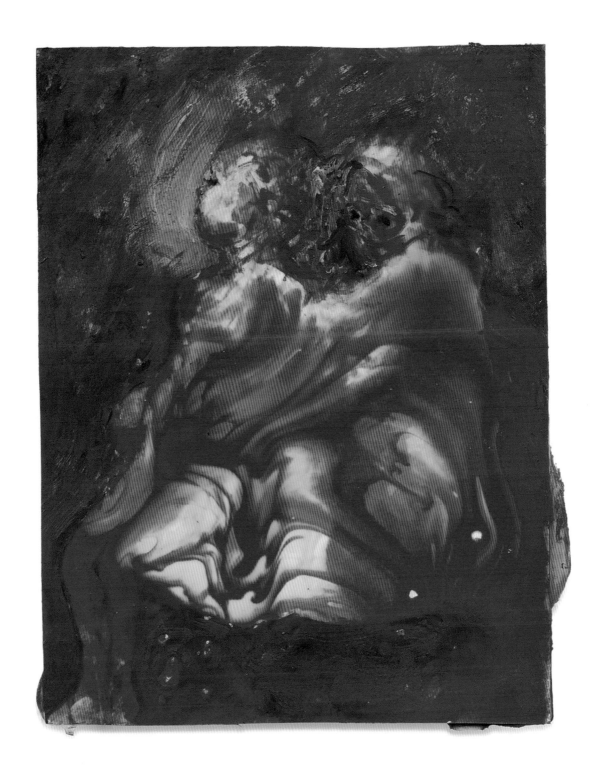

Warm Waters [71], 2018–19
glue, ink, and oil on paper, 11.6 x 9 in.

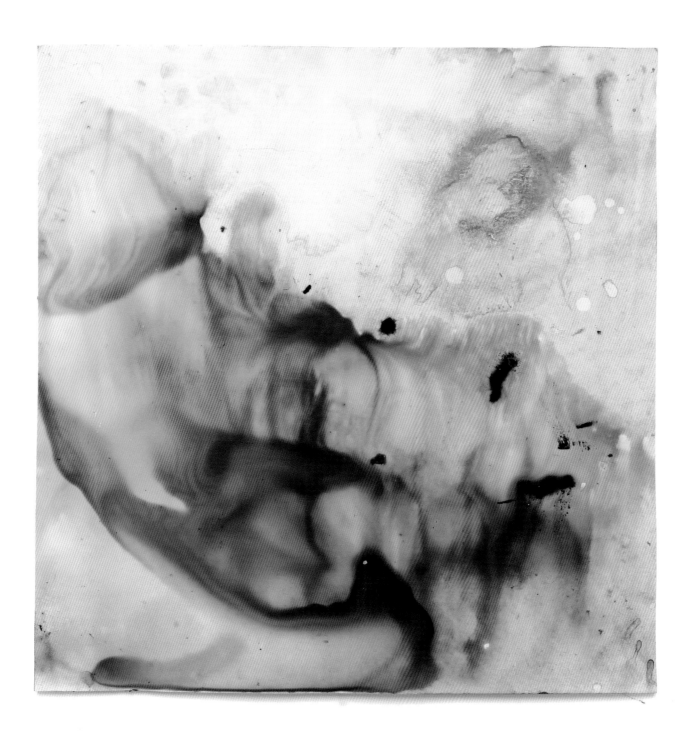

Warm Waters [73], 2018–19
glue, ink, and oil on paper, 14.8 x 14.8 in.

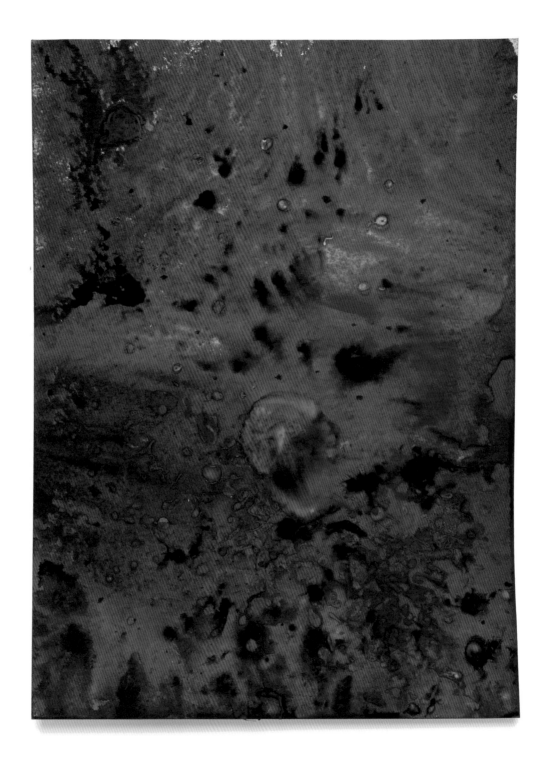

Warm Waters [77], 2018—19
glue, ink, and oil on paper, 11.6 x 8.9 in.

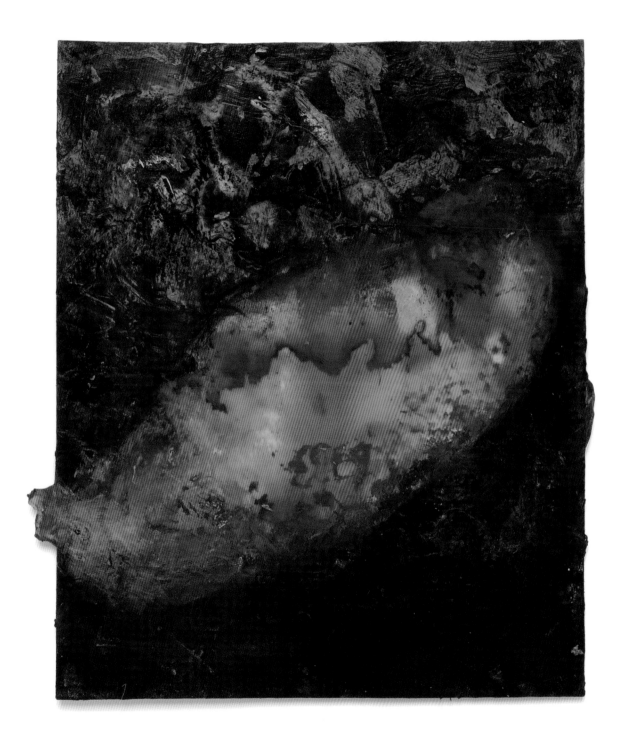

Warm Waters [81], 2018–19
glue, ink, and oil on paper, 10.8 x 8.9 in.

Climate Change and the Future of the Indian Ocean

Sunil Amrith

The work of the six artists featured in *Indian Ocean Current* is driven by a vital and creative engagement with an ocean that has a long history as a crucible of empires—and which, today, is at the sharp edge of global warming. The ocean is again at the heart of strategic competition and political consciousness, not least because it is the world's major conduit feeding our collective addiction to supplies of petroleum.

The works presented here imagine three broad moments in the life of the Indian Ocean, and chart connections between them previously unseen. The first is a longue durée of commerce and cultural exchange, cannibalized and reoriented by European domination after the eighteenth century. Colonial rule allowed a restless industrial capitalism to reshape the Indian Ocean rim. In the nineteenth century, this maritime region reached its zenith of integration: a violent, painful integration that forced people together, but also unleashed an unruly, and sometimes insurgent, process of cultural mixture that still characterizes the Indian Ocean world. The traces of the hybrid cultures shaped by this history are everywhere in Shiraz Bayjoo's series of photographs, *Extraordinary Quarantines* (21–24), rooted in the landscape of his native Mauritius.

The second historical conjuncture captured in these works is the mid-twentieth-century moment of border-making, which tempered the liberatory possibilities of decolonization with a new sense of enclosure. The starkness of Shilpa Gupta's *Speaking Wall* (42–45) speaks of the violence done by borders that divided insiders from outsiders, majorities from minorities.

Finally, in a third and ongoing moment, we confront a present and future of foreboding, as the rising waters of the Indian Ocean menace those who inhabit its coastal arc. The specter of climate change hangs over *Indian Ocean Current*, lending these works their urgency and moral force.

What is the relationship between these three moments? As Amitav Ghosh reminds us in *The Great Derangement*, the origins of global warming are linked inextricably with the history not only of capitalism, but of imperialism.[1] The elevation of private profit over public good, of environmental destruction over preservation, was integral to European imperialism in the Indian Ocean, notwithstanding its occasional communitarian urges and the stirrings of early environmentalism. Despite a few dissenting voices, postcolonial states learned these lessons well, and tried to apply them better. Has the Indian Ocean's centrality to imperial competition left legacies that inhibit new forms of cooperation in the face of environmental crisis? How have the inequalities of the age of empire imprinted themselves on contemporary Indian Ocean societies, shaping the uneven levels of vulnerability to rising waters, across and within nations? Perhaps the most challenging question posed by these works is this: How might the cultural intimacies forged by centuries of contact across the waters allow us to imagine new sorts of solidarity, now, when the waters are rising?

The Indian Ocean was no tabula rasa for European chartered companies to reshape in their own image. Long before the arrival of Europeans, merchants from Kachchh moved money and traded in cloth and cloves along the coast of East Africa and in Zanzibar; Tamil Muslims established themselves in Kedah and in port cities across Southeast Asia; Chinese ships visited every port on the ocean's rim. The economic vitality of this world is what attracted the Europeans in the first place (fig. 1).

The Portuguese entry into the Indian Ocean was made possible by lethal cannons made of sturdier metal. They sailed on ships furnished with effective navigational aids. Their advance was sustained by Christian fervor and greed for Asia's fabled wealth. Brutal, Portuguese power was concentrated at strategic coastal fortresses. Fragile, it never reached far inland. Violence was not unknown in the Indian Ocean before the arrival of Euro-

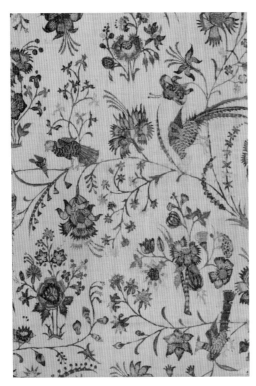

1. Chintz fragment from the Coromandel Coast, made for the European market, c. 1720–40 (Victoria & Albert Museum, London, 1584-1899).

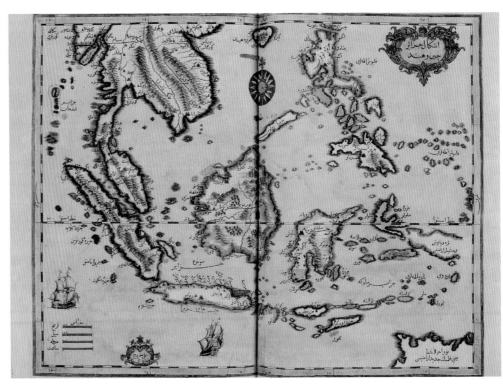

2. A 1728 map of the Indian Ocean and the China Sea by Ibrahim Müteferrika for Kâtip Çelebi's *Universal Geography* (Cambridge University Library).

peans; what was new were the claims of exclusive sovereignty that European chartered companies, backed by states and navies, asserted over land and sea. As the Dutch and English East India Companies rose to challenge Portuguese supremacy in the seventeenth century, the maritime highway between India and China became a corridor of conflict. For every claimant to power and wealth in the Indian Ocean, well into the age of steam power, the knowledge of climate was vital.

The word "monsoon" appeared in English first in the late sixteenth century, derived from the Portuguese *monção*. It comes from the Arabic *mawsim* (for "season"). In its simplest definition, it is a weather system of regularly reversing winds, characterized by pronounced wet and dry seasons. The monsoon allowed the Indian Ocean to be traversed from the earliest times.

European navigators relied on local nautical knowledge. Among the first to

record this nautical wisdom was the Arab navigator Ahmad Ibn Majid in the late fifteenth century. For Ibn Majid, the "monsoon" (*mawsim*) was above all a specific *date* for sailing from a port. His treatise shows how regular and predictable the sailing schedules were for each of the Indian Ocean's seas. In his discussion of the westward journey from Southeast Asia back to eastern India, he cautions mariners to take advantage of the favorable winds of the northeast monsoon, advising them not to set out too late in the season while reminding them that the northeast monsoon did not usually arrive in Sumatra before the beginning of January. The timing had to be just right. He warned of the unreliability of the winds when the monsoons changed over in March and April, and the threat of fearsome storms in October and November.[2]

Ibn Majid's work was a faithful companion to sailors for hundreds of years and publications such as Kâtip Çelebi's

Universal Geography likewise contributed to spreading geographic knowledge of the Indian Ocean in the Arabic-speaking world (fig. 2). Yet, as Europeans' ambitions in the region grew, they were no longer satisfied with the state of navigational knowledge. In the words of K. N. Chaudhuri, "the greatest achievement of Spanish and Portuguese hydrographers was to bring together the work of theoretical mathematicians and combine these with the practical experience of seamen." By the seventeenth century, English and Dutch navigational charts surpassed those of the Portuguese; the captains of East Indiamen were "carefully trained to follow generalized methods on their voyages to the Indian Ocean."[3] The introduction of seagoing chronometers improved the accuracy with which sailors could measure time.

By the middle of the nineteenth century, English sailors began to collect systematic observations of the fearsome storms of the Indian Ocean, of interest

142

to meteorologists and navigators alike. Understanding of Indian Ocean storms owed much to the work of a retired ship's captain and president of the Marine Courts of Calcutta, Henry Piddington (1797–1858). Piddington's interest in the characteristic storms of the Indian Ocean was deeply practical; he dedicated his work to "mariners of all classes in all parts of the world." In his catalogue of different types of storms, Piddington proposed a new word, "cyclone," to describe those driven by "circular or highly curved winds." He derived his term "from the Greek *kukloma* (which signifies amongst other things the coil of a snake)." The new science of cyclones demanded attention from sailors, he wrote, "for it is…a question of life and death, of safety or ruin." He described a "storm wave," of the kind that struck Bengal with ferocity in 1864, as a "mass of water…driven bodily along with the storm or before it"; crashing upon bays and estuaries, they caused "dreadful inundations." Piddington published in the Asiatic Society's journal a series of ships' logs, from which he derived his work on the forces driving the Bay of Bengal's cyclones.[4]

The 1864 cyclone in Bengal was so devastating as to spur the development of a permanent meteorological service in India. The science of meteorology presented a new way of imagining the Indian Ocean across borders. The expansion of telegraphic communication allowed for a new sense of scale to emerge; a new way of envisaging weather in time and space. From the collaboration of meteorologists across imperial borders emerged an oceanic Asia of storm tracks that traversed sea and land: a coastal rim from the Philippines in the east to India in the west, which shared risks to an extent previously unimagined. The networks of storm warnings along the coastal crescent from India to China mirrored Asia's maritime geography. The names of the stations that broadcast telegraph reports were the names of the great ports; the tracks of the tropical cyclones they monitored were the tracks of busy shipping lanes.

But as the British colonial government intensified its interventions into agrarian India, research on the longer-term regularities of India's *climate*, as opposed to episodic weather, pointed in a different direction. India's climatology emphasized the distinctiveness, even isolation, of the "subcontinent"—that phrase itself came into common use in the early twentieth century. Henry Blanford, first director of the Indian Meteorological Department, observed that the monsoon system rendered India "a secluded and independent area of atmospheric action."[5] Ideas about climate coincided with new understandings of both geology and geopolitics. As sail gave way to steam and as the demands of industrial capitalism grew more forceful, the intimate relationship between seafaring and meteorology frayed.

Even before the nineteenth century, the scale of human impact on the forests of the Indian Ocean's rim attracted the attention of European naturalists and botanists. As Richard Grove has shown in his seminal work, they were especially concerned with the fate of "island Edens," like Mauritius. The desiccationists, as they were known, believed that deforestation was a cause of drought. This view gained prominence through the work of Alexander von Humboldt, who wrote in 1819 that "by the felling of trees that cover the tops and the sides of mountains, men in every climate prepare at once two calamities for future generations; the want of fuel and a scarcity of water."[6] Grove sees in the writings of European naturalists in the Indian Ocean the early stirrings of conservationism—yet it would be hard to see their interventions as decisive.

In the nineteenth century, the transformation of the lands around the Indian Ocean accelerated. Precaution was cast aside. The demands of British factories precipitated a rush for the commodities of the Indian Ocean's frontiers—sugar and tea, rubber and tin, timber and cotton. Massive migration followed. In the 1830s, as political pressure mounted at home for slavery's abolition in the British Empire,

sugar planters looked to India and China for unfree labor. The demands of sugar underpinned the nineteenth century's worldwide shift from enslaved African to indentured Asian labor. In all, around 1.5 million indentured workers moved from India to destinations across the Indian and Atlantic Oceans—Mauritius, Natal, Trinidad, and Fiji were among their main destinations. Alongside indentured laborers, tens of thousands of convicted prisoners from India were transported from India to Bencoolen, the Straits Settlements, and the Andaman Islands. They built roads, cleared forests, erected buildings, cultivated gardens, cleaned cities. The empire's violent appetite for labor distinguished the mobility of the nineteenth century from earlier times. The scars of that violence, and memories of the Indian Ocean's distinctive experience of unfree labor, run through the work of Shiraz Bayjoo (16–24) and Wangechi Mutu (86–91). Bayjoo's moving video installation, *Sea Shanty*, evokes the journeys of the indentured laborers, the song a testimony to their suffering and resilience.

In the Indian Ocean's history, changes in the sea came long after the lands around its edge had been transformed by migrant labor. "With an ever-accelerating tide of human impact," a leading marine biologist writes, "the oceans have changed more in the last thirty years than in all of human history before."[7] The relative ease of crossing the Indian Ocean's water created bonds of culture and commerce over centuries. Under colonial rule, the force of capital transformed the landscapes of the Indian Ocean's littoral. Through all of these changes, "the oceans themselves seemed changeless," and "contrasted with the world above water, where landscapes underwent dramatic alterations." This contrast holds no more.[8] Starting around the 1950s, and with accelerating effects since the 1970s, a concatenation of changes began to affect the seas—a rapid expansion in the human population;

increased settlement in large coastal cities; an expansion of the "fishing frontier," propelled by deep-sea trawling; rapid, if uneven, industrialization in the parts of the world once under European colonial rule; agricultural intensification, buoyed by massive pesticide use; and an insatiable appetite for fossil fuels.

The forces that now choke the life from the Indian Ocean began as unintended, initially unseen, consequences of the political choices that states and peoples made as a new world arose from the ruins of war and the remnants of empires. The policies that sought to extend territory into the ocean—projects to increase food security, schemes of industrialization to provide employment—represented an advance in human freedom around the Indian Ocean. They emerged in reaction to an imperial world where lives were cheap: where labor was uprooted for the profit of European planters, where migrant workers were denied their humanity, where colonial policies left millions to starve. When the Indian Ocean began to be walled off, in the 1930s and 1940s, it was at least partly in order to secure a different—and, many felt, a more substantive—freedom: the political rights of citizens of free nations,

and the rights to livelihood that these new nations would provide. From the mid-twentieth century, the Indian Ocean's political and economic fragmentation had important ecological consequences, some of which are only clear in retrospect. As the avenues of emigration and interregional trade were closed off by new national borders, the growing populations of the region could only be sustained by a massive intensification of domestic agricultural production. As they turned away from oceanic commerce, coastal cities grew rapidly: port cities turned inland, and became industrial centers. The treatment of the ocean as an extension of national territory facilitated its over-exploitation as a resource.

In a world newly divided between the superpowers, in which newly independent countries asserted their rights to develop their resources, the Indian Ocean became both a source and a conduit for that most vital of modern substances. During the Second World War, Bengali astrophysicist and left-leaning nationalist Meghnad Saha saw how important oil would be to the future; he urged soon-to-be independent countries like India not to cede their oil resources to the ever more powerful conglomerates. Two decades later, Auguste Toussaint, chief archivist of Mauritius and a noted local historian, wrote a synthetic history of the Indian Ocean in 1961 (translated into English in 1966); he saw the age of petroleum as inaugurating a new phase in the ocean's history. "After the steamship and electricity came oil," he wrote; "the three formed a triad which has dominated all oceanic history until today." Toussaint compared these technologies to "those deities with several arms which are found in Hindu temples." Among them, "oil might appear as a kind of

terrifying Shiva, frenetically dancing in a circle of fire, principle at once of creation and destruction, yet more often engaged in destroying than creating."[9] The works in *Indian Ocean Current* show that Toussaint was prescient.

―――――――――――――

By the 1960s the Indian Ocean was largely invisible to states in South Asia, which looked no further than the waters immediately off their coasts. Migrants had once traversed the sea with few restrictions, in a pattern of circular migration. Now they faced an obstacle-strewn space governed by passports and visa restrictions. Trading connections across the Indian Ocean reached their lowest ebb.

But despite its long centrality to the ambitions of empire builders, to many scientists the Indian Ocean remained "the largest unknown area on earth." Paul Tchernia, who worked in the physical oceanography laboratory of the Muséum national d'histoire naturelle in Paris, described it as the "forlorn ocean." Returning from a voyage through the Indian Ocean en route to and from the Antarctic, he suggested that an international investigation of the Indian Ocean should be incorporated into the activities of the UN's International Geophysical Year in 1957–58: a massive exercise in coordinated data gathering that transformed knowledge of Earth's physical processes. Tchernia's suggestion came too late to include the Indian Ocean in that giant program, but there was a convergence of interest in investigating the least well-studied among the world's oceans. The International Indian Ocean Expedition ran from 1959 to 1965, involving forty ships from thirteen countries (fig. 3).[10]

Oceanographers were drawn to the Indian Ocean for the same reason that medieval traders could cross it—the seasonal reversal of the monsoon winds. This pattern of reversing winds made the Indian Ocean unique; "a model of the world ocean," upon which scientists could test their "wind-driven models."[11] Many scien-

3. Cruise tracks of vessels on the International Indian Ocean Expedition (ESSO-Indian National Centre for Ocean Information Services, https://incois.gov.in/portal/iioe/aboutus.jsp).

tists who lived on the ocean's rim, especially those in government service, had more immediate interests. The ocean's fisheries held the potential to address concerns about food shortage in Asia and Africa; its mineral wealth had barely begun to be exploited. Unlocking the mechanism of the ocean's influence on climate could provide the key to food security and economic development.[12]

The Expedition's research aims encompassed the study of ocean currents and littoral drift; an investigation of ocean chemistry, salinity, and temperature; the exploration of marine life, especially fisheries; and the study of atmospheric conditions, including wind and rainfall. Much of the excitement came from the new technologies that allowed scientists to see the sea afresh. Sonar let scientists hear enough to map the Indian Ocean's seafloor with heightened accuracy—their images evoked an underwater continent as varied in its topography as the land above. Advances in satellite technology provided synoptic pictures of cloud cover and precipitation. Computers allowed scientists to process quantities of data beyond all precedent: Klaus Wyrtki of the University of Hawaii oversaw the production of an oceanographic atlas, which processed data from twelve thousand hydrographic stations stored on two hundred thousand computer cards.[13]

Among all of the Indian Ocean Expedition's endeavors, one observer wrote, "none shows more contrast between past and present than meteorology."[14] The Expedition marked the most intensive investigation of the South Asian monsoon since the work of Sir Gilbert Walker in the 1910s and 1920s, now with a raft of new tools. Fascinating though it was to glimpse the ocean's floor, for many scientists the most urgent priority for the Indian Ocean Expedition was to provide a better picture of Asia's climate. Almost a century after the establishment of the Indian Meteorological Department, scientists wrote in 1962 that "inadequate knowledge of the large-scale influences on

weather have always hampered weather forecasting." The need to understand the monsoon "has become even greater and more urgent," they argued, "in view of the large-scale development plans of many of the countries in the field of agriculture, exploitation of water resources, flood control programmes, and programmes for ameliorating the consequences of weather extremes." Economic planning demanded "accurate advance information on the onset of the rains, its variations from day-to-day" and "the occurrence of spells of heavy rain and breaks."[15]

In his 1927 presidential address to the Royal Meteorological Society, Gilbert Walker had speculated that "variations in activity of the general oceanic circulation" would likely be "far reaching and important" in understanding the world's climate.[16] It was not until the 1960s, bolstered by data collected during the International Geophysical Year and the Indian Ocean Expedition, that his insight would be developed. Walker's pioneering work on the lateral connection between the climates of the Indian Ocean and the Pacific—what he had called the Southern Oscillation—now acquired a vertical dimension. The Indian Ocean Expedition focused on understanding the exchange of energy between the ocean and the atmosphere, driven by monsoon winds. Piece by piece, scientists sought to understand the large-scale monsoon circulation of the Indian Ocean. The reversal in the direction of the monsoon winds had been well known for centuries, but it was more difficult, one scientist wrote, to "determine the vertical limits—than the horizontal—of the monsoon influence." Changes on Earth's surface were linked with changes in the deep sea, and in the upper atmosphere.[17]

More ominous signs emerged from the Indian Ocean Expedition. Two years before it began, one of its leaders, Scripps oceanographer Roger Revelle had written with his colleague, geochemist Hans Suess, that human beings were conducting, unwittingly, a "large scale geophysical experiment" with the world's climate.

"Within a few centuries," Revelle and Suess wrote, "we are returning to the atmosphere and oceans the concentrated organic carbon stored in sedimentary rocks over hundreds of millions of years."[18] One of Revelle's students, Charles Keeling, was the first to start systematic measurements of atmospheric carbon the following year, at Mauna Loa, in 1958. Revelle and colleagues had long-range goals for their study of the Indian Ocean: they wanted to see how far the Indian Ocean was being treated as a "dump for the waste products of industrial civilization." And they sought to determine "the role of the ocean in climatic change, especially in absorbing the carbon dioxide spewed into the atmosphere when fossil fuels are burned."[19]

We have forgotten how important the Indian Ocean was to documenting anthropogenic climate change, prompting early stirrings of alarm. The data to come out of the Indian Ocean voyages suggested that the sea and the atmosphere were being affected by human activity on land. But these "long-range" problems were then distant from the level of human experience. The time horizons of oceanic research were incommensurable with those of planning for food security. Because the long-range monsoon forecast remained elusive, because understandings of climate grew more complex, it was easier to focus on what could be contained and controlled—one river valley at a time.

Already the warmest of the world's oceans, there has been a steady and continuous warming of the "warm pool" in the central-eastern Indian Ocean over the past half century. These changes were only beginning at the time of the Indian Ocean Expedition of the 1960s; but the international cooperation of that era laid the foundations for the infrastructure of data collection and oceanographic study that has made clear the Indian Ocean's plight. Recent studies have suggested an even sharper warming trend in the nor-

mally cooler western Indian Ocean, which has implications for the thermal contrasts that drive monsoon circulation.[20] From the time of Gilbert Walker's research in the early twentieth century, it has been recognized that the Indian Ocean affects climate dynamics across the tropics; it is becoming increasingly clear that a warming Indian Ocean has planetary effects.

The UN's Fifth Assessment Report of the Intergovernmental Panel on Climate Change estimates that 90% of the heat generated by global warming has been accumulated in the oceans. The El Niño Southern Oscillation serves as "a vent to exchange this heat from the ocean to the atmosphere"; this is then "partially transferred to the Indian Ocean through a modified Walker Circulation, and is reflected in the warming trend over the region."[21] One of the mechanisms of Indian Ocean warming has been the unexpectedly large transfer of heat from the Pacific Ocean—long thought to play the most significant role in the absorption of atmospheric heat—via the thoroughfare of the Indonesian seas: the very same seas crossed by merchants and traders for centuries, at the hinge of the Indo-Pacific world.[22]

4. A dust storm ("brown cloud") caused hazardous air pollution conditions in New Delhi, prior to monsoon season, June 14, 2018 (NASA-Earth Observatory, https://earthobservatory.nasa.gov /images/92309/hazardous-pre-monsoon-dust-pollution).

The transformation of the Indian Ocean over the past few decades is not a story of warming alone. In 1995, the crew of a small research vessel noticed, as they crossed the inter-tropical convergence zone around the equator, a sharp increase in atmospheric pollutants over the northern compared with the southern Indian Ocean. The next year, following up these findings, the *Sagar Kanya*, a research vessel operated by India's National Centre for Antarctic and Ocean Research (now the National Centre for Polar and Ocean Research), observed a sharp rise in aerosol depths north of the equator. A satellite study followed, and revealed the now infamous atmospheric "brown cloud" covering most of the Bay of Bengal and the Arabian Sea. These findings prompted oceanographers and atmospheric chemists to initiate the Indian Ocean Experiment, which ran between January and March 1999. It involved over two hundred scientists from India, Europe, and the United States; "with five aircraft, two ships, an observatory in the Maldives, surface stations in India and several satellites."[23]

V. Ramanathan, the Scripps Institute oceanographer in charge of the project, noted that "the equatorial Indian Ocean is a unique natural laboratory for studying the impact of anthropogenic aerosols on climate, because pollutants from the Northern Hemisphere are directly connected to the pristine air from the Southern Hemisphere by a cross equatorial monsoonal flow into the inter-tropical convergence zone."[24] The haze, the Experiment showed, was composed of "sulphate, nitrate, organics, black carbon, dust and fly ash particles and natural aerosols such as sea salt and mineral dust";[25] three-quarters of the composition of the brown cloud were anthropogenic. The study found that

the aerosol plume reaches its maximum extent and strength in the dry months of February and March, spreading over most of Nepal, Pakistan, India, the Bay of Bengal, the Arabian Sea, and into the southern Indian Ocean.

It is commonplace in oceanic history that the sea has shaped the history of the littoral: the patterns of the monsoon winds opened up trade routes and storm surges and cyclones sweeping in from the sea have posed a recurrent and perennial threat to life on land. Environmental concerns from the 1960s focused on the polluting effects of industry on the beach and the coastal seas. But the Experiment suggested that, for the first time, something quite new was happening: human activity on land, including far inland, was now impacting the atmospheric chemistry of the Indian Ocean. By affecting temperature contrasts between the northern and southern Indian Ocean, the "brown cloud" was changing the sea itself. This suggests a different relationship between the land and the sea from the one oceanic historians are used to working with. Even more fundamentally, scientists suggest that this "atmospheric brown cloud" is not just a source of pollution, as we conventionally understand it; it may be responsible for changes in the pattern of rainfall over South Asia (fig. 4). That is to say, it might be responsible for changing the monsoon itself: the monsoon that K. N. Chaudhuri, in a Braudelian vein, had once described as a "history of constant repetition, ever-recurring cycles."[26]

An overwhelming proportion of the pollutants that spill into the Indian Ocean every year come from the land. They flow out with the great rivers that empty into the Indian Ocean—the Ganges, the Brahmaputra, the Meghna, the Godavari, the Kaveri, the Krishna, the Indus. They trickle in as refuse from the large coastal cities that ring the sea's littoral, places that were the departure points for millions of journeys in the age of sail and steam, now swollen with people and riven with the new inequalities of globalization. Because

of the size and number of the rivers that feed into it, and the density of population around its rim, "the total amounts of nutrients reaching the Bay of Bengal...must be close to the highest in the world."[27] Every day, the Bay receives a noxious cocktail of "organic matter, nutrients, metabolised drugs, medical wastes, cytotoxic, antibiotic and hormone-mimicking materials, bacteria, viruses and worms, chemicals such as detergents and a significant quantity of sediments."[28] Floods and storm surges dislodge pollutants and carry them over long distances. A plague of plastic floats out to sea.

The rivers themselves are in "dire" health; around 80% of the world's population lives in areas where human water security and biodiversity of river systems is under cumulative threat.[29] The excess of nutrients that flows through the rivers—most damaging is the nitrogen from agricultural fertilizer run-off—creates "dead zones" starved of oxygen.[30] Writing from the southeastern edge of the Bay of Bengal in the early nineteenth century, British naturalist John Crawfurd declared that "no part of the world abounds in more fine fish."[31] Two centuries later, the fish are disappearing.

The Indian Ocean's coastline is shifting. Deforestation and aquaculture encroach on the mangrove swamps that provide coastal zones with their best natural flood defenses (fig. 5). And aquaculture expands as deep-sea fishing provides diminishing returns. "Mangroves," Rachel Carson wrote, "are among the far migrants of the plant kingdom, forever sending their young stages off to establish pioneer colonies." Since her lyrical account, penned in 1955, her beloved mangroves have almost everywhere been pushed back, their "colonies" disbanded. Mangroves excelled in "creating land where once there was sea."[32] As they give way to industrial (and often state-subsidized) shrimp farms, the land recedes with the loss of the "complex matrix of roots and stems" that "traps and binds sediment and stabilizes the coast."[33]

The coasts are destabilized (fig. 6): so much so that many of the world's river deltas are sinking. According to studies conducted in the first decade of this century, the great deltas—which host some of the largest population concentrations on Earth—are sinking at up to four times the rate that sea levels are rising. In the past decade, over ten million people each year have experienced severe flooding due to storm surges alone: most of them live along Asia's coastal littorals. As a result of human intervention, much less sediment reaches the river deltas than would naturally—sediment that is essential for the deltas to sustain and replenish themselves. The "predominant" role is played by projects of hydraulic engineering, epitomized by large dams, which proliferated in the second half of the twentieth century. The trapping of sediment by dams far outstrips the effects of land clearance and construction in displacing it; rather, bypassing "an important natural filtration system," storm surges and floods carry displaced sediment directly to the sea, while large quantities remain trapped in reservoirs. The attempt to engineer away the smaller tributaries that feed the great rivers breaks the "critical links between channels and their floodplains" and "starves delta systems of necessary sediments." Reservoirs have increased by 600 or 700% the volume of water held by rivers.[34]

The map of cities most at risk from rising waters resembles a series of beads on a necklace threaded along the coastline of Asia. One study predicts that by 2070, nine out of the ten cities with the most people at risk from extreme weather will be in Asia—Miami is the only non-Asian inclusion. The list includes Kolkata and Mumbai in India, Dhaka in Bangladesh, Guangzhou and Shanghai in China, Ho Chi Minh City and Hai Phong in Vietnam, Bangkok in Thailand, and Yangon in Myanmar.[35] Each of these cities will confront immediately any change in the interaction

of land and water, winds, and rain over Asia's oceans. In coastal cities along the ocean's rim, climate change compounds a cavalcade of risks that are severe in and of themselves—hasty development driven by property speculation and new forms of middle-class consumption, crumbling health and sanitary infrastructures, and a lack of preparedness and precaution, are all symptoms of profound social and

5. Mangrove conservation project in coastal Tamil Nadu (author's photo).

6. Coastal erosion in Tamil Nadu, near Puducherry (author's photo).

economic inequalities both among and within nations.[36]

The scale of the crisis ahead is so forbidding that it can seem unfathomable. That is where the works featured in *Indian Ocean Current* come into their own. By shifting our attention to a more intimate scale, by appealing to our imagination, they move us even as they frighten us.

They touch on the ways that the fragile bonds of culture across the Indian Ocean, born of a long and painful history, still cohere. Penny Siopis's remarkable series, *Warm Waters* (110–39)—using glue, ink, and oil on paper—forces us to imagine possible futures: "What do we imagine?" she asks, "Burning? Drowning? Absolute alterity?"[37] In the shifting, inchoate forms of the figures that rise from the warming waters, she invites us to imagine different forms of society, different forms of economy, different forms of solidarity that can show us a way out of catastrophe.

In 2017, T. M. Krishna—one of the most talented vocalists to emerge from the Carnatic music tradition of South India in recent decades—made a music video in cooperation with environmental activist Nityanand Jayaraman. Iconoclastic and forthright, Krishna was already an important public voice, outspoken on the caste-based discrimination that continues to preserve classical music as an elite pursuit. His video demonstrates the power of art in the face of ecological crisis. The song, "Poromboke," was intended to raise awareness and support for the preservation and restoration of Ennore Creek, a wetland in Chennai that has been eviscerated by unauthorized construction and unregulated dumping (fig. 7). It stands, in many ways, as a symbol of the risks faced by coastal communities across Asia.[38]

The film is visually striking. Krishna and his fellow musicians sit surrounded by garbage, by construction equipment, by pipes spilling effluent into the Bay of Bengal just beyond them, the air is hazy from pollution. At the beginning of the video, their faces are covered by masks. And then Krishna's powerful voice enters. He sings:

> poromboke is not for you, nor
> for me
> it is for the community, it is for
> the earth

"Poromboke" is a term once used to denote common lands: grazing grounds, tanks, land shared by the community. The lyrics to Krishna's song trace the semantic transformation of the word by colonialism and capitalism. Under British administration, "poromboke" came to mean "wasteland"—lands to be acquired by the state for development and improvement. It also came to mean "useless person"—in common parlance in Tamil, still widely used, a "poromboke" is a wastrel.[39] Mining the word for its buried meanings, the song urges an ethic of care for the land. Krishna sings:

> it was not the rivers that chose
> to flow through cities
> rather, it was around rivers that
> the cities chose to grow

Krishna's song probes a deep cultural and literary tradition to evoke attachment to a particular patch of land and water. But on YouTube his video has found hundreds of thousands of viewers around the world—touching upon something universal.

Indian Ocean Current shows us that profoundly local attachments to landscapes and memories still map onto broader solidarities. They are embedded in expansive imaginative and moral geographies. They are underpinned by ecological as well as cultural connections. These remembered pasts, and imagined futures, are sustained by collective memory and collective action, brought to life in stories, song, and art.

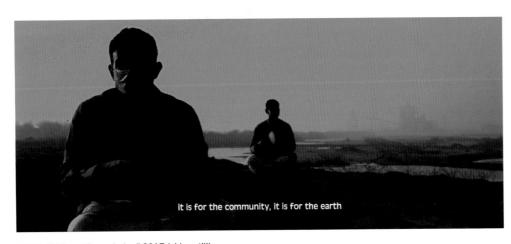

it is for the community, it is for the earth

7. T. M. Krishna, "Poromboke," 2017 (video still).

Sunil Amrith is the Mehra Family Professor of South Asian History at Harvard University. He works on the history of South and Southeast Asia in an Indian Ocean context, with a focus on the history of migration and environmental history. He is the author of *Crossing the Bay of Bengal: The Furies of Nature and the Fortunes of Migrants* (2013) and *Unruly Waters: How Rains, Rivers, Coasts, and Seas Have Shaped Asia's History* (2018). Amrith was awarded a MacArthur Fellowship in 2017, and the Infosys Prize in Humanities in 2016.

1 Amitav Ghosh, *The Great Derangement: Climate Change and the Unthinkable* (Chicago: University of Chicago Press, 2016).

2 G. R. Tibbetts, trans., *Arab Navigation in the Indian Ocean before the Coming of the Portuguese: Being a Translation of "Kitāb al-fawā'dfī usūl al-bahr wa'l-qawā'id" of Ahmad b. Mājid al-Najdī* (London: Royal Asiatic Society, 1971), 124.

3 K. N. Chaudhuri, *Trade and Civilisation in the Indian Ocean: An Economic History from the Rise of Islam to 1750* (Cambridge: CUP, 1985), 135.

4 Henry Piddington, *The Sailor's Horn-Book for the Law of Storms* (London: John Wiley, 1848); description of "storm wave" in Henry Piddington, *The Horn-Book of Storms for the Indian and China Seas* (Calcutta: Bishop's College Press, 1844), 20.

5 Henry F. Blanford, *Meteorology of India: Being the Second Part of the Indian Meteorologist's Vade-Mecum* (Calcutta: Government Printer, 1877), 48.

6 Cited in Diana K. Davis, *The Arid Lands: History, Power, Knowledge* (Cambridge: MIT Press, 2016), 83.

7 Callum Roberts, *Ocean of Life: How Our Seas Are Changing* (London: Allen Lane, 2012), 3.

8 Roberts, 2.

9 Auguste Toussaint, *History of the Indian Ocean* (1961), trans. June Guicharnaud (London: Routledge and Kegan Paul, 1966), 215.

10 This discussion draws on Sunil Amrith, "The Ocean and the Underground," chap. 8 in *Unruly Waters: How Rains, Rivers, Coasts, and Seas Have Shaped Asia's History* (New York: Basic Books, 2018).

11 Warren S. Wooster, "Indian Ocean Expedition," *Science* 150, no. 3694 (Oct. 15, 1965): 290–92.

12 Indian National Committee on Oceanic Research (INCOR), *International Indian Ocean Expedition: Indian Scientific Programmes, 1962–1965* (New Delhi: Council of Scientific and Industrial Research, 1962), 15.

13 Klaus Wyrtki, *Oceanographic Atlas of the International Indian Ocean Expedition* (Washington, DC: National Science Foundation, 1971).

14 Daniel Behrman, *Assault on the Largest Unknown: The International Indian Ocean Expedition, 1959–65* (Paris: UNESCO Press, 1981), 64.

15 INCOR, *Indian Ocean Expedition*, 44.

16 Gilbert T. Walker, "The Atlantic Ocean," *Quarterly Journal of the Royal Meteorological Society* 53, no. 222 (Apr. 1927): 113.

17 G. E. R. Deacon, "The Indian Ocean Expedition," *Nature* 187 (Aug. 13, 1960): 561–62; INCOR, *Indian Ocean Expedition*, 12; Wyrtki, *Atlas*, quote on 7.

18 Roger Revelle and Hans E. Suess, "Carbon Dioxide Exchange between Atmosphere and Ocean and the Question of an Increase of Atmospheric CO_2 during the Past Decades," *Tellus* 9 (Feb. 1957): 18–27, quote on 19–20. On oceanography and the discovery of climate change, see Naomi Oreskes, "Changing the Mission: From the Cold War to Climate Change," in *Science and Technology in the Global Cold War*, ed. Naomi Oreskes and John Krige (Cambridge: MIT Press, 2014), 141–87.

19 Behrman, *Assault*, 11–12.

20 Mathew Koll Roxy et al., "Drying of Indian Subcontinent by Rapid Indian Ocean Warming and a Weakening Land-Sea Thermal Gradient," *Nature Communications* 6 (June 16, 2015), https://doi.org/10.1038/ncomms8423.

21 Mathew Koll Roxy et al., "The Curious Case of Indian Ocean Warming," *Journal of Climate* 27, no. 22 (Nov. 4, 2014): 8501–9, https://doi.org/10.1175/jcli-d-14-00471.1.

22 Ying Zhang et al., "Strengthened Indonesian Throughflow Drives Decadal Warming in the Southern Indian Ocean," *Geophysical Research Letters* 45 (June 22, 2018): 6167–75, https://doi.org/10.1029/2018GL078265.

23 V. Ramanathan et al., "The Indian Ocean Experiment and the Asian Brown Cloud," *Current Science* 83, no. 8 (Oct. 25, 2002): 947–55, 948.

24 Ramanathan et al., 947.

25 Ramanathan et al., 948.

26 Chaudhuri, *Trade and Civilisation*, 23.

27 Ursula L. Kaly, "Review of Land-Based Sources of Pollution to the
Coastal and Marine Environments of the BOBLME Region," Bay of
Bengal Large Marine Ecosystem (BOBLME) Theme Report, Mar. 1
2004, https://www.boblme.org/documentRepository/Theme_
%20Land%20Based%20Pollution%20-%20%20Urusla%20Kaly.pdf,
14.

28 Kaly, 25.

29 Charles J. Vörösmarty et al., "Global Threats to Human Water Secu-
rity and River Biodiversity," *Nature* 467 (Sept. 30, 2010): 555–61.

30 United Nations Environment Program (UNEP), "Dead Zones Emerg-
ing as Big Threat to Twenty-First Century Fish Stocks," press release
no. ENV/DEV/758, Mar. 19, 2004, https://www.un.org/press/en
/2004/envdev758.doc.htm.

31 John G. Butcher, *The Closing of the Frontier: A History of the Marine
Fisheries of Southeast Asia, c. 1850–2000* (Singapore: Institute of
Southeast Asian Studies, 2004), 28–29.

32 Rachel Carson, *Edge of the Sea* (Boston: Houghton Mifflin, 1955),
240.

33 Roberts, *Ocean of Life*, 94.

34 Charles J. Vörösmarty et al., "Battling to Save the World's River Del-
tas," *Bulletin of the Atomic Scientists* 65, no. 2 (Nov. 2009): 31–43.

35 Susan Hanson et al., "A Global Ranking of Port Cities with High
Exposure to Climate Extremes," *Climatic Change* 104, no. 1 (Jan.
2011): 89–111; Orrin H. Pilkey, Linda Pilkey-Jarvis, and Keith C.
Pilkey, *Retreat from a Rising Sea: Hard Choices in an Age of Climate
Change* (New York: Columbia UP, 2016), 65–74.

36 Pilkey, Pilkey-Jarvis, and Pilkey, 70–71.

37 "Penny Siopis: *Warm Water Imaginaries*," Stevenson, https://www
.stevenson.info/exhibition/3917.

38 T. M. Krishna, "Poromboke," YouTube video, 9:33, posted by Vettiver
Collective, Jan. 14, 2017, https://www.youtube.com/watch?v
=82jFyeV5AHM.

39 On the history of this transition in Tamil Nadu, see Haruka Yanagi-
sawa, *A Century of Change: Caste and Irrigated Lands in Tamilnadu,
1860s–1970s* (New Delhi: Manohar, 1996) and Prasannan Par-
thasarathi, "Water and Agriculture in Nineteenth-Century Tamil-
nad," in "New Directions in Social and Economic History: Essays in

Honour of David Washbrook," ed. Joya Chatterji and Prasannan Par-
thasarathi, special issue 2, *Modern Asian Studies* 51 (Mar. 2017):
485–510.

150

Hajra Waheed

(b. 1980) was born in Calgary and lives and works in Montréal. Waheed's multidisciplinary practice ranges from interactive installations to collage, video, sound, and sculpture. Among other issues, she explores the nexus between security, surveillance, and the covert networks of power that structure lives while also addressing the traumas and alienation of displaced subjects affected by legacies of colonial and state violence. Upcoming and recent exhibitions include: Lahore Biennale (2020); *Global(e) Resistance*, Centre Pompidou, Paris (2020); *Hold Everything Dear*, the Power Plant, Ottawa (2019); 57th Venice Biennale (2017); 11th Gwangju Biennale (2016); BALTIC Centre for Contemporary Art, Gateshead (2016); and KW Institute for Contemporary Art, Berlin (2015). She was a finalist for the 2016 Sobey Art Award, Canada's preeminent contemporary art prize, and received the 2014 Victor Martyn Lynch-Staunton Award. Waheed's works can be found in the permanent collections of MoMA, New York; National Gallery of Canada, Ottawa; British Museum, London; Centre Pompidou; Burger Collection, Hong Kong; and Devi Art Foundation, New Delhi.

Credits: © 2016–17 Hajra Waheed
All works appear courtesy of Hajra Waheed and belong to the artist.
Installation views: The Mosaic Rooms, London, 2016 (152); Nanaimo Art Gallery, 2017 (153–55)
Photos: Vipul Sangoi (152); Sean Fenzl (153–55); Paul Litherland (156–81)

151

Untitled (MAP), 2016 (edition 1/6)
infographic print on vellum, 304 x 25 in.

Untitled (MAP), 2016 (edition 1/6)
infographic print on vellum, 304 x 25 in.

Untitled (MAP), 2016 (edition 1/6)
infographic print on vellum, 304 x 25 in.

Untitled (MAP), 2016 (edition 1/6)
infographic print on vellum, 304 x 25 in.

Strata 1–24, 2017 (detail, 1–12/24)
cut Letratone and Mylar, ink and archival tape on paper, 12.2 x 17.9 in. (each)

Strata 1–24, 2017 (detail, 13–24/24)
cut Letratone and Mylar, ink and archival tape on paper, 12.2 x 17.9 in. (each)

Strata 1–24, 2017 (detail, 1/24)
cut Letratone and Mylar, ink and archival tape on paper, 12.2 x 17.9 in.

Strata 1–24, 2017 (detail, 2/24)
cut Letratone and Mylar, ink and archival tape on paper, 12.2 x 17.9 in.

Strata 1–24, 2017 (detail, 3/24)
cut Letratone and Mylar, ink and archival tape on paper, 12.2 x 17.9 in.

Strata 1–24, 2017 (detail, 4/24)
cut Letratone and Mylar, ink and archival tape on paper, 12.2 x 17.9 in.

161

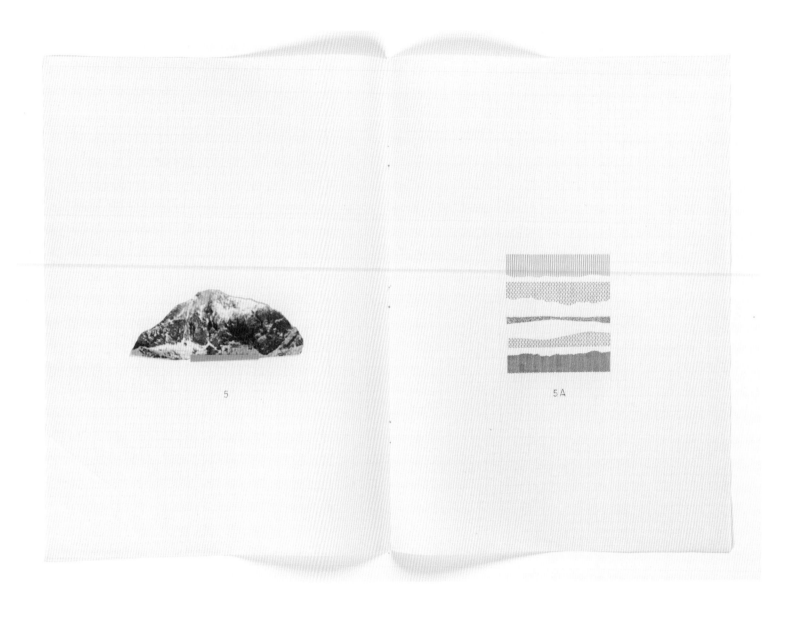

Strata 1–24, 2017 (detail, 5/24)
cut Letratone and Mylar, ink and archival tape on paper, 12.2 x 17.9 in.

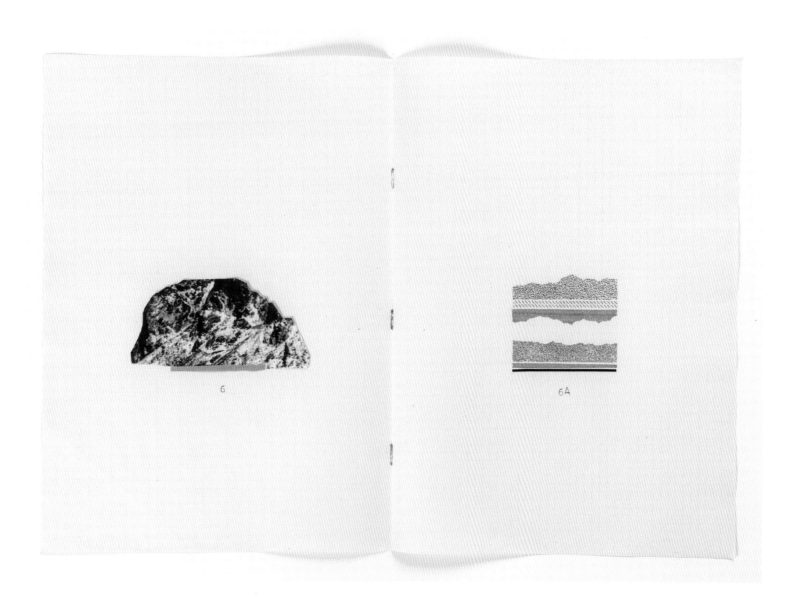

Strata 1–24, 2017 (detail, 6/24)
cut Letratone and Mylar, ink and archival tape on paper, 12.2 x 17.9 in.

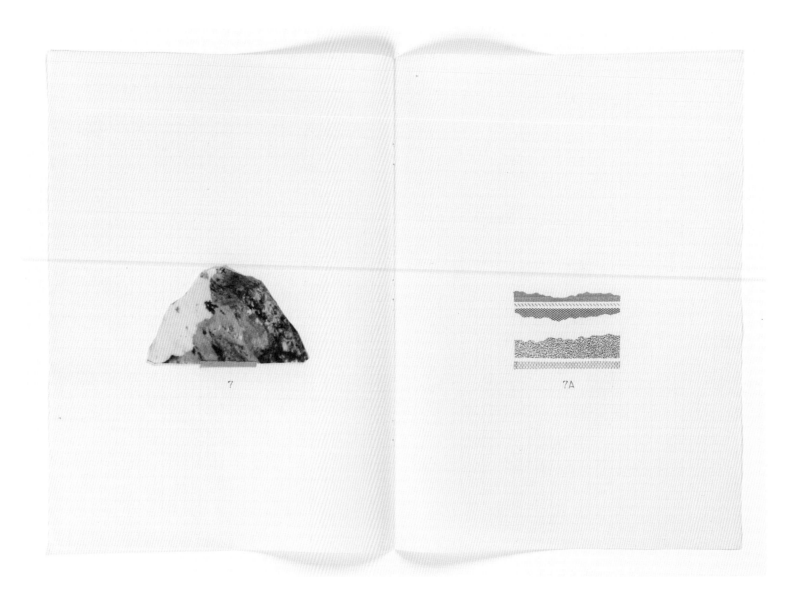

Strata 1–24, 2017 (detail, 7/24)
cut Letratone and Mylar, ink and archival tape on paper, 12.2 x 17.9 in.

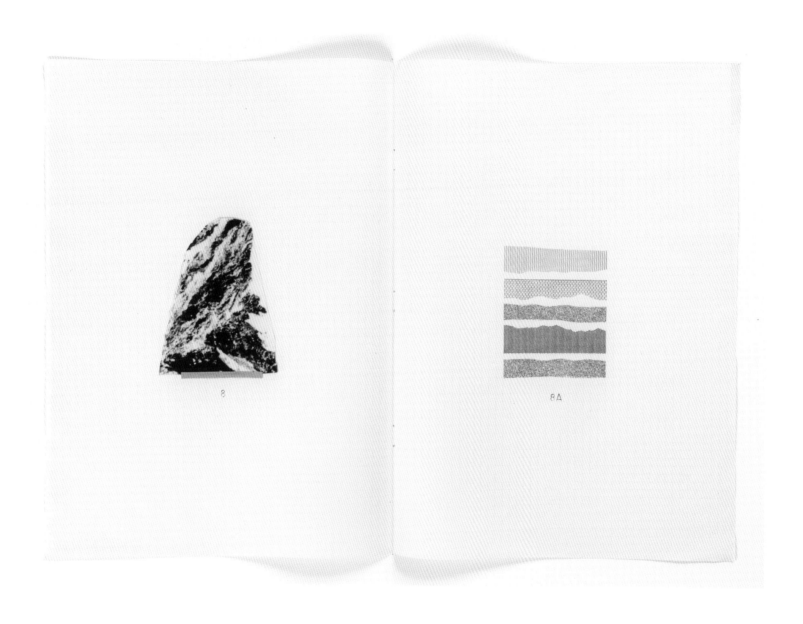

Strata 1–24, 2017 (detail, 8/24)
cut Letratone and Mylar, ink and archival tape on paper, 12.2 x 17.9 in.

Strata 1–24, 2017 (detail, 9/24)
cut Letratone and Mylar, ink and archival tape on paper, 12.2 x 17.9 in.

166

Strata 1–24, 2017 (detail, 10/24)
cut Letratone and Mylar, ink and archival tape on paper, 12.2 x 17.9 in.

Strata 1–24, 2017 (detail, 11/24)
cut Letratone and Mylar, ink and archival tape on paper, 12.2 x 17.9 in.

Strata 1–24, 2017 (detail, 12/24)
cut Letratone and Mylar, ink and archival tape on paper, 12.2 x 17.9 in.

Strata 1–24, 2017 (detail, 13/24)
cut Letratone and Mylar, ink and archival tape on paper, 12.2 x 17.9 in.

170

Strata 1–24, 2017 (detail, 14/24)
cut Letratone and Mylar, ink and archival tape on paper, 12.2 x 17.9 in.

Strata 1–24, 2017 (detail, 15/24)
cut Letratone and Mylar, ink and archival tape on paper, 12.2 x 17.9 in.

172

Strata 1–24, 2017 (detail, 16/24)
cut Letratone and Mylar, ink and archival tape on paper, 12.2 x 17.9 in.

Strata 1–24, 2017 (detail, 17/24)
cut Letratone and Mylar, ink and archival tape on paper, 12.2 x 17.9 in.

Strata 1–24, 2017 (detail, 18/24)
cut Letratone and Mylar, ink and archival tape on paper, 12.2 x 17.9 in.

175

Strata 1–24, 2017 (detail, 19/24)
cut Letratone and Mylar, ink and archival tape on paper, 12.2 x 17.9 in.

Strata 1–24, 2017 (detail, 20/24)
cut Letratone and Mylar, ink and archival tape on paper, 12.2 x 17.9 in.

Strata 1–24, 2017 (detail, 21/24)
cut Letratone and Mylar, ink and archival tape on paper, 12.2 x 17.9 in.

Strata 1–24, 2017 (detail, 22/24)
cut Letratone and Mylar, ink and archival tape on paper, 12.2 x 17.9 in.

Strata 1–24, 2017 (detail, 23/24)
cut Letratone and Mylar, ink and archival tape on paper, 12.2 x 17.9 in.

Strata 1–24, 2017 (detail, 24/24)
cut Letratone and Mylar, ink and archival tape on paper, 12.2 x 17.9 in.

The State of the Indian Ocean: A Scientific Perspective

Zara Currimjee

In discussing her series *Warm Waters* (110–39), Penny Siopis grapples with the future of our world with climate change. Siopis asks: "With global warming, what do we imagine? Burning? Drowning? Absolute alterity? And what forms—or formlessnesses—do we imagine this through?"[1] I too, a young person from the island nation of Mauritius, confront these questions. I seek answers from the world of science, however, which I have studied and know.

Growing up, I was taught that the Indian Ocean was the bridge between Europe and the silks and spices of the East. It was an ocean crossed by many, starting early. We learned the story of the Portuguese captain Vasco da Gama, who in 1498 rounded the Cape of Good Hope and found a sea route to the Indian Ocean. With the help of a navigator, Majid, he succeeded in reaching western India and in 1499 he returned to Portugal and described to the royal family everything he had seen: gold, ivory, porcelain, silks, and cottons being bought and sold in the port cities along the east coast of Africa and the west coast of India.

Vasco da Gama was not the only one to cross the Indian Ocean. Arabs, Indians, Portuguese, Dutch, French, and British established themselves all along the Indian Ocean rim as traders and conquerors. While these settlers undertook scientific investigations, those were secondary to the pursuit of economic and political interests.

The first comprehensive scientific exploration of the Indian Ocean began only fifty years ago. The International Indian Ocean Expedition (1959–65) is, to this day, considered one of the greatest oceanographic expeditions. The Expedition was a truly interdisciplinary effort, embracing meteorology, geophysics, physical and chemical oceanography, and marine biology and geology. Results from the hydrographic surveys undertaken during this expedition dramatically advanced our understanding of monsoon variability and dynamics and described for the first time the complex surface ocean circulation that emerges in response to monsoon seasons.[2]

Years later, in 2014, scientists in Pune, India published a study revealing that the western Indian Ocean has been warming for more than a century at a rate faster than any other region of the tropical oceans.[3] The reasons behind this steady heating are still debated but the results reveal that the warming of the western Indian Ocean is the largest contributor to the increase in global mean sea surface temperatures (fig. 1). In 2018, scientists from Austin, Texas, examined geological records and published their research showing that the Indian Ocean had a much larger impact on climate change

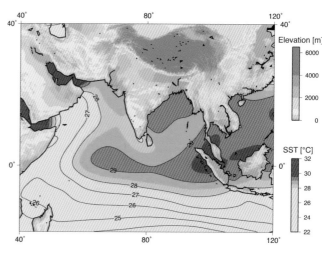

1. Observed mean sea surface temperatures (SST) in Indian Ocean (Roxy et al., "Indian Ocean Warming," fig. 2).

during the last ice age than previously thought. The scientists behind the study now fear that history could repeat itself.[4]

Despite these most recent findings, the Indian Ocean remains the least studied ocean on our planet. While there is still much to learn about the ocean, scientists and policy makers know enough to warn us that it and its coastal regions are under rising environmental pressures. Moreover, we now also know that significant portions of the Indian Ocean are among the most highly impacted marine ecosystems on Earth, and the littoral countries along the Indian Ocean rim are

counted among the world's most vulnerable to coastal environmental risks.

The rest of this essay will examine what we know about the future of the Indian Ocean with climate change, and what we do not.

The Indian Ocean

The Indian Ocean is the third largest ocean. It goes from the southern tip of Africa all the way in the west to Australia in the east. North to south it runs from the Indian landmass to Antarctica. Unlike the Atlantic and the Pacific, it is not connected to the Arctic and almost resembles a massive lake. The Indian Ocean is about six times the size of the United States, and even though it is the newest ocean on Earth, it is nearly sixty-five million years old.

In the roughly seventy-five million square kilometers that the Indian Ocean covers there are nine distinct marine ecosystems: the Agulhas Current, the Somali Coastal Current, the Red Sea, the Arabian Sea, the Bay of Bengal, the Gulf of Thailand, the West Central Australian Shelf, the Northwest Australian Shelf, and the Southwest Australian Shelf. The Indian Ocean is also home to four biodiversity

2. Indian Ocean food web (Zeynep Alta).

hot spots located in southwest Africa, southern India and Sri Lanka, Southeast Asia, and western Australia. Thirty-five thousand marine species coexist in the Indian Ocean and of all the 793 coral species known worldwide, 719 are found in the Indo-West Pacific region.[5]

The Indian Ocean comprises over 30% of the planet's ocean area and it is rimmed by thirty-six littoral and eleven hinterland nations.[6] Indian Ocean rim countries are home to approximately 30% of the world's population with many of their citizens highly dependent on the ocean for their livelihoods and wellbeing. The yearly value of ecosystem services provided by the Persian Gulf, the eastern coast of India, the Bay of Bengal, Southeast Asia, the western Australian coast, and the Indian Ocean's small island states is among the highest in the world.[7] These goods and services include:

Fisheries

Indian Ocean fisheries supplied about 14.6% of the world catch of 77.4 million tons in 2010.[8] People rely on fish for jobs; in Indonesia alone, fishing and fish farming employ approximately six million.[9] People also, just as importantly, rely on fish for food. It is estimated that in Egypt, Malaysia, Mozambique, the Seychelles, Singapore, Tanzania, and Thailand, 20% or more of animal protein in local diets comes from fish. In Bangladesh, Comoros, Indonesia, Maldives, and Sri Lanka, that percent increases to more than half.[10]

Tourism

Coastal and marine tourism contribute immensely to the economies of Indian Ocean countries. This is especially true in small island states that rely on healthy coral reefs and

pristine beaches and seas for tourism. In the western Indian Ocean, coastal and marine tourism account for $14.3 billion annually.[11]

Carbon Sequestration and Coastal Protection

Indian Ocean ecosystems support economic activity and offer associated benefits for people and industry. Many services provided by marine ecosystems are intangible and the benefits are non-market products, including carbon sequestration as well as water filtration and coastal protection from mangroves, seagrass, and wetlands.

What Is at Risk

Marine Food Webs

In the summer, phytoplankton blooms cover the surface of the western Indian Ocean. Phytoplankton are important because they help regulate climate and also form the base of the marine food web; countless species of fish depend on phytoplankton for their food (fig. 2).

According to scientists at the Indian Institute of Tropical Meteorology in Pune, rapid warming of the Indian Ocean has reduced phytoplankton populations by as much as 20%.[12] As waters warm, the churning of surface water and nutrient-rich deep waters slows down. This prevents nutrients from reaching the surface where the plankton receive sufficient light for photosynthesis. As a consequence, rising sea surface temperatures reduce the availability of a fundamental building block of life in the Indian Ocean with cascading effects through the entire food web. This is leading to falling populations of fish and other animals in the Indian Ocean.

According to the United Nations Food and Agriculture Organization, the Indian Ocean accounts for 20% of the total global tuna catch, especially the most valuable bigeye tuna.[13] Tuna catches in the Indian Ocean have declined by 50–90% in the past half century. Indus-

trial overfishing is responsible for much of that decline. However, scientists warn that reduced levels of phytoplankton will be an additional stressor on the tuna population. This overexploitation can easily lead to a point of no return and species extinction, not only for tuna, but for many other varieties of fish in the Indian Ocean.

Coral Reefs

Warming sea waters, caused by climate change and extreme climatic events, also threaten the stability of tropical coral reefs.

Scientists at the University of Exeter found that higher ocean temperatures during the 2016 El Niño led to the die-off of coral in the Maldives.[14] The most alarming aspect of coral die-off is that it leads to a calamitous decline in the growth of reefs. Before the warming event, the reefs were growing rapidly, but after the heat wave the growth collapsed, threatening the structural stability of the reefs. This reduces the resilience of these reefs and makes them more vulnerable to future heat waves, which are likely to increase in intensity and frequency as a consequence of global warming (fig. 3).

The loss of coral reefs has serious consequences. Coral reefs are fish nurseries, providing shelter for countless newly hatched fish. Their destruction means shrinking adult populations and declining catches. Coral reef-associated fisheries sustain the livelihoods, food security, and protein intake of many small-scale fishers in the region. The destruction of coral reefs also leads to decreased biodiversity as well as weakened shoreline protection.

Northern Indian Ocean Coastal Communities

Since 1880, sea levels around the world have risen on average by 0.07 inches per year. However, in recent years, scientists have observed a much more accelerated rise in sea level in the north Indian Ocean.[15] Data on tides show that the north Indian Ocean has risen by 0.12 inches per year for the last three decades, nearly double the global average.

Many of the world's most vulnerable coastal populations are in the northern Indian Ocean and, for many years, scientists could not explain why that section of the ocean was rising so fast.

A study from 2017 provides a compelling explanation. It argues that the swift rise is due to a weakening of the Indian monsoon. Summer monsoon winds and rainfall have decreased in frequency and intensity in the last seventy years. In the summer, the coming of the monsoon moves heat from the northern Indian Ocean to the southern, but the weakening of the monsoon has slowed that heat transfer. As a result, the northern sections of the ocean have warmed disproportionately, inducing seawater molecules to heat up and swell in a phenomenon known as thermal expansion. Unlike other oceans, where sea level rise is caused primarily by melting continental ice sheets, the Indian Ocean's rise is driven largely by thermal expansion.

Jakarta, the capital of Indonesia, is at particular risk. The city is so vulnerable to rising seas that in May 2019 Indonesia's president-elect announced a plan to move the capital.[16] Researchers predict that by 2050, 95% of northern Jakarta could be submerged. Global warming is not the only reason for the massive floods that engulf Jakarta regularly. The city is also sinking, and more quickly than any other big city on the planet. The sinking—at a rate of about ten inches per year—is due to a combination of the illegal drilling of wells and the weight of the capital's buildings. The wells have drained the underground aquifers on which the city sits.

While the situation in Jakarta is extreme, many other Indian Ocean cities face having to adapt to rising seas. Some 2.6 billion people, or about 40% of the global population, live in and around the Indian Ocean. Several cities in India, such as Chennai and Mumbai, with thousands of slum settlements along the coast, are threatened by submergement.

In addition to big cities, many small island states, including Mauritius, Comoros, Maldives, and the Seychelles, are in the Indian Ocean. As one of the lowest-lying countries on Earth, the Maldives is especially vulnerable to sea level rise. Aside from their unfavorable

3. Coral bleaching in the Maldives, May 2016 (The Ocean Agency/XL Catlin Seaview Survey/Richard Vever).

topography, the islands that comprise the Maldives are threatened because much of their critical infrastructure is located within one hundred meters of the ocean.[17] In recent years, the citizens of the Maldives have been subjected to more intense rainfall, higher cyclonic winds, and larger storm surges. The government has been working to make infrastructure more resilient and relocating residents of low-lying atolls.

Southern Indian Ocean Coastal Communities

The southern Indian Ocean is warming quickly as well. Regions where ocean temperatures reached 26.5°C (the temperature that facilitates tropical cyclone formation) are now experiencing water temperatures of 30–32°C.[18] Climate change models predict more intense tropical cyclones with these water temperatures. However, the dynamics of storm formation in the Indian Ocean were poorly understood until a study published

in 2018 by a researcher at the University of the Witwatersrand in Johannesburg showed that with the warming, tropical cyclones are less frequent, but high-intensity level five storms are more common.[19]

Mozambique, an underdeveloped country with a long coastline, is especially vulnerable to storms. In March 2019, Idai was one of the most severe storms to have ever made landfall in

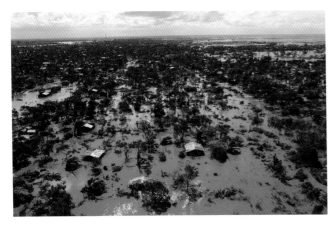

4. Flood waters in Buzi District, Mozambique after Cyclone Idai, Mar. 21, 2019 (Siphiwe Sibeko/Reuters).

that country and one of the most deadly tropical cyclones to make landfall on the African continent (fig. 4).

Six weeks later, Kenneth, a category four tropical cyclone, struck the border zone between Mozambique and Tanzania. Kenneth was the most northerly cyclone to make landfall in Mozambique and the first to ever strike Tanzania. It was also unusual to have two severe tropical cyclones so late in the season, which usually runs from January to March.

The impact of those two storms on Mozambique was disastrous and left close to 2.2 million people in need of urgent assistance. Many were left stranded with no homes, food, water, or basic infrastructure.[20] There were outbreaks of communicable diseases, with cholera of most concern. More frequent storms pose a grave threat to southern Indian Ocean coastal countries and island states. The increased risks are a

result of strong winds, heavy rainfall, and ocean surges associated with category five storms.

The developing countries and small island states in the region cannot afford large investment in infrastructure adaptation to protect against the threats of tropical cyclones. In any given year, only about 5% of the tropical cyclones that form in the southern Indian Ocean make landfall. However, they invariably have devastating impacts on the livelihoods, economies, and environments of the countries affected.

The Poorly Understood Ocean

Some of the most severe impacts of climate change are being felt and will continue to be felt in the Indian Ocean. As I write this essay, the *Washington Post* is reporting on Cyclone Kyarr, a storm on the brink of category five status that is threatening the Arabian Sea. The journalist writes: "Cyclone Kyarr is a monster. The Indian Ocean beast—dubbed a top-tier 'super cyclonic storm' by the Indian Meteorological Department—is the first storm of such intensity to rage in the Arabian Sea in 12 years."[21]

On December 26, 2004, I became aware of and came to fear the destructive power of the sea. On that day, a magnitude 9.1 earthquake struck beneath the Indian Ocean, generating a massive tsunami that claimed more than 230,000 lives in fourteen countries. It was one of the deadliest natural disasters ever recorded. While Mauritius was not affected by that tsunami, I was afraid of a wall of water coming from nowhere and taking my home and neighborhood away. It haunted me. Today, I know there is much more than tsunamis to fear and much more that can take our homes away. Deadly floods, category five cyclones, sea level rise, and the biggest of all: climate change.

I have seen the Indian Ocean change dramatically in my lifetime, and I am only in my twenties. All scientists agree that these changes are not about to end.

Despite recent gains in knowledge, the Indian Ocean remains poorly understood. In the face of climate change, the Indian Ocean will be a hot topic of conversation. We will need much more than talk though. I hope the Indian Ocean can—like it has done so well for so long—bring people together, not displace individuals and drive communities apart.

Zara Currimjee, born and raised in Mauritius, manages the office of the CEO at Oceana, the largest advocacy organization focused solely on ocean conservation in the world. She holds an MA in international environmental policy from the Middlebury Institute of International Studies and a BA in environmental biology and maritime studies from Williams College. At Oceana she previously worked on feasibility studies and campaigned against harmful fisheries subsidies. Currimjee co-produced *Vey nou Lagon*, an award-winning documentary that shows how fishermen forged solutions to the fisheries crisis in Mauritius. She has also designed and implemented sustainable financing mechanisms for ocean management in small Caribbean islands with the Waitt Institute.

1 "Penny Siopis: *Warm Water Imaginaries*," Stevenson, https://www.stevenson.info/exhibition/3917.

2 Raleigh R. Hood, Michael J. McPhaden, and Ed Urban, "New Indian Ocean Program Builds on a Scientific Legacy," *EOS, Transactions, American Geophysical Union* 95, no. 39 (Sept. 2014): 349–60.

3 Mathew Koll Roxy et al., "The Curious Case of Indian Ocean Warming," *Journal of Climate* 27, no. 22 (Nov. 4, 2014): 8501–9, https://doi.org/10.1175/jcli-d-14-00471.1.

4 Pedro N. Dinezio et al., "Glacial Changes in Tropical Climate Amplified by the Indian Ocean," *Science Advances* 4, no. 12 (Dec. 12, 2018), https://doi.org/10.1126/sciadv.aat9658.

5 David Michel, "Environmental Pressures in the Indian Ocean," in *Indian Ocean Rising: Maritime Security and Policy Challenges*, ed. David Michel and Russell Sticklor (Washington, DC: Stimson, July 2012), 115, https://www.stimson.org/content/indian-ocean-rising-maritime-security-and-policy-challenges.

6 Mohideen Wafar et al., "State of Knowledge of Coastal and Marine Biodiversity of Indian Ocean Countries," *PLOS ONE* 6, no. 1 (Jan. 31, 2011), https://doi.org/10.1371/journal.pone.0014613.

7 David Obura et al., *Reviving the Western Indian Ocean Economy: Actions for a Sustainable Future* (Gland: WWF International, 2017), 64, https://sustainabledevelopment.un.org/content/documents/13692WWF2.pdf.

8 *The State of World Fisheries and Aquaculture 2010* (Rome: Food and Agriculture Organization of the United Nations, FAO Fisheries and Aquaculture Department, 2010), 11, http://www.fao.org/3/i1820e/i1820e00.htm.

9 *Fisheries and Aquaculture*, 30.

10 *Fisheries and Aquaculture*, 65.

11 Obura et al., *Western Indian Ocean Economy*, 7.

12 Mathew Koll Roxy et al., "A Reduction in Marine Primary Productivity Driven by Rapid Warming over the Tropical Indian Ocean," *Geophysical Research Letters* 43 (Dec. 18, 2015): 826–33, https://doi.org/10.1002/2015gl066979.

13 *Fisheries and Aquaculture*, 35.

14 "Impacts of Mass Coral Die-Off on Indian Ocean Reefs Revealed," *ScienceDaily*, Feb. 20, 2017, https://www.sciencedaily.com/releases/2017/02/170220190632.htm.

15 P. Swapna et al., "Multidecadal Weakening of Indian Summer Monsoon Circulation Induces an Increasing Northern Indian Ocean Sea Level," *Geophysical Research Letters* 44 (Sept. 17, 2017): 10560–72, https://doi.org/10.1002/2017gl074706.

16 Matt Simon, "Jakarta Is Sinking: Now Indonesia Has to Find a New Capital," *Wired*, May 2, 2019, https://www.wired.com/story/jakarta-is-sinking/.

17 Hartwig Schafer, "Bracing for Climate Change Is a Matter of Survival for the Maldives," *World Bank Blogs*, Jan. 20, 2019, https://blogs.worldbank.org/endpovertyinsouthasia/bracing-climate-change-matter-survival-maldives.

18 Tim P. Barnett et al., "Penetration of Human-Induced Warming into the World's Oceans," *Science* 309, no. 5732 (Aug. 2005): 284–87, https://doi.org/10.1126/science.1112418.

19 Jennifer M. Fitchett, "Recent Emergence of CAT5 Tropical Cyclones in the South Indian Ocean," *South African Journal of Science* 114, nos. 11–12 (2018): 1–6, https://dx.doi.org/10.17159/sajs.2018/4426.

20 "Cyclones Idai and Kenneth," OCHA, 2019, https://www.unocha.org/southern-and-eastern-africa-rosea/cyclones-idai-and-kenneth.

21 Matthew Cappucci, "Category 4 Kyarr Is the Strongest Cyclone over the Arabian Sea in 12 Years," *Washington Post*, Oct. 28, 2019, https://www.washingtonpost.com/weather/2019/10/28/category-kyarr-is-strongest-cyclone-over-arabian-sea-years/.

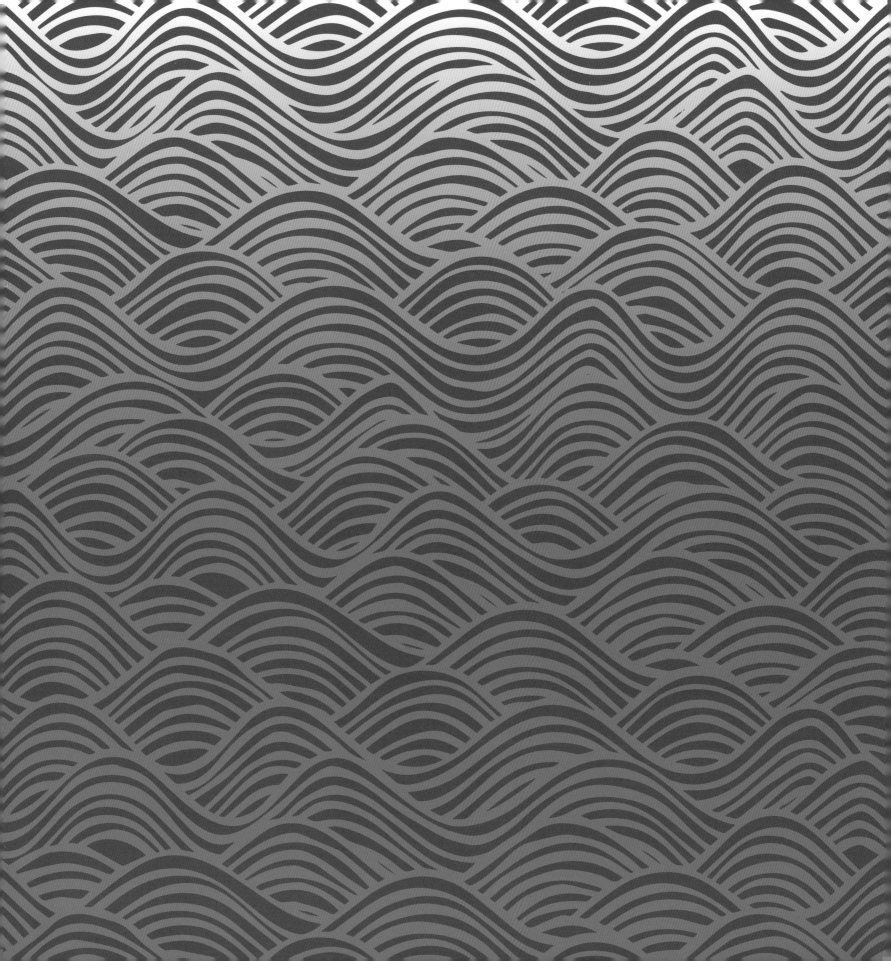

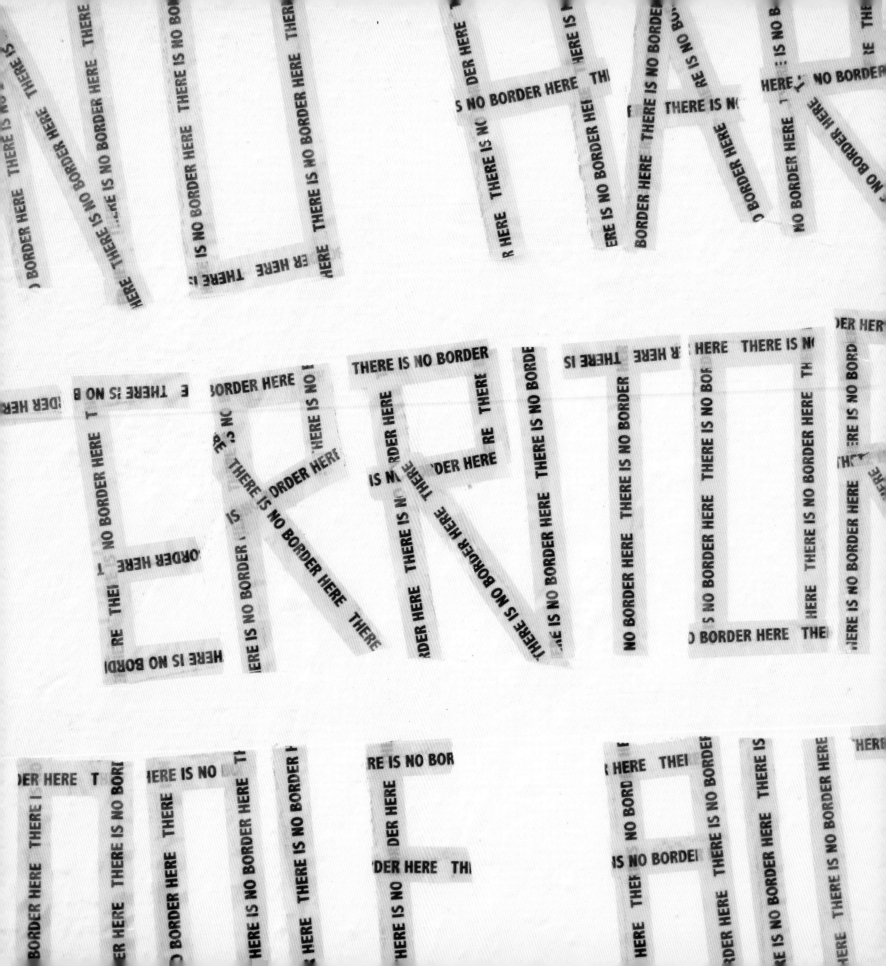